ART IN TR

KUNST IM

ANSITION
ÜBERGANG

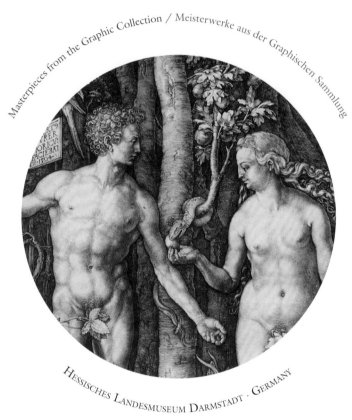

ART IN TRANSITION

ALBRECHT DÜRER

KUNST IM ÜBERGANG

Curated by / Kuratiert von **Mechthild Haas, Hessisches Landesmuseum Darmstadt, Germany**

Exhibition circulated by / Ausstellungstour organisiert durch **International Arts & Artists, Washington, DC**

Exhibition Venues/Ausstellungsorte ... Museum of Biblical Art, New York,
July 26–September 21, 2008

Mobile Museum of Art, Alabama,
October 10, 2008–January 4, 2009

Museum of Fine Arts, St. Petersburg, Florida,
January 17–April 12, 2009

Curator/ Kuratorin .. Mechthild Haas

Catalogue text/ Katalogtexte .. © 2008 Mechthild Haas

Cover/ Umschlagvorderseite ... *Dancing Peasant Couple* (detail)
Das tanzende Bauernpaar (Ausschnitt), 1514, engraving

Images/Abbildungen .. © Hessisches Landesmuseum Darmstadt

Photos ... © Wolfgang Fuhrmannek,
Hessisches Landesmuseum Darmstadt

Exhibition coordinator/Ausstellungskoordination Amanda Cane, senior exhibitions manager at IA&A

Design ... Katie Dahl, Design Studio director at IA&A

Editor/Redaktion ... Penny Kiser, editorial manager at IA&A

Translator/Übersetzer ... Ian Pepper

Text/Schrift .. Hypatia Sans Pro/ITC Galliard

Printer/Druck ... Badger Press, Fort Atkinson, WI

ISBN .. 978-0-9767102-6-4

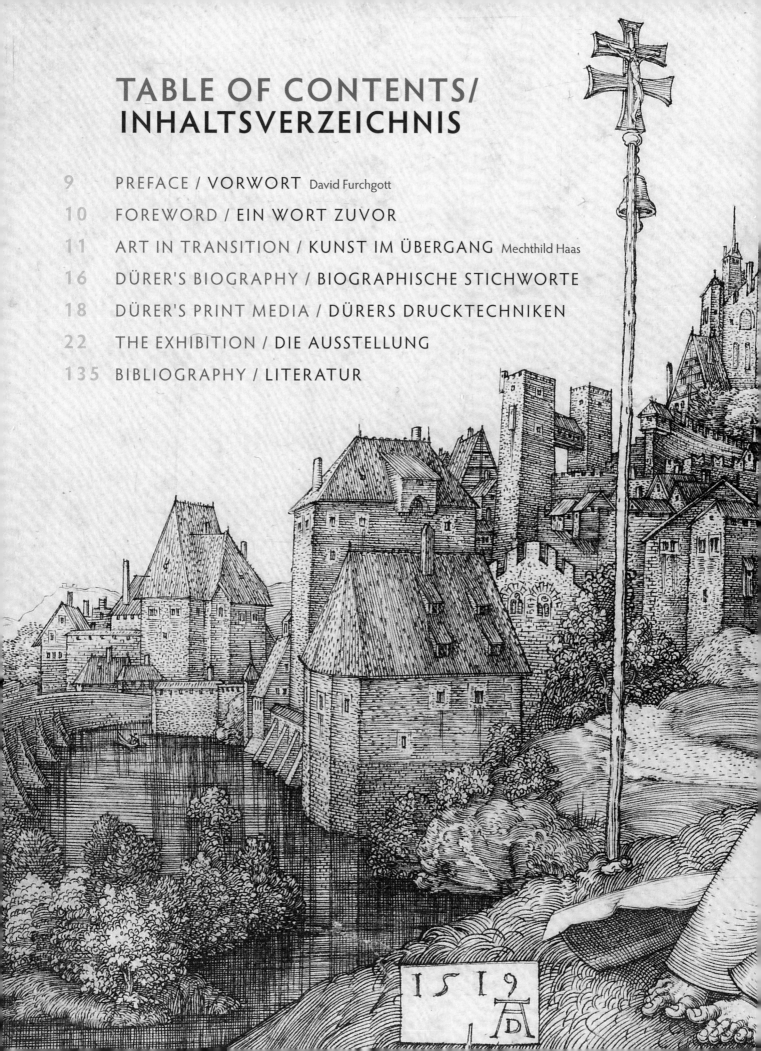

TABLE OF CONTENTS/
INHALTSVERZEICHNIS

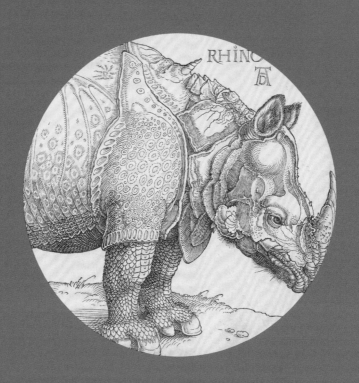

PREFACE/VORWORT

It has been a great honor to collaborate with the Hessisches Landesmuseum Darmstadt, a highly-renowned German cultural institution with one of the world's finest collections of Dürer graphics, now sharing some of its treasures with America for an exclusive three-venue tour. We are deeply indebted to Dr. Ina Busch, director of the museum, for allowing this fascinating collection to travel to the United States, and to Dr. Mechthild Haas, graphics curator, for her tireless efforts in the development of the exhibition and the writing of the catalogue. Her hard work and guidance have been invaluable to us throughout this process.

Within International Arts & Artists, we acknowledge the director of our Traveling Exhibition Service, Marlene Rothacker, Katie Dahl, Design Studio director and designer of the Art in Transition catalogue. We also thank Amanda Cane and her predecessor Reid Buckley, the senior exhibitions managers who organized the U.S. part of this collaboration and arranged the tour.

Es war uns eine große Ehre, mit dem Hessischen Landesmuseum Darmstadt zusammenarbeiten zu dürfen. Zu den Beständen dieser bedeutenden deutschen Kulturinstitution zählt eine der weltweit besten Sammlungen an Dürergraphik. Eine Auswahl daraus wurde uns für eine exklusive, auf drei Stationen begrenzte Ausstellungstour entliehen. Wir sind Dr. Ina Busch, der Leitenden Museumsdirektorin, zu großem Dank verpflichtet, dass sie einwilligte, diese einzigartigen Meisterwerke durch die Vereinigten Staaten von Amerika reisen zu lassen, genauso wie Dr. Mechthild Haas, der Leiterin der Graphischen Sammlung, für ihre unermüdlichen Bemühungen um diese Ausstellung und das Erstellen des Kataloges. Während der Vorbereitungszeit zu dieser Ausstellung sind uns ihre intensive Arbeit und ihre Beratung unschätzbar gewesen.

Bei International Arts & Artists gilt unser Dank der Leiterin des Ausstellungs-Reise-Services, Marlene Rothacker, genauso wie Katie Dahl, der Leiterin des Design Studios, die für das Layout des vorliegenden Kataloges verantwortlich war. Außerdem danken wir Amanda Cane und ihrem Vorgänger Reid Buckley, den Senior-Ausstellungs-Managern, die den U.S.-Part dieser Kooperation organisierten und die Ausstellungstour arrangierten.

For the Benefit of All,
Zur Freude aller,

David Furchgott
President / Präsident
International Arts & Artists

FOREWORD / EIN WORT ZUVOR

The Hessisches Landesmuseum Darmstadt is one of the few museums worldwide whose collections are based on the integration of the natural sciences and art. In 1820, Grand Duke Ludewig I of Hessen signed a deed of foundation which transferred his private collections to a public museum. Up to the present day, this institution unites cultural and natural history under a single roof. Despite the grievous loss of irreplaceable objects during World War II, the museum has succeeded over the centuries in honing the collection's profile and significantly expanding its holdings. In fall of 2007, the museum building closed temporarily to begin comprehensive construction work and renovations, with completion anticipated for 2011. Plans involve the restructuring and modernization of the original building, erected by Alfred Messel in 1906 in the heart of the town, along with an extension annex that will provide an additional 7300 square meters of usable surface area. The museum is using this closure period as an opportunity to loan portions of its holdings. The paleontological finds from the Messel Pit are on tour, as is the collection of medieval ivories and the sculptures of the Spierer Collection. From its abundant holdings of old master prints, the Department of Prints and Drawings has assembled a selection of 100 prints by Albrecht Dürer, which will go on tour in the United States for a period of one year. These masterpieces of graphic art provide access to one of the most important phases in the development of European visual culture.

Because of the extreme fragility of these exceptionally valuable prints, this exhibition tour has been restricted to three venues. Given these limitations, we are extremely pleased that International Arts & Artists has succeeded in securing important exhibition venues for the Darmstadt Dürer holdings, which will be seen now for the first time outside of Hessen. The prints will travel first to New York City, then to Mobile (Alabama), and finally to St. Petersburg (Florida). Our thanks to International Arts & Artists for planning and organizing the exhibition tour so carefully, as well as for producing the present bilingual catalogue publication. We are confident that "our" Dürer will encounter many admirers in the USA. We hope that American museum visitors will enjoy and learn from these works, and we look forward to welcoming these priceless treasures of graphic art back to their home in Darmstadt safe and sound after their long journey.

Ina Busch
Executive Director /
Leitende Direktorin
Hessisches Landesmuseum Darmstadt

Das Hessische Landesmuseum Darmstadt ist eines der wenigen Museen europaweit, dessen Sammlungskonzeption sich auf die Verbindung von Naturwissenschaft und Kunst gründet. 1820 hatte Großherzog Ludewig I. von Hessen durch eine Stiftungsurkunde seine privaten Sammlungen in ein öffentliches Museum überführt. Bis heute vereinigt das Haus Kulturgeschichte und Naturkunde unter einem Dach. Über die Jahrhunderte gelang es – obgleich die Verluste durch den Zweiten Weltkrieg schmerzlich und unersetzbar bleiben – das Sammlungsprofil zu schärfen und die Bestände bedeutend zu erweitern. Seit Herbst 2007 bis voraussichtlich 2011 ist der Museumsbau wegen umfangreicher Bau- und Sanierungsarbeiten geschlossen. Die Planung sieht die Neustrukturierung und Modernisierung des 1906 von Alfred Messel im Herzen der Stadt errichteten Gebäudes sowie einen Erweiterungsbau mit 7.300 qm zusätzlicher Nutzfläche vor. Diese Schließungszeit nutzt das Museum, um Teile seiner Bestände auf Reisen zu schicken: Die paläontologischen Funde aus der Grube Messel sind auf Tour, genauso wie die mittelalterlichen Elfenbeine oder die Skulpturen der Sammlung Spierer. Die Graphische Sammlung hat für eine einjährige Tournee in den USA aus ihrem reichen Fundus an Altmeistergraphik 100 Blätter von Albrecht Dürer zusammengestellt. Diese Glanzstücke der Graphikkunst eröffnen die Perspektive auf einen der wichtigsten Abschnitte der abendländischen künstlerischen Entwicklung überhaupt.

Wegen der Fragilität der wertvollen Blätter musste die Ausstellungstour auf drei Stationen begrenzt werden. Umso größer ist unsere Freude, dass sich durch die Vermittlung von International Arts & Artists bedeutende Spielorte fanden und der Darmstädter Dürer-Bestand, der erstmals außerhalb Hessens zu sehen ist, nach New York, nach Mobile in Alabama und nach St. Petersburg in Florida reisen wird. Wir danken International Arts & Artists für die umsichtige Planung und Durchführung der Ausstellungstournee, sowie für die Realisierung dieses zweisprachigen Kataloges. Wir sind sicher, dass „unser" Dürer in den USA viele Bewunderer findet. Allen wünschen wir Genuss und Freude beim Betrachten der Werke und hoffen, dass dieser unwiederbringliche Schatz an Meistergraphiken von seiner weiten Reise wohlbehalten zu uns nach Darmstadt zurückkehren wird.

Mechthild Haas
Curator, Department of Prints and Drawings /
Leiterin der Graphischen Sammlung
Hessisches Landesmuseum Darmstadt

ALBRECHT DÜRER :
ART IN TRANSITION / KUNST IM ÜBERGANG

Introduction

Beginning with Wilhelm Heinrich Wackenroder, the German Romantics cultivated the image of the great artistic Dioscuri: Raphael and Dürer. Albrecht Dürer was regarded as the greatest Northern European artist, his glory by no means dimmed by that of his above–named Italian counterpart, and not even by Leonardo or Michelangelo. Inaugurated in 1792, the graphics collection of the Landgrave Ludwig X – later Grand Duke Ludewig I of Hessen – came to form the core of the Hessisches Landesmuseum in Darmstadt. Doubtless, the prevailing late 18th-century veneration of early German art was a crucial factor leading toward Ludwig's decision to expand his collection to include works by Dürer. In Mannheim, he commissioned Artaria (then Germany's leading art dealer), who was able by 1802/03 to procure an almost complete set of Dürer's graphic output in superb quality for the Darmstadt collection, to which there have been very few subsequent additions of Dürer prints. Artaria probably procured the Dürer prints mainly in Paris. Handwritten inscriptions on a number of pages indicate that they belonged in the 17th century to the famous print dealer Pierre Mariette, a name which even today stands for connoisseurship and the highest standards of quality. From among the approximately 350 Dürer prints owned by the Hessisches Landesmuseum in Darmstadt, this catalogue presents a selection of 100 precious works in chronological order, including exemplary versions of woodcuts and copperplate engravings and several rare iron engravings and drypoints. The selection is intended to convey the prominent role played by the print media in the 16th century, and to illustrate their elevation by Dürer to the rank of high art.

Albrecht Dürer was a German artist on the threshold of European modernity, and he lived during one of the most emphatically transitional epochs of European history. As early as 1455, Gutenberg had printed his celebrated "42 Line Bible" in Mainz, thereby setting a

Einführung

Die deutsche Romantik pflegte seit Wilhelm Heinrich Wackenroder das Bild der großen Dioskuren Raffael und Dürer. Albrecht Dürer galt als der Künstler des Nordens, sein Glanz musste keineswegs neben Raffael, und, so ließe sich ergänzen, Leonardo oder Michelangelo, verblassen. Diese Verehrung der altdeutschen Kunst in der zweiten Hälfte des 18. Jahrhunderts war sicher mit ein Grund dafür, dass auch der Landgraf Ludwig X., der spätere Großherzog Ludewig I. von Hessen, auf dessen Sammlungen das heutige Hessische Landesmuseum Darmstadt gründet, seine 1792 ins Leben gerufene Graphische Sammlung um das Werk Dürers zu erweitern wünschte. Er beauftragte die damals in Deutschland führende Kunsthandlung Artaria in Mannheim, durch deren Vermittlung bereits 1802/03 Dürers graphisches Werk fast vollständig und in schönster Druckqualität für die Darmstädter Sammlung erworben werden konnte. Später ist der Darmstädter Dürer-Bestand kaum noch ergänzt worden. Artaria hatte die Dürer-Kollektion wahrscheinlich hauptsächlich in Paris zusammengestellt. Aus handschriftlichen Vermerken auf einigen Blättern geht hervor, dass sie im 17. Jahrhundert im Besitz des berühmten Graphikhändlers Pierre Mariette waren, ein Name der bis heute Kennerschaft und höchste Qualitätsmaßstäbe verbürgt. Aus dem heute rund 350 Blatt umfassenden Gesamtbestand an Dürer-Druckgraphik des Hessischen Landesmuseum in Darmstadt stellt dieser Katalog 100 kostbare Arbeiten in chronologischer Folge vor, Holzschnitte und Kupferstiche in vorzüglichen Abzügen, sowie einige rare Eisen- und Kaltnadelradierungen. Die Auswahl soll vermitteln, welch herausragende Rolle der Druckgraphik im 16. Jahrhundert zukam und wie Dürer das druckgraphische Medium in den Rang der Kunst erhob.

Albrecht Dürer war ein deutscher Künstler an der Schwelle zum Europa der Moderne, er lebte in einer der markantesten historischen Epochen des Übergangs.

process in motion that would lead in just a few years to the establishment of book publishing workshops in every major European city. As late as the end of the 15th century, the various relief and intaglio printing techniques – each with its origin in a different craft tradition – developed relatively independently of one another. Albrecht Dürer devoted himself to the print media with an intensity unmatched by any earlier artist. He was the first to overcome the traditional division between printing techniques still in force in his own time, exploiting the woodcut, the engraving, the etching, and the drypoint simultaneously as equals. Like many 15th-century engravers, Dürer came from a family of goldsmiths. After receiving training in his father's workshop, Dürer transferred to the studio of the Nuremberg painter–entrepreneur Michael Wolgemut. Among other things executed in Wolgemut's workshop were the 645 woodcuts for Hartmann Schedel's illustrated World Chronicle, so we can assume that by this time, Dürer was familiar with the technique of woodcut production for printed books.

Today, Dürer is regarded as the greatest master of the printed image besides Rembrandt. What instigated Dürer's genuinely revolutionary decision to make the graphic arts the main field of his artistic activity? Unquestionably, he would have prospered and flourished as a painter as well. In general, religious subjects and portraiture were the preferred themes of Dürer's paintings. In contrast, his graphic interests were broader in character. Through the graphic media, Dürer was able to communicate more readily and on a larger scale. In this regard, he addressed a new public, one with some comprehension of art, and one open to both the religious and philosophical questions of the day. But at the same time, he addressed the individual – the believer as well as the collector and art lover. The entire spectrum spanned by Dürer in his graphic work was marked by his intense intellectuality. He moved between science and alchemy, philosophy and the mystery of faith, the study of nature and visionary imagination. But for the most part, the center of gravity in Dürer's graphic production was the depiction of biblical scenes. His most important theme, the sufferings of Christ, was developed to the fullest degree in his graphic production. He produced three narrative cycles based on scenes from the Passion, all of which he published in book form accompanied by text (with the exception of the Engraved Passion (cat. 69 ff), which lacked a text). Also accompanied by text were the images of Dürer's Apocalypse (cat. 13 ff) and his Life of the Virgin (cat. 45 ff). For this reason, the contemplation of selected individual scenes from these cycles of images runs counter to their original integration into the larger context of the printed volume.

Dürer was able to publish his engravings and

Bereits 1455 hatte Gutenberg in Mainz seine berühmte „Bibel der 42 Zeilen" gedruckt und damit einen Prozess in Gang gesetzt, der in den darauf folgenden Jahren in jeder größeren europäischen Stadt zur Einrichtung einer typographischen Werkstatt führte. Noch bis zum Ende des 15. Jahrhunderts hatten sich die Hoch- und Tiefdrucktechniken, die auf unterschiedliche handwerkliche Wurzeln zurückgehen, relativ unabhängig von einander entwickelt. Wie bis dahin kein anderer Künstler widmete sich Albrecht Dürer der Druckgraphik. Er war der Erste, der die traditionelle Trennung der druckgraphischen Techniken seiner Zeit überwand und den Holzschnitt, den Kupferstich, die Radierung und Kaltnadelradierung gleichberechtigt nebeneinander nutzte. Wie viele Kupferstecher des 15. Jahrhunderts entstammte auch Dürer einer Goldschmiedefamilie. Nach einer Ausbildung in der väterlichen Goldschmiedewerkstatt wechselte Dürer in die Lehre des Nürnberger Maler-Unternehmers Michael Wolgemut. In dieser Werkstatt wurden u. a. die 645 Holzschnitte für Hartmann Schedels illustrierte Weltchronik erarbeitet, so dass davon auszugehen ist, dass sich Dürer bereits hier mit der Buchholzschnitttechnik vertraut machen konnte.

Heute gilt Dürer als der größte Meister des gedruckten Bildes neben Rembrandt. Was stand hinter Dürers wahrhaft revolutionärer Entscheidung, die Graphik zum Hauptfeld seiner künstlerischen Arbeit zu machen? Zweifellos hätte es Dürer auch als Maler zu Wohlstand gebracht. Allgemein Religiöses und Porträts waren die bevorzugten Themen von Dürers Gemälden. Dagegen waren seine Interessen in der Graphik breiter angelegt. Mit seinen graphischen Arbeiten konnte sich Dürer rascher und weitreichender mitteilen. Hier richtete sich der Künstler an ein neues, kunstverständiges, religiösen wie philosophischen Fragestellungen gegenüber offenes Publikum, aber zugleich auch an den einzelnen Menschen, den Gläubigen, wie den Sammler und Kunstliebhaber. Der Spannungsbogen, den Dürer in seiner Graphik anschlug, war von Intellektualität geprägt. Der Künstler bewegte sich zwischen Wissenschaft und Alchemie, Philosophie und Mysterium des Glaubens, Naturstudium und visionärer Schau. Das Schwergewicht der Themenbereiche in Dürers Druckgraphik lag dabei weiterhin bei den biblischen Szenen. Dürer hat sein eigentliches Hauptthema, die Leidensgeschichte Christi, in der Druckgraphik voll verwirklicht und aus den Passionsszenen insgesamt drei erzählende Serien entwickelt, die er in Buchform, versehen mit einem Text, herausgab. Alleine die „Kupferstich-Passion" (Kat. 69ff) erschien ohne Text. Ebenfalls von einem Text begleitet waren Dürers „Apokalypse" (Kat. 13ff) und sein „Marienleben" (Kat. 45ff). Deshalb entspricht die isolierte Betrachtung ausgewählter

woodcuts in large editions, and to market them beyond the confines of Nuremberg. His prints soon came to be known and prized throughout Europe. Every art historical handbook mentions the fact that even during his lifetime, Dürer's prints were copied, for instance by members of the school of Raphael and by Marcantonio Raimondi. Dürer's monogram became a kind of seal of quality, one that was recognized internationally. Alongside their technical perfection, the special quality of his prints was their balanced formal elaboration, both at the compositional level and in isolated details. More than anything else, however, it was Dürer's sheer inventiveness that attracted widespread admiration. By emphasizing his print production both commercially as well as in artistic terms, Dürer distanced himself from the official church and its typical artistic commissions, from altar painting, for example, instead emphasizing a more personal experience of God and of religion. The printed image was not solely an object for private use, but also acquired a public character by being printed in editions. This rejection of the unique religious image in favor of an "ars multiplicata," an art of reproduction, indicated a turn away from the traditional Christian work of art, one that was publicly accessible in a church, and toward the work of private contemplation, and finally to the book, which could be issued in large editions.

During the initial five years that followed the opening his workshop in 1495, Dürer produced a wide-ranging repertoire of prints. In this period, he proceeded at his own risk, since commissions for printed works arrived only later in his career. The larger portion of Dürer's oeuvre stood in the iconographic tradition of the 15th-century: the focus is on religious themes and devotional images, as well as profane genre scenes. Through his highly detailed observations and psychological empathy, Dürer succeeded in filling these inherited pictorial prototypes with fresh content, thereby reaching a new target public: the urban bourgeoisie. He also added hitherto unknown motifs such as the Four Nude Women (cat. 11) and the Sea Monster (cat. 23). These images reflect Dürer's confrontation with the elevated style and with themes found in the Italian Quattrocento and Antiquity. Evident even in the late years of Dürer's career was the tension between the highly elaborate late–Gothic German style and the lucid forms of the Italian Renaissance. The dimensions of his print works were graded according to price category, with the more expensive large-format works being more likely to explore novel thematic regions.

Dürer's intensive work with the woodcut medium as well as with engraving led to an artistic convergence between the two techniques. In the case of the woodcut, the pictorial possibilities are relatively restricted,

Szenen aus diesen Serien als Einzelbilder eigentlich nicht dem ursprünglichen Zusammenhang dieser Blätter in der Buchform.

Dürer konnte seine Kupferstiche und Holzschnitte in hohen Auflagen drucken und auch außerhalb Nürnbergs verkaufen. Dürers Graphiken waren in weiten Teilen Europas bekannt und geschätzt. In jedem kunstgeschichtlichen Handbuch ist zu lesen, dass Dürergraphik bereits zu Lebzeiten des Künstlers kopiert wurde, etwa von der Raffaelschule oder Marcanton Raimondi. Dürer machte sein Monogramm zu einer Art Qualitätssiegel, das international anerkannt war. Neben der technischen Perfektion war das Besondere dieser graphischen Arbeiten die ausgewogene Formgebung in der Gesamtkomposition wie in den Einzelheiten. Vor allem aber dürfte es Dürers Erfindungsreichtum gewesen sein, der die Menschen mit Bewunderung erfüllte. Mit der Konzentration der kommerziellen wie künstlerischen Aktivitäten auf die Graphik vollzog Dürer einen Schritt weg von der offiziellen Kirche und ihren Auftragsarbeiten, etwa der Altarmalerei, hin zu einer eher persönlichen Gotteserfahrung und Religiosität. Das gedruckte Blatt war nicht nur ein Bild allein für den privaten Gebrauch, sondern es erhielt durch die gedruckte Auflage zugleich auch einen öffentlichen Charakter. Die Abwendung vom religiösen Bild in seiner Einmaligkeit zugunsten der „ars multiplicata", der Auflagenkunst, bezeichnete die Wende vom christlichen Kunstwerk, das in der Kirche der Öffentlichkeit zugänglich war, hin zum Werk privater Betrachtung und schließlich zum in hoher Auflage gedruckten Buch.

Bereits in den ersten fünf Jahren nach Eröffnung seiner Werkstatt 1495 erarbeitete Dürer ein umfangreiches druckgraphisches Repertoire. Das geschah damals noch auf eigenes Risiko, Aufträge zu druckgraphischen Arbeiten erhielt Dürer erst in späterer Zeit. Der größte Anteil von Dürers Arbeiten stand in der ikonographischen Tradition des 15. Jahrhunderts: Religiöse Themen, Andachtsbilder sowie profane Genreblätter. Mit detailreicher Beobachtung und psychologischer Einfühlung gelang es Dürer die überlieferten Bildmuster mit aktuellem Inhalt zu füllen und das stadtbürgerliche Publikum als neue Zielgruppe anzusprechen. Hinzu kamen neue bis dato unbekannte Motive, wie die „Vier nackten Frauen" (Kat. 11) oder das „Meerwunder" (Kat. 23). In diesen Bildern spiegelt sich Dürers Auseinandersetzung mit dem pathetischen Stil und den Themen des italienischen Quattrocento und der Antike. Die Spannung zwischen dem kleinteiligen Stil der deutschen Spätgotik und dem klaren Stil der italienischen Renaissance blieb bis in die späten Jahre in Dürers Arbeiten spürbar. Die Formate seiner Druckgraphiken waren nach Preiskategorien gestaffelt. Dabei waren die teuren, großformatigen Arbeiten eher

for compared with the brilliance of the engraving, a print made from a wooden block has a rather dull and inanimate appearance. The depiction of detail is possible only to a limited degree, so that the strength of the woodcut can be found instead in its clarity and legibility. Dürer was intimately familiar with the potentialities and limitations of the various printing procedures. This enabled him to choose the technique which corresponded most closely to the desired character of a given scene, allowing him to arrive at the intended artistic result. For this reason, Dürer preferred the woodcut medium for simple narratives such as those of the Life of the Virgin (1511) (cat. 45 ff), and for the Small Passion (1508-1510) (cat. 54 ff). But in the 15 woodcuts of the Apocalypse series (1498) (cat. 13 ff), for instance, Dürer heightened the woodcut line to the level of calligraphy. During the teens of the 16th century, finally, Dürer exploited the woodcut line in a decorative fashion in a way that emancipated it from the narrative framework altogether. This approach generated the kind of flowing ornamental linear forms found in the Great Triumphal Chariot of the Emperor Maximilian (1522) (cat. 96).

By introducing the use of hatching lines, Dürer strove to compensate for the deficits of the woodcut medium in relation to the engraving. By subjecting his compositions to a choreography of light and shadow and by constructing space according to the tenets of central perspective, he adopted the standards of modern Renaissance painting for his woodcuts. The result of these efforts was the crystallization in the woodcuts around 1510 of something that Erwin Panofsky referred to as Dürer's "graphic middle tone." Independently of the composition's forms or figural contours, a uniform, horizontal hatching was used to submerge certain areas of the sheet into a gray tone from which the brightest white and the darkest black could emerge. This procedure endowed each scene with a unified spatial continuum.

When it came to the engraving technique in particular, Dürer oriented himself toward his predecessor Martin Schongauer. The elder artist had attempted to solve the problem of depicting convincing spatial recession through the artifice of a series of receding angular curves which he used to suggest the depth of the ground plane. Dürer succeeded for the first time around 1496 in his engraving The Prodigal Son (cat. 6) in unifying the various individual elements into a convincing, realistic whole: for the first time, foreground, middleground, and background are joined into a single continuum. For his engravings, Schongauer had developed a regular stroke formed of systematic hatching lines. The result was a uniform network of strokes that generated a metallic and clear–cut look. Dürer exploited the limited possibilities of the engraving with a hitherto unknown technical mastery. By superimposing up to three

den neuen Themen gewidmet.

Dürers intensives Arbeiten sowohl im Medium des Holzschnitts als auch des Kupferstichs führte zu einer künstlerischen Annährung beider Techniken. Beim Holzschnitt sind die bildnerischen Möglichkeiten relativ eingeschränkt, denn der Abdruck von der Holzplatte hat gerade im Vergleich zur Brillanz eines Kupferstichs ein eher stumpfes und unbelebtes Aussehen. Detailschilderungen sind nur begrenzt möglich, stattdessen liegt die Qualität des Holzschnitts in seiner Eindeutigkeit. Dürer kannte die Möglichkeiten und Grenzen der unterschiedlichen Druckverfahren genau, so dass er die Techniken dem Thema entsprechend auswählte und dem Charakter der jeweiligen Darstellung angemessen umsetzte. Mit Vorliebe nutzte Dürer deshalb den Holzschnitt zur Darstellung von schlichten Erzählungen, wie im „Marienleben" (1511) (Kat. 45ff) oder der „Kleinen Passion" (1508-1510) (Kat. 54ff). Doch auch ins Kalligraphische steigerte Dürer die Holzschnittlinie etwa in der 15 Holzschnitte umfassenden „Apokalypse" (1498) (Kat. 13ff). Im zweiten Jahrzehnt des 16. Jahrhunderts verwendete Dürer die Holzschnittlinie schließlich losgelöst von der erzählenden Rahmenhandlung als dekoratives Element in Form ornamentaler Schmucklinien, wie im Triumphwagen Kaiser Maximilians (1522) (Kat. 96).

Dürer war bemüht, die Defizite des Holzschnitts gegenüber dem Kupferstich wett zumachen, indem er in die Holzschnitttechnik die Kreuzschraffur einführte. Dürer machte die Maßstäbe der neuzeitlichen Renaissancemalerei auch für seine Holzschnitte geltend; er unterwarf seine Kompositionen einer Licht-Schatten-Regie und konstruierte die Räume zentralperspektivisch. Dies führte dazu, dass sich in Dürers Holzschnitten um das Jahr 1510 das herauskristallisierte, was Erwin Panofsky den „graphischen Mittelton" nannte. Unabhängig von gegebenen Formen und figürlichen Konturen senkt eine gleichmäßige, horizontale Schraffierung bestimmte Blattpartien in einen Grauton, von dem aus sich hellstes Licht und schwärzeste Dunkelheit entwickeln, so dass die Bildszene zu einem räumlichen Kontinuum wird.

Insbesondere in der Technik des Kupferstichs orientierte sich Dürer an seinem Vorläufer Martin Schongauer. Hatte Schongauer die Entwicklung des Raumes in die Tiefe durch den Kunstgriff der schrägen Bodenwelle zu lösen versucht, so gelang es Dürer um 1496 in seinem Kupferstich „Der verlorene Sohn" (Kat. 6) die Einzelelemente seiner Schilderung erstmals zu einem wirklichkeitsnahen Ganzen zusammenzuschließen: Vorder-, Mittel- und Hintergrund entstanden kontinuierlich. Schongauer hatte für den Kupferstich ein regelhaftes Strichbild aus systematischen Kreuzschraffuren entwickelt. Daraus ergab sich ein gleichartiges Strichnetz, das ein metallisch-klares Bild

layers of crosshatched lines, and by combining points, discontinuous lines, and short strokes, he mastered the graphic depiction of the contrasting qualities and properties of a variety of materials, almost endowing this black-and-white medium with an impression of color. The unsurpassed highpoints in his graphic oeuvre are the three so-called "master engravings," namely The Knight (1513) (cat. 78), St. Jerome in his Study (1514) (cat. 79), and Melencolia I (1514) (cat. 80). While Dürer's virtuosic handling of light and shadow is reminiscent of the look of a painted picture, it should be emphasized that the graphic media were more than mere surrogates for works in color. Instead, his prints are independent works executed in media possessing autonomous qualities. Dürer captures each detail with remarkable precision, yet if we attempt to imagine these pictorial worlds in color, it becomes evident just how much the black-and-white media restrained and abstracted his sense of fantasy before allowing it to take shape in a given image.

The precision of the engraving technique was congenial to Albrecht Dürer's artistic personality, for in both practical and theoretical terms, his activities were directed wholly toward the search for the eternal laws of beauty. Dürer engaged intensively in studies of the proportions of the human body. The first outstanding result of these investigations was the engraving Adam and Eve of 1504 (cat. 32). Appearing posthumously in 1528, the year of Dürer's death, was his treatise on proportions. Dürer's tireless studies were not simply expressions of diligence or pedantry. He knew that neither technical nor theoretical rules were capable of doing justice to the infinite multiplicity of creation, and as a deeply religious man, was painfully aware of this discrepancy. Through his work, he offered a wide public access to the religious and philosophical discussions of the times. His impressive education, which found expression not least in his works on the theory of art, ranked him among the most cultivated minds of his era. Through Dürer, the social standing of the artist attained new levels of prestige.

While not detracting from the quality and value of his paintings, Dürer's printed oeuvre constitutes a central contribution to the history of European art, and an achievement unsurpassed by his artistic contemporaries. Emerging in his printed works was an art form capable of disseminating and doing full justice to the modern type of image that had evolved recently in Italy. Dürer turned toward the various graphic media not solely for the sake of their potential to be reproduced, but equally in order to create new and independent pictorial worlds.

erzeugte. Dürer nutzte die begrenzten Möglichkeiten des Kupferstichs mit bis dahin nicht gekannter handwerklicher Meisterschaft. Indem er Kreuzlagen bis zu dreimal übereinander legte, Punktierungen, unterbrochene Linien und kurze Striche kombinierte, entlockte er der druckgraphischen Darstellung unterschiedliche stoffliche Qualitäten, ja Materialeigenschaften und ließ das Schwarz-Weiß gleichsam farbig werden. Unübertroffene Höhepunkte sind die so genannten drei Meisterstiche „Der Reiter" (1513) (Kat. 78), „Hieronymus im Gehäus" (1514) (Kat. 79) und „Melencolia I" (1514) (Kat. 80). Die vollendete Technik des Hell-Dunkels erinnert an das gemalte Bild, doch unübersehbar bleibt die Druckgraphik mehr als ein Surrogat für Farbigkeit. Vor uns stehen spezifische Bilder in einem spezifischen Medium. Dürer hat alle Details präzise festgehalten, stellen wir uns aber diese Bildwelten farbig vor, erkennen wir, wie sehr das Schwarz-Weiß die Dingphantasien bändigt, abstrahiert und erst zum Bild werden lässt.

Die Präzision der Kupferstichtechnik kam dem Künstler Albrecht Dürer entgegen, hatte er doch sein künstlerisches Arbeiten theoretisch wie praktisch ganz auf die Suche nach dem Gesetz der Schönheit ausgerichtet. Dürer studierte die Abmessungen des menschlichen Körpers, das erste herausragende Ergebnis in einer Reihe von Einzeluntersuchungen ist der Kupferstich „Adam und Eva" von 1504 (Kat. 32). Und noch in Dürers Todesjahr, 1528, erschien postum sein Lehrbuch über die Proportionen. Dürers unermüdliche Studien waren nicht einfach Ausdruck von Fleiß oder Pedanterie. Vielmehr wusste Dürer, dass handwerkliche wie theoretische Regeln der unendlichen Vielfalt der Schöpfung nicht gerecht werden konnten. Als tief religiöser Mensch erlebte Dürer diesen Widerspruch schmerzlich. Der Künstler erschloss in seinem Werk die religiösen und philosophischen Diskussionen seiner Zeit einem breiten Publikum. Seine beachtliche Bildung, die nicht zuletzt in seinen kunsttheoretischen Arbeiten Ausdruck fand, stellte ihn in eine Reihe mit den kultiviertesten Geistern seiner Zeit. Durch Dürer gewann der Stand des Künstlers bedeutend an Ansehen.

Dürers gedruckte Bilder waren sein zentraler Beitrag zur abendländischen Kunstgeschichte, was die Qualität und den Wert seiner gemalten Bilder keineswegs schmälert. Seine Druckgraphik war im zeitgenössischen Vergleich unübertroffen. Durch sie wurde eine Kunst geschaffen, die das moderne, in Italien entstandene Bild vervielfältigte, ohne es zu zerstören. Die Druckgraphik diente Dürer nicht zur Reproduktion, sondern zur Erschaffung neuer Bildwelten.

Mechthild Haas

1471

Albrecht Dürer is born in Nuremberg on 21 May 1471, son of the goldsmith Albrecht Dürer the Elder (circa 1427-1502) and Barbara Holper (1451-1514). After attending Latin school, Dürer learns the goldsmith's craft in his father's workshop.

1486-1489

Aged 15, Dürer transfers to the Nuremberg workshop of Michael Wolgemut, where he receives training as a painter.

1490-1493

Travels as an apprentice through large parts of the "Holy Roman Empire of the German Nation," including the Upper Rhine, Colmar, Basel, and Strasbourg. In 1492, Dürer arrives in Colmar, where he hopes to meet Martin Schongauer, who has unfortunately died the previous year. In 1493, his father arranges his marriage to Agnes Frey (1475-1539), daughter of a Nuremberg city councilman.

1494

A few months after his wedding, Dürer departs for Italy. His journey takes him across the Alps to Venice. In Pavia, he visits his Nuremberg friend Willibald Pirckheimer (1470-1530), gaining access to the latter's circle, consisting of humanists, artists, and scholars.

1495

In spring, Dürer returns to Nuremberg, bringing impressions of the Italian Renaissance. He opens his own workshop, producing paintings and engaging intensively with print media, partly for financial reasons. He executes his first engravings: Young Woman Menaced by Death and The Holy Family with the Dragonfly. Dürer begins to use the "AD" monogram.

1498

An apocalyptic mood prevails, and the end of the world is predicted for the year 1500. In 1498, Dürer publishes his woodcuts series The Apocalypse in book form.

1501-1504

Dürer begins his studies of human proportions. Execution of Nemesis and Adam and Eve.

1505-1507

Dürer makes a second trip to northern Italy and Venice, where he remains for an entire year.

1507

Dürer returns to Nuremberg, where he executes a number of commissioned sacred works.

1471

Albrecht Dürer wird am 21. Mai 1471 in Nürnberg als Sohn des Goldschmieds Albrecht Dürer d. Ä. (um 1427-1502) und der Barbara Holper (1451-1514) geboren. Nach dem Besuch der Lateinschule erlernt Dürer das Handwerk des Goldschmieds in der Werkstatt seines Vaters.

1486-1489

Mit 15 Jahren wechselt er in die Nürnberger Werkstatt von Michael Wolgemut, wo er zum Maler ausgebildet wird.

1490-1493

Gesellenwanderung in weite Teile des „Heiligen Römischen Reiches Deutscher Nation", u. a. an den Oberrhein, nach Colmar, Basel und Straßburg. 1492 kommt Dürer nach Colmar, wo er hofft, Martin Schongauer kennen zu lernen. Doch dieser ist bereits ein Jahr zuvor verstorben. 1493 arrangiert sein Vater die Ehe mit Agnes Frey (1475-1539), der Tochter eines Nürnberger Ratsherrn.

1494

Wenige Monate nach der Hochzeit bricht Dürer nach Italien auf. Die Reise führt ihn über die Alpen bis nach Venedig. In Pavia besucht er den Nürnberger Freund Willibald Pirckheimer (1470-1530) und hat Zugang zu dessen Freundeskreis aus Humanisten, Künstlern und Wissenschaftlern.

1495

Mit den Eindrücken der italienischen Renaissance kehrt Dürer im Frühjahr nach Nürnberg zurück. Er eröffnet eine eigene Werkstatt und widmet sich neben der Malerei intensiv der Druckgraphik, auch um seinen Lebensunterhalt zu bestreiten. Es entstehen erste Kupferstiche: „Junge Frau vom Tode bedroht", „Die Heilige Familie mit der Libelle". Dürer beginnt, das Monogramm AD zu verwenden.

1498

Untergangsstimmung macht sich breit, das Ende der Welt wird für das Jahr 1500 angekündigt. Dürer veröffentlicht die Holzschnitte seiner „Apokalypse" 1498 in Buchform.

1501-1504

Dürer beginnt mit Studien zur menschlichen Proportion. Es entstehen „Nemesis" und „Adam und Eva".

1505-1507

Dürer unternimmt seine zweite Reise nach Oberitalien und Venedig. Über ein Jahr bleibt er in der Lagunenstadt.

1507

Rückkehr nach Nürnberg, wo Dürer zunächst einige sakrale Auftragsarbeiten ausführt.

1511
Publishes book editions of The Large Passion, The Small Passion, The Life of the Virgin, and a second edition of The Apocalypse.

1512
Commences his activities for Emperor Maximilian I, who patronizes him and commissions a number of works, including the large-scale Triumphal Arch and Triumphal Chariot. Beginning in 1515, Maximilian awards Dürer lifetime annuity.

1513/1514
In 1513, Dürer becomes an honorary citizen of Nuremberg. He executes the three so-called "master engravings": The Knight, St. Jerome in his Study, and Melencolia I.

1517
Martin Luther's "95 Theses" launch the German Reformation. Dürer is attracted by the new doctrine, and becomes a follower of Luther.

1518
Dürer takes part in the Augsburg Diet as a member of the Nuremberg Council delegation. Executes large-format portrait drawings in charcoal of high-ranking individuals. Produces his first print portrait, Cardinal Albrecht von Brandenburg.

1519
Death of Emperor Maximilian. The city declines to pay Dürer's annuity. He plans a trip to the Netherlands to press his claim with the new emperor Charles V.

1520-1521
Journey to the Netherlands with his wife Agnes. Dürer takes some engravings and woodcuts along to sell and as give as gifts. He keeps a travel journal and fills several sketchbooks.

1524-1525
Outbreak of the Peasant's War.

1526
Dürer bequeaths the pair of panels depicting the Four Apostles to the Nuremberg City Council in his own memory. In his later years, Dürer devotes himself mainly to theoretical writings on art: the Course in the art of Measurement (1525), the Treatise on Fortifications (1527), and the Four Books on Human Proportions (1528, published posthumously).

1528
Dürer dies in his hometown on April 6, aged 57 years.

1511
Dürer veröffentlicht die Buchausgaben der „Großen" und „Kleinen Passion", des „Marienlebens", sowie die zweite Ausgabe der „Apokalypse".

1512
Beginn seiner Tätigkeit für Kaiser Maximilian I., der sein Gönner und Auftraggeber zahlreicher Arbeiten wird, darunter die Großaufträge „Ehrenpforte" und „Triumphwagen". Ab 1515 bewilligt ihm der Kaiser eine jährliche Leibrente.

1513/1514
Dürer wird 1513 Ehrenbürger Nürnbergs. Es entstehen die drei sogenannten Meisterstiche: „Der Reiter", „Hieronymus im Gehäus" und „Melencolia I".

1517
Mit Martin Luthers 95 Thesen beginnt die Reformation in Deutschland. Dürer fühlt sich von der neuen Lehre angezogen und wird Anhänger Luthers.

1518
Als Delegationsmitglied des Nürnberger Rates nimmt Dürer am Reichstag in Augsburg teil. In Kohle fertigt er großformatige Porträtzeichnungen der hochrangigen Persönlichkeiten. Das erste druckgraphische Porträt entsteht, es zeigt den „Kardinal Albrecht von Brandenburg".

1519
Tod des Kaisers Maximilian. Die Stadt will Dürers Gehalt nicht mehr zahlen. Deshalb plant Dürer, in die Niederlande zu reisen, um seinen Anspruch vom neuen Kaiser Karl V. bestätigen zu lassen.

1520-1521
Reise in die Niederlande in Begleitung seiner Frau Agnes. Dürer nimmt Kupferstiche und Holzschnitte mit, um sie zu verkaufen oder auch zu verschenken. Er führt Tagebuch und füllt etliche Skizzenbücher.

1524-1525
Ausbruch des Bauernkriegs.

1526
Dürer vermacht zu seinem Gedächtnis die beiden Tafeln der „Vier Apostel" dem Rat seiner Heimatstadt Nürnberg. In den letzten Lebensjahren widmet sich Dürer überwiegend seinen kunsttheoretischen Schriften: „Unterweisung der Messung" (1525); „Befestigungslehre" (1527); „Vier Bücher von menschlicher Proportion" (1528 postum erschienen).

1528
Dürer stirbt am 6. April im Alter von 57 Jahren in seiner Heimatstadt.

DÜRER'S PRINT MEDIA / DÜRERS DRUCKTECHNIKEN:

ENGRAVING – DRYPOINT – ETCHING – WOODCUT
KUPFERSTICH – KALTNADEL – RADIERUNG – HOLZSCHNITT

The **engraving** is among the oldest intaglio (i.e., with recessed lines) printing techniques, and is one of the most important and most precise early modern resources for duplicating images. It is believed that the technique was developed in the mid-15th century in the context of goldsmithing, and in connection with the decoration of dishes, goblets, and blades. In close association with Humanism and the Reformation, movements which tended to promote book printing, the technique of engraving was diffused throughout the German-speaking world.

Engraving is an extremely demanding and labor-intensive process. It took Dürer, for example, approximately three months to engrave the copperplate for The Knight. To produce an engraving, a copperplate with a thickness of between 1 and 3 mm must be painstakingly smoothed and polished. A drawing is now transferred onto this surface in laterally reversed form. The engraving is composed of lines and points that are cut into the metal by means of a burin. Because of the differing designs of the burin tips, these incisions can be extremely varied in character. Burin work is laborious, and requires great precision. When in use, the incising tool is pushed away from the body, and raises a shaving from the copperplate that is narrower at the ends and broader toward the center. The shaving is then removed with a scraper. Cutting is guided by the pressure of the hand, with greater pressure producing a wider shaving, and hence a wider and deeper furrow. Because broader incisions absorb more ink than narrow ones, some lines are thicker, and hence darker, than others. In order to remove broader surfaces from the metal plate, thereby attaining larger surface effects, numerous lines must be incised in close formation. The engraving medium allows extremely fine strokes, which may be superimposed as hatching or used to produce flowing transitions. This rich detail permits the creation of an abundance of forms, and the depicted objects can be made to appear extraordinarily nuanced and three-dimensional.

Once the metal plate has been engraved, it is warmed and inked. Warming permits the printer's ink to penetrate into the narrowest crevices. Finally, the plate is wiped clean, so that the ink remains only within the incised lines. At this point, printing can proceed. A roll press is used, which allows the moistened paper to receive the ink, which is now pressed out of the incised indentations in the plate. For the production of each new proof, the plate is cleaned and re-inked. The copperplate is quickly worn down, not only as a consequence of the printing process itself, but even more so as a result of wiping. Early impressions, hence, are of superior quality. Plates with shallower incisions do not last as long as those that are more deeply

Der **Kupferstich** gehört zu den ältesten Tiefdrucktechniken und ist eines der wichtigsten und präzisesten Vervielfältigungsmittel der frühen Neuzeit. Man nimmt an, dass das Verfahren im Goldschmiedehandwerk Mitte des 15. Jahrhunderts im Zusammenhang mit dem Verzieren von Tellern, Bechern oder Klingen entwickelt wurde. In enger Beziehung mit Humanismus und Reformation, die den Buchdruck befördern, steht auch die Verbreitung des Kupferstichs im deutschsprachigen Kulturbereich.

Der Kupferstich ist ein sehr schwieriges und arbeitsaufwendiges Verfahren, so benötigte Dürer beispielsweise für das Stechen der Platte des „Reiters" rund ein Vierteljahr. Um einen Kupferstich herzustellen, muss zunächst eine ein bis drei Millimeter starke Kupferplatte sorgfältig geschliffen und poliert werden. Darauf wird die seitenverkehrte Zeichnung übertragen. Der Kupferstich setzt sich aus Linien und Punkten zusammen, die mit Hilfe eines Grabstichels in das Metall geschnitten werden und durch verschieden geschliffene Spitzen des Stichels sehr unterschiedlich sein können. Das Führen des Stichels ist mühsam und verlangt höchste Genauigkeit. Das Schnittwerkzeug wird vom Körper weg geschoben und hebt oder pflügt einen Span aus der Kupferplatte, der an den Enden schmaler und in der Mitte breiter ist. Mit Hilfe eines Schabeisens wird dieser Span entfernt. Gesteuert wird er durch den Druck der Hand, wobei ein hoher Druck einen breiten Span und damit breitere bzw. tiefere Furchen erzeugt. Da diese mehr Farbe aufnehmen können, als die schmalen Linien, ergeben sie beim Drucken fettere bzw. schwärzere Linien. Um größere Flächen aus der Metallplatte heraus zu stechen und eine flächenhafte Wirkung zu erzielen, müssen zahlreiche Linien dicht nebeneinander gesetzt werden. Der Kupferstich erlaubt extrem feine Striche, deren schraffierende Überlagerung sowie fließende Übergänge. Dieser Detailreichtum ermöglicht eine große Formenvielfalt, die das Dargestellte äußerst differenziert und plastisch erscheinen lässt.

Ist die Platte fertig graviert, wird sie erwärmt und eingefärbt. Durch die Erwärmung dringt die Druckerschwärze bis in die feinsten Linien, anschließend wird die Platte wieder gesäubert, so dass nur noch in den Linien Farbe zurückbleibt. Schließlich erfolgt der Druck mit einer Walzenpresse, in der das angefeuchtete Papier die Farbe aus den Vertiefungen aufnimmt. Die Platte wird für jeden neuen Abzug gereinigt und neu eingefärbt. Die Abnutzung der Kupferplatte ist stark, nicht nur der Druckvorgang selbst, sondern vor allem das Wischen der Platte wirkt sich aus. Die frühen Drucke sind von besserer Qualität. Flach gestochene Platten sind weniger haltbar als tief gestochene. Man geht in der Regel von 300 bis 400

cut. As a rule, 300 – 400 exemplars are produced using a single engraved copperplate, with the upper limit lying somewhere around 1000.

With **drypoint** technique, the drawing is scratched into the plate with the application of pressure using an instrument that is held in the hand like a pencil or stylus. Unlike engraving, the metal is not lifted from the plate and removed as a shaving, but instead pushed or displaced. With drypoint, the incised line resembles a furrow, with the metal pushed out to the sides, creating a raised burr. In contrast to engraving, it is far easier to alter the direction of the line, allowing greater freedom in the production of curved or sinuous lines. Finally, the plate is covered with printing ink, and once again, wiped clean. Additional ink adheres to the fine raised burr found on either side of the incised line. The typically fuzzy line created by the burr, often so reminiscent of the indistinct lines of charcoal drawing, and the more varied and looser trajectory of the line clearly distinguish drypoint from engraving. Since the burr is highly sensitive, and is incapable of withstanding the severe pressure of the printing process for long, only a few high-quality impressions are possible for each plate.

The **etching** medium vastly simplifies the labor-intensive manual process by which lines are incised with a burin into the printing plate in engraving. The metal plate is coated with an acid–resistant layer of wax and varnish through which the etching stylus can easily scratch, creating lines. The plate is then placed in an acid bath, where the acid eats through these exposed areas. The printing ink is then deposited into these incised, acid–treated lines. Because no acetic liquid for copperplates was known in Dürer's time, he exclusively used sheets of iron for his etchings. This material suffers from the disadvantages of extreme brittleness and susceptibility to rusting, making it possible to produce only a very limited number of good impressions from an etched iron plate.

Although an etching cannot attain the precision of an engraving, it does significantly enrich the range of possibilities offered by printing techniques, for it allows the individual artist's graphic style to be easily reproduced. In contrast to copperplate engraving and drypoint, the lines of the acid–treated etching plate are not sharp–edged. An etching also lacks the velvety dark quality of a good engraving or drypoint.

The **woodcut** is a relief printing procedure. The earliest artistic woodcuts were produced as individual sheets in the religious monasteries of the Alpine lands and Bavaria around 1400. Beginning in 1430, so-called "block books" were produced using wooden blocks. Gutenberg's invention (ca 1440/65) of book printing with movable type revolutionized the reproduction of texts. At this point, woodcuts started to be used to illustrate printed books.

A piece of wood, generally of pear, nut, alder,

Abzügen aus, die Obergrenze liegt bei etwa 1000 Kupferstichabdrucken.

Bei der Technik der **Kaltnadel** wird die Zeichnung unter Kraftaufwand in die Druckplatte eingeritzt, wobei das Instrument wie ein Bleistift oder Griffel geführt wird. Anders als beim Kupferstich wird das Metall nicht aus der Platte herausgehoben und als Span entfernt, sondern nur verdrängt. Das heißt, das Metall wird zu beiden Seiten der eingekratzten Furche aufgeschoben und bleibt als Grat stehen. Die Technik verlangt große Aufmerksamkeit, da das Metall der Nadel Widerstand entgegensetzt, was ihre Führung bei Krümmungen und Schwüngen erschwert. Auf die Platte wird anschließend vollflächig Druckfarbe aufgetragen und wieder blank gewischt. Dabei bleibt am feinen Grat neben der eingeritzten Linie zusätzlich Farbe haften. Die typische, unscharfe, oft wie ein Kreidestrich wirkende Verschattung, die durch den Grat verursacht wird, und die in der Breite variierende, lockere Führung der Linien unterscheidet das Kaltnadelblatt vom Kupferstich. Da die Grate sehr empfindlich sind und dem starken Druck der Presse nicht lange standhalten können, sind nur wenige vorzügliche Abzüge möglich.

Der aufwendige manuelle Arbeitsprozess, mit dem beim Kupferstich die Linien in die Druckplatte eingegraben werden, wird durch die **Radierung** vereinfacht. Hier wird die Metallplatte mit einer säurefesten Schicht von Wachs und Harz bestrichen, in die mit einer Graviernadel die Zeichnung leicht eingeritzt wird. Im anschließenden Säurebad frisst sich die Säure in die freigelegten Stellen ein. In diese durch Zeichnung und Ätzvorgang entstandenen Vertiefungen wird dann Farbe gewischt. Da zu Dürers Zeit noch kein Ätzwasser für Kupfer bekannt ist, verwendet Dürer für seine Radierungen ausschließlich Eisenbleche. Diese haben den Nachteil, sehr spröde und anfällig für Rostflecke zu sein, weshalb sich von einer Eisenradierung nur eine äußerst begrenzte Anzahl von guten Abzügen machen lässt.

Eine Radierung erreicht zwar nicht die Präzision eines Kupferstichs, doch erweitert sie die druckgrafischen Techniken um die Möglichkeit, den individuellen Zeichenstil wiederzugeben. Im Unterschied zu Kupferstich und Kaltnadel besitzen die Linien der Ätz-Radierung keine Taille, d. h. sie sind nicht spitzer ein- und auslaufend. Auch fehlt der Radierung die samtene Dunkelheit guter Kupferstich- oder Kaltnadel-Abzüge.

Der **Holzschnitt** ist ein Hochdruckverfahren. Die frühesten künstlerischen Holzschnitte entstehen als Einblattholzschnitte um 1400 in alpenländischen und bayerischen Klöstern. Außerdem werden seit 1430 im Holztafeldruck auch sogenannte „Blockbücher" hergestellt. Die Erfindung des Buchdrucks durch Gutenberg mit beweglichen Lettern (um 1440/65) revolutioniert die Textreproduktion. Ab jetzt werden Holzschnitte auch zur Illustration von Büchern verwendet.

or cherry wood, was cut along the grain to produce a wooden block 2 to 4 cm in thickness. The block was painstakingly planed, smoothed, and polished until the surface was entirely uniform and could be given a base coat, generally of thinned white chalk. A preliminary drawing was then applied to this white coating, generally by the artist himself. Then the plate was cut into around these lines using a variety of knives and gouges. As a result, the lines and surfaces of the composition remained intact as ridges, ligaments, or raised areas. Once these raised elements had been coated with ink, the printing process could proceed, whether through rubbing by hand, or by means of a printing press. Given the relatively minimal pressure required to produce a woodblock print, the resultant impressions display no depressions or platemarks. This distinguishes the woodblock medium from intaglio printing processes. Several hundred prints can be produced without noticeable wearing of the block. In the course of time, however, the block begins to show signs of wear and tear, such as the breakage of the more delicate ridges and the formation of splits in the wood. These damaged areas are visible in the print as breaks or gaps in the black lines. As time passes, the areas of the plate which stand in relief also broaden out due to pressure, resulting in wider lines in later exemplars.

Both technically and thematically, Dürer set new standards for the woodblock medium. Although the artist's signet was customarily found only on the most elaborate copperplate engravings during his lifetime, Dürer's monogram is found on each woodblock print. Before Dürer, woodcuts consisted mainly of simple contour lines, which had to be colored in order to generate a differentiated image. By contrast, Dürer exploited his knowledge of the engraving medium, transferring its subtle modeling of light and dark areas onto woodcut technique. His woodcut lines are no longer simple contours. Instead, they swell and narrow, and are capable of suggesting volume. Moreover, Dürer organized his compositions in terms of the distribution of light and dark. The novel chiaroscuro effects offered by his woodcuts use the white of the paper to stand for light, and the dark lines for shadowed areas. Differently than in the case of his intaglio prints, Dürer's role in his woodcut production was restricted to executing the preliminary drawing on the block. As was customary at the time, he employed a highly specialized form cutter in his workshop to execute the carving of woodblocks under his supervision. There is little doubt that Dürer's designs presented such craftsmen with considerably greater challenges than anything they had encountered previously. To date, it has proved impossible to firmly document the assumption that Dürer must have carved his earlier woodblocks himself, owing to the absence early in his career of any form cutters skillful enough to undertake such demanding work.

Ein Holzblock, meist von Birne, Nuss, Erle oder Kirsche, wird in Faserrichtung so zugeschnitten, dass eine zwei bis vier Zentimeter starke Holzplatte entsteht. Sie wird sorgfältig gehobelt, geschliffen und geglättet, bis die vollkommen plane Fläche mit einer Grundierung, meist einer dünnen weißen Kreideschicht, überzogen werden kann. Auf dieser Kreideschicht wird in der Regel vom Künstler die Vorzeichnung angebracht, danach werden mit verschiedenen Messern die vorgezeichneten Linien umschnitten. Am Ende dieses Prozesses bleiben die Linien und Flächen der Zeichnung als Grate, Stege oder Inseln stehen. Nach Einfärbung dieser erhabenen Teile erfolgt der Abdruck durch Handabreibung oder mittels einer Druckpresse. Wegen des verhältnismäßig geringen Kraftaufwands, mit dem der Abdruck von einem Holzstock erfolgt, zeigt der Abzug keinen Quetsch- oder Plattenrand, er unterscheidet sich dadurch von jedem Tiefdruck. Die Anzahl der möglichen Abzüge eines Holzschnitts ist sehr groß. Einige hundert Blätter sind ohne wesentliche Abnützung möglich. Doch mit der Zeit stellen sich Schäden am Druckstock ein, etwa durch Ausbrechen zarter Grate sowie durch Sprünge im Holz. Sie sind als weiße Fehlstellen auf dem Blatt sichtbar. Auch werden die hochstehenden Partien im Lauf der Zeit etwas breitgedrückt, weshalb breitere Linien auf einen späten Abzug hindeuten.

Dürer setzt mit seinen Holzschnitten inhaltlich wie technisch neue Maßstäbe. Sein Monogramm steht auf jedem Blatt, bis dato ist ein Künstlersignet nur bei anspruchsvollen Kupferstichen üblich gewesen. Vor Dürer bestehen die Holzschnitte meistens aus Umrisslinien, die koloriert werden müssen, um einen differenzierten Bildeindruck zu erzeugen. Dürer hingegen benutzt seine Kenntnisse des Kupferstichs und überträgt dessen modellierende hell-dunkle Linienführung in die Technik des Holzschnitts. Er lässt die Holzschnittlinien an- und abschwellen, so dass die Linien nicht mehr nur Konturlinien sind, sondern auch Volumen darstellen können. Außerdem strukturiert Dürer seine Darstellung über die Hell-Dunkel-Verteilung. Dieses neuartige Chiaroscuro seiner Holzschnitte lässt das weiße Papier für Licht und die schwarzen Linien für Dunkelheit stehen. Anders als bei den eigenhändig ausgeführten Tiefdrucken beschränkt sich Dürers Anteil an der Holzschnittproduktion auf das Vorzeichnen des Holzstocks. Wie damals üblich, beschäftigt er in seiner Werkstatt hoch spezialisierte Formenschneider, die unter seiner Aufsicht das Schneiden des Holzstocks übernehmen. Sicher ist, dass Dürers Entwürfe an diese Handwerker weit höhere Anforderungen stellen als bisher üblich. Unbelegt und eher unsicher bleiben muss aber die Vermutung, Dürer habe seine frühen Holzschnitte noch selbst geschnitten, da er zu diesem Zeitpunkt noch keine entsprechend sorgfältig ausgebildeten Formenschneider als Mitarbeiter hatte.

Mechthild Haas

THE EXHIBITION / DIE AUSSTELLUNG

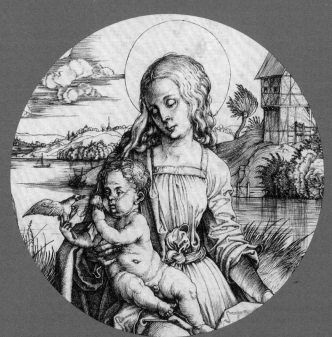

THE CATALOGUE / DER KATALOG

Young Woman Attacked by Death
(The Ravisher)
Ca 1495
Engraving
111 : 101 mm
Not monogrammed
No watermark

Provenance: acquired in
1802/1803 from Artaria by Lud-
wig X, Landgrave of Hesse.
Inv. no. GR 87

Literature: Bartsch 92; Meder 76
c; Hollstein 76; Schoch et al. 1.

Junge Frau, vom Tode bedroht
(Der Gewalttätige)
um 1495
Kupferstich
111 : 101 mm
nicht monogrammiert
ohne Wasserzeichen

Herkunft: 1802/1803 über
Artaria an Ludwig X. Landgraf
von Hessen.
Inv. Nr. GR 87

Literatur: Bartsch 92; Meder 76
c; Hollstein 76; Schoch u. a. 1.

Ever since Adam Bartsch, this small sheet has been regarded as Dürer's first engraving. A young woman has seated herself on a grassy bank for a lover's tryst. Now, her would–be lover shows his true face, a grimace of death not unlike the ones we encounter in the figure of Death on horseback in the Apocalypse (cat. 15) or the Death in The Knight (cat. 78). Dürer reinterprets the theme of the amorous couple, so popular among the urban and bourgeois public of the 15th century, converting a conventional lover's idyll into a macabre scene of violence. In place of intimate handholding, we find clenched fists and desperately clutching fingers. Rent garments are juxtaposed against naked, wrinkled skin. The pair's body language and gestures contradict every notion of harmonious intimacy. Viewers can easily fill in the moralizing commentary – one can almost see it inscribed onto the empty banner above. As seen clearly in this richly contrasting exemplar from Darmstadt, Dürer uses an expressive engraving technique, with deeply incised lines, to further emphasize the brutality of the depicted events. The spontaneous arrangement of lines in this early work is more reminiscent of a pen and ink drawing or a drypoint than of the more disciplined technique of engraving.

1

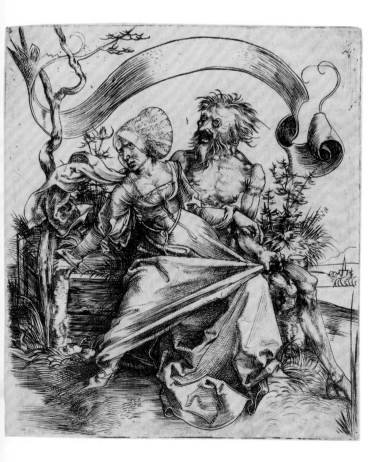

Das kleine Blatt gilt seit Adam Bartsch als Dürers erster Kupferstich. Eine junge Frau hat sich zu einem Stelldichein auf einer Rasenbank niedergelassen. Da zeigt ihr vermeintlicher Liebhaber sein wahres Gesicht, die Fratze des Todes, wie sie uns in der Figur des reitenden Todes aus der „Apokalypse" (Kat. Nr. 15) oder mit dem Tod in „Der Reiter" (Kat. Nr. 78) begegnen wird. Dürer liefert eine Neuinterpretation des im 15. Jahrhundert unter dem stadtbürgerlichen Publikum beliebten Themas der Paardarstellungen. Er verwandelt das gängige Liebesidyll in eine makabre Gewaltszene. Statt sich innig haltender Hände sehen wir zupackende Fäuste und hilflos Halt suchende Finger. Zum Zerreißen gespannte Kleidung steht gegen nackte faltige Haut. Die Körpersprache und Gesten des Paares auf der Rasenbank widersprechen jeder Idee von harmonischer Zweisamkeit. Unschwer imaginiert der Betrachter den moralisierenden Kommentar, der auf dem leer gebliebene Spruchband stehen könnte. Wie der gute, kontrastreiche Abzug aus Darmstadt deutlich erkennen lässt, unterstreicht Dürer durch eine expressive Stechtechnik, mit tief eingegrabenen Linien die Brutalität des Geschehens zusätzlich. In dieser frühen Arbeit verweist die spontane Liniensetzung mehr auf die Federzeichnung oder Kaltnadel als auf die disziplinierte Technik des Kupferstichs.

Found for the first time on this sheet – datable to the period after his first Italian journey – is Dürer's monogram, still in Gothic lettering. This large-format engraving integrates influences from the Hausbuchmeister and Schongauer. Also for the first time, we find a variation of Dürer's favorite theme of the Virgin Mary in a landscape. Doubtless, this sheet was meant to compete with small and highly marketable devotional paintings. The Holy Family with the Dragonfly unites motifs from the Birth of Christ with those from the Rest on the Flight to Egypt. With his urban, bourgeois public in mind, Dürer combines familiar iconographic elements such as the gated garden, a reference to the "hortus conclusus," a metaphor for Mary's virginity. Also interpretable in Marialogical terms are the tower, the sea, the thorn bush, and the dragonfly which gives the work its name. The triangular composition of the figural group corresponds to the strictly symmetrical Holy Trinity appearing in the heavens. This fine Darmstadt impression clearly shows Dürer at the very beginning of his career as an engraver. He has incised his lines deeply into the copperplate, and short strokes are superimposed on contour lines, resulting in an irregular, somewhat angular overall impression. Nor has he succeeded in causing the space of the landscape to recede in a continuous fashion, leaving his figures seated in front of rather than within the natural setting.

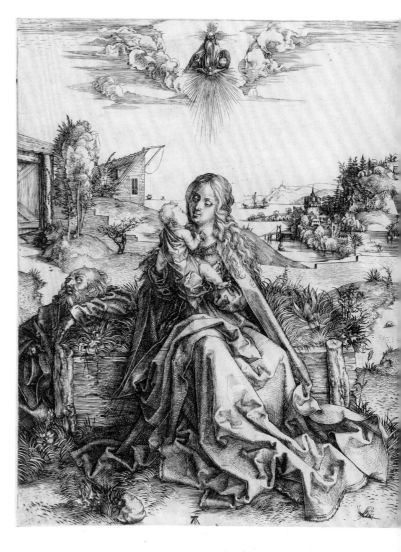

Auf dem Blatt, das nach der ersten Italienreise zu datieren ist, findet sich zum ersten Mal Dürers Monogramm, noch in gotisierenden Buchstaben. Der großformatige Kupferstich verarbeitet Einflüsse des Hausbuchmeisters und Schongauers. Erstmals variiert Dürer sein Lieblingsthema der Muttergottes in der Landschaft. Das Blatt ist zweifellos als Konkurrenz zu den gut verkäuflichen gemalten kleinen Andachtsbildern gedacht. Die „Heilige Familie in der Landschaft" vereint Motive der „Geburt Christi" mit Motiven der „Ruhe auf der Flucht nach Ägypten". Für sein stadtbürgerliches Zielpublikum kombiniert Dürer vertraute ikonographische Elemente, etwa das Gartentor, ein Verweis auf den „hortus conclusus" als Metapher für Mariens Jungfräulichkeit. Mariologisch zu deuten sind auch der Turm, das Meer, der

The Holy Family with the Dragonfly
Ca 1495
Engraving
237 : 186 mm
Monogrammed
No watermark

Provenance: acquired in 1802/1803 from Artaria by Ludwig X, Landgrave of Hesse.
Inv. no. GR 43

Literature: Bartsch 44; Meder 42 b; Hollstein 42; Schoch et al. 2. Antwerp 1970, 6.

Die Heilige Familie mit der Libelle
um 1495
Kupferstich
237 : 186 mm
monogrammiert
ohne Wasserzeichen

Herkunft: 1802/1803 über Artaria an Ludwig X. Landgraf von Hessen.
Inv. Nr. GR 43

Literatur: Bartsch 44; Meder 42 b; Hollstein 42; Schoch u. a. 2. Antwerpen 1970, 6.

Dornbusch oder die dem Blatt seinen Namen gebende Libelle. Die Dreieckskomposition der Figurengruppe korrespondiert zu der in strenger Symmetrie am Himmel erscheinenden Dreifaltigkeit. Der sehr gute Darmstädter Abdruck zeigt deutlich, dass der Künstler hier noch am Anfang seiner Stecherkunst steht. Tief hat Dürer die Linien in das Kupfer gestochen, kurze Striche überlagern die Umrisslinien, es ergibt sich ein unregelmäßiges, eher kantiges Gesamtbild. Auch gelingt es noch nicht, den Landschaftsraum kontinuierlich in die Tiefe zu entwickeln, so dass die Figuren mehr vor als in der Landschaft sitzen.

Surviving from Dürer's hand are six different print versions of St. Jerome (see cat. 79). This substantial number was a response to growing demands for depictions of the erudite church father and Bible translator (ca. 340 - 420), whose cult gained strength during the 15th century. Dürer's large-format engraving shows the church father as a hermit in the wilderness, where he renounces worldly affairs and engages in penitence through fasting and self–mortification. This theme, known to Dürer in particular through northern Italian prototypes, goes back to an account contained in the Golden Legend, one of the most beloved and widely diffused popular religious books of the Middle Ages. Between 1263 and 1273, Jacobus de Voragine, a Dominican monk, translated accounts of the lives of the saints into Latin. He drew on a variety of source materials, including the Bible, Passionals, the Apocryphal Evangels, the Acts of the Apostles and the Martyrs, as well as tales circulating in monasteries and among the common folk. According to the Golden Legend (Legenda Aurea), Jerome removed a thorn from a lion's throbbing paw, whereupon the creature became the saint's helper and companion. In Dürer's scene, the rather small lion lies at the saint's feet like a tamed house pet. Jerome kneels before a small crucifix that is propped up inside a tree stump. In remembrance of Christ's Passion, he strikes his breast with a stone. The landscape elements are based on the artist's nature studies, some of them executed in the Nuremberg vicinity (Winkler 108, 109). Dürer has constructed an inhospitable locale whose various elements have not been joined seamlessly into a unified whole. In a well–considered way, Dürer exploits a differentiated technique in order to translate his observations of the natural world into graphic form: the expanses of the sand pits are rendered as flowing waves produced by parallel incised lines, while the saint's naked upper body is modeled with fine parallel hatchings. The steep sides of the cliffs appear as white surfaces, while short lines and points stand for mounds of sand and earth. Fissured rock formations are described using dense intersecting hatching lines.

Von Dürers Hand existieren insgesamt sechs verschiedene druckgraphische Blätter zum heiligen Hieronymus (vgl. Kat. Nr. 79). Die beachtliche Anzahl orientiert sich an der steigenden Nachfrage nach Darstellungen des gelehrten Kirchenvaters und Bibelübersetzers (um 340 - 420), dessen Verehrung im Laufe des 15. Jahrhunderts zunimmt. Der großformatige Kupferstich zeigt den Kirchenvater Hieronymus als Einsiedler in der Wüste, der mit Fasten und Selbstkasteiung Buße tut und der Welt entsagt. Dieses Thema, das Dürer insbesondere von norditalienischen Vorbildern kennt, geht auf den Bericht aus der „Legenda Aurea" zurück. Die „Goldene Legende" ist das populärste und am weitesten verbreitete religiöse Volksbuch des Mittelalters. Zwischen 1263 und 1273 hatte der Dominikanermönch Jacobus de Voragine die Sammlung der Lebensgeschichten von Heiligen in lateinischer Sprache verfasst. Dabei benutzte er vielfältiges Quellenmaterial wie die Bibel, Passionalien, apokryphe Evangelien, Apostel- und Märtyrerakten, sowie die in Klöstern

St. Jerome in the Wilderness
Ca 1496
Engraving
305 : 223 mm
Monogrammed
Watermark 321 (Gothic "P" with flower)
Front inscribed with ink in Gothic letters: Avj.

Provenance: acquired in 1802/1803 from Artaria by Ludwig X, Landgrave of Hesse. Inv. no. GR 60

Literature: Bartsch 61; Meder 57 b; Hollstein 57; Schoch et al. 6.

Der heilige Hieronymus in der Wüste
um 1496
Kupferstich
305 : 223 mm
monogrammiert
Wasserzeichen 321 (Gotisches p mit Blume)
Vorderseite bezeichnet mit Tinte in gotischen Buchstaben: Avj.

Herkunft: 1802/1803 über Artaria an Ludwig X. Landgraf von Hessen.
Inv. Nr. GR 60

Literatur: Bartsch 61; Meder 57 b; Hollstein 57; Schoch u. a. 6.

und im Volk überlieferten Geschichten. Dieser „Legenda Aurea" nach hatte Hieronymus aus der Pranke eines Löwen einen stechenden Dorn entfernt, worauf das Tier zum treuen Helfer und Begleiter des Heiligen wurde. In Dürers Darstellung liegt der proportional verkleinerte Löwe gleich einem possierlichen Haustier zu Füßen des Heiligen. Hieronymus kniet vor einem kleinen Kruzifix, das in einem Baumstumpf steckt. Im Gedenken an die Passion Christi schlägt er sich mit einem Stein auf die Brust. Die Landschaftselemente basieren auf Dürers Naturstudien, die teilweise in der Umgebung von Nürnberg entstanden (Winkler 108,109). Dürer konstruiert eine unwirtliche Gegend, wobei sich die Teile noch nicht nahtlos zu einem einheitlichen Ganzen zusammenschließen. Wohl überlegt setzt er differenzierte Techniken ein, um seine Naturbeobachtungen in den Kupferstich zu übersetzen: Mit strömenden Wellen aus parallelen Stichlinien beschreibt er die Ausdehnung der Sandmulde, hingegen modelliert er mit feinen Parallelschraffuren den nackten Oberkörper des Heiligen. Durch weiße Flächen charakterisiert er die steilen kahlen Felswände, kurze Linien und Punkte stehen für Erd- und Sandhaufen, mit dichten Kreuzschraffen bezeichnet er die zerklüfteten Gesteinsformationen.

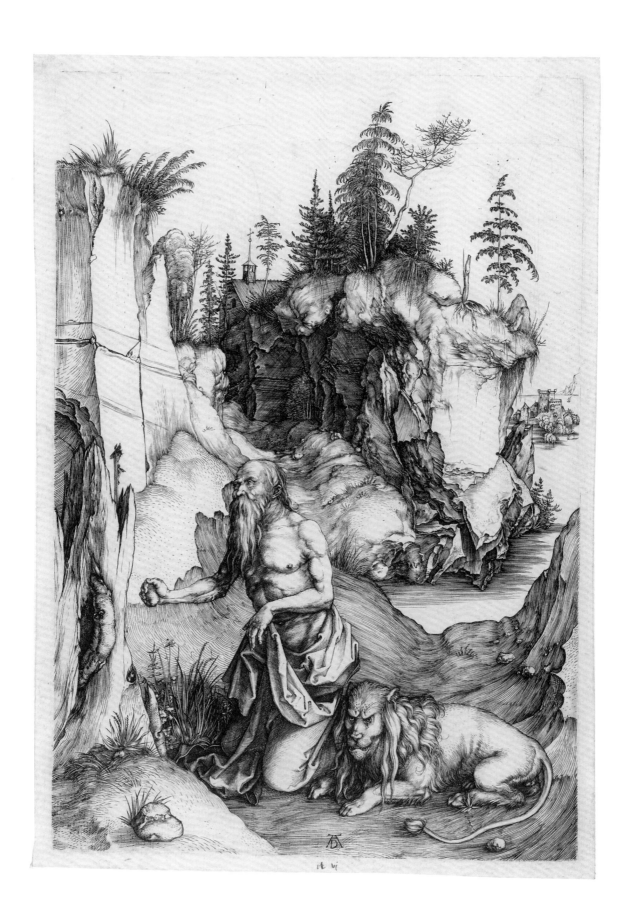

The Penitence of St. John
Chrysostom
Ca 1496
Engraving
182 : 120 mm
Monogrammed
Watermark 62 (oxhead)

Provenance: acquired in
1802/1803 from Artaria by
Ludwig X, Landgrave of Hesse.
Inv. no. GR 61

Literature: Bartsch 63; Meder 54
b; Hollstein 54; Schoch et al. 7.
Antwerp 1970, 11.

Die Buße des heiligen Johannes
Chrysostomus
um 1496
Kupferstich
182 : 120 mm
monogrammiert
Wasserzeichen 62 (Ochsenkopf)

Herkunft: 1802/1803 über
Artaria an Ludwig X. Landgraf von
Hessen.
Inv. Nr. GR 61

Literatur: Bartsch 63; Meder 54 b;
Hollstein 54; Schoch u. a. 7.
Antwerpen 1970, 11.

A number of strange tales surround the life of John Chrysostom. It is said that the emperor's daughter sought refuge in the saint's den, which he occupied as a forest hermit. There, Chrysostom seduced the girl. Half–mad with remorse over his crime, he hurled his victim from a cliff, failing to realize that the girl survived unharmed. Recognizing his double sin, the saint repented, vowing to crawl along the ground until God forgave him. 15th century depictions of St. Chrysostom generally show him bearded and crawling along on all fours like an animal. Dürer's visual interpretation of this legend poses certain questions. The repentant saint has been shifted into the background as a small, secondary figure, while the center of the composition is occupied by the young princess, depicted with luxurious hair, who nurses her child while seated on a rocky ledge. This early, very fine impression highlights the wealth of graphic possibilities explored by Dürer's engraving technique. Behind the girl, cliffs rise to dramatic heights. On the one hand, these bizarre mineral formations, pointy and menacing, seem poised at the nude figure's back. On the other, they envelop her figure like a sheltering cave.

Absonderliche Geschichten ranken sich um das Leben des Heiligen Chrysostomus. Angeblich suchte eines Tages die Tochter des Kaisers Schutz in der Klause des Heiligen, der als Eremit im Wald lebte. Chrysostomus verführte das Mädchen. Halb irrsinnig über seine eigene Untat stieß er sein Opfer von einem Felsen, ohne zu wissen, dass das Mädchen unversehrt überlebte. Als der Heilige seine doppelten Todsünden erkannte, bereute er und gelobte, so lange am Boden zu kriechen, bis Gott ihm vergebe. So zeigen die gängigen Heiligendarstellungen des 15. Jahrhunderts Chrysostomus behaart wie ein Tier auf allen Vieren. Dürers Bildinterpretation dieser Legende gibt Rätsel auf. Der schuldbeladene Heilige ist als kleine Randfigur in den Hintergrund gerückt. Im Zentrum der Darstellung sitzt die nackte junge Frau mit üppigem Haar auf einer Felsbank und stillt ihr Kind. Der frühe, sehr gute Druck des vorliegenden Blattes zeigt die Fülle der graphischen Möglichkeiten, die Dürer in der Stechtechnik auslotet. Hinter der Frau türmen sich die Felsen in dramatische Höhen. Einerseits scheinen die bizarren Gesteinsformationen der nackten Frauengestalt spitz und bedrohlich auf den Leib zu rücken, andererseits umhüllen sie die Figur gleich einer bergenden Höhle.

This is the first sheet among Dürer's early engravings to be securely datable. Heinrich Deichsler reports in the Nuremberg Chronicle that at Easter 1496, the conjoined twins of a sow were exhibited in Nuremberg. It remains unclear whether this so-called freak of nature was indeed the "Miraculous Sow of Landser," which was born on 1 March 1496 in the Upper Alsatian village of Landser. The creature had two torsos, eight legs, four ears, and two tongues which were contained in a single head. The animal achieved celebrity through an illustrated broadsheet by Sebastian Brant, produced by the Basel publishing house of Johann Bergmann von Olpe. In the context of contemporary expectations of the End Times, much anticipated around 1500, the poet and humanist Brant interpreted this strange animal – along with other unusual natural phenomena – as a divine omen. In it, he perceived the threat of Turkish invasion and the arrival of the Antichrist. Differently than Brant, Dürer did not present his theme in the woodcut technique, which corresponded to the high number of editions possible with the broadsheet medium. Instead, he turned to the demanding medium of engraving. This print eschews textual commentary entirely, treating the malformed animal as a natural phenomenon thoroughly deserving of objective description, carried out here with a highly differentiated engraving technique. Using a complex representational system consisting of hooks and short and long curves, he models the animal's form while simultaneously vividly depicting its pelt. As in most of the early engravings, Dürer is still dependent upon a spatial model derived from Schongauer. Strips of ground are layered successively without spatial transition, so that the animal appears to stand in the foreground before a kind of landscape stage.

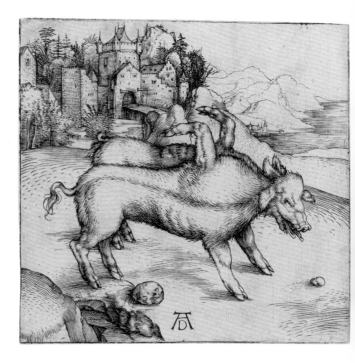

5

The Miraculous Sow of Landser	Die Missgeburt eines Schweines
1496	(Die wunderbare Sau von
Engraving	Landser)
120 : 127 mm	1496
Monogrammed	Kupferstich
Watermark 20 (high crown)	120 : 127 mm
	monogrammiert
Provenance: acquired in	Wasserzeichen 20 (Hohe Krone)
1802/1803 from Artaria by	
Ludwig X, Landgrave of Hesse.	Herkunft: 1802/1803 über
Inv. no. GR 90	Artaria an Ludwig X. Landgraf von
	Hessen.
Literature: Bartsch 95; Meder 82	Inv. Nr. GR 90
c; Hollstein 82; Schoch et al. 8.	
	Literatur: Bartsch 95; Meder 82 c;
	Hollstein 82; Schoch u. a. 8.

Als erstes Blatt aus Dürers stecherischem Frühwerk ist der kleine Kupferstich eindeutig datierbar: In der Nürnberger Chronik berichtet Heinrich Deichsler darüber, dass zu Ostern 1496 in Nürnberg die siamesische Zwillingsgeburt eines Schweins zur Schau gestellt wurde. Ob es sich dabei um die Missgeburt der „Wunderbaren Sau von Landser" handelte, ist unklar. Diese war am 1. März 1496 im oberelsässischen Dorf Landser zur Welt gekommen. Das Schwein hatte zwei Leiber, acht Beine, vier Ohren und zwei Zungen an einem Kopf. Berühmt wurde es durch das illustrierte Flugblatt von Sebastian Brant, das im Basler Verlag des Johann Bergmann von Olpe erschien. In der Endzeiterwartung der Jahre vor 1500 deutete der Dichter und Humanist Brant die Missgeburt wie andere ungewöhnliche Naturerscheinungen als göttliche Fingerzeige; er sah in dem Schwein die drohende Türkengefahr und die Ankunft des Antichristen. Anders als Brant gestaltet Dürer das Thema nicht in der dem Flugblatt entsprechenden Technik des Holzschnitts, der höhere Auflagen zulässt, sondern er wählt den aufwändigen Kupferstich. Ganz ohne Textkommentar hält Dürer das missgebildete Schwein als Naturerscheinung für abbildungswürdig. Das Tier wird mit differenzierter Stechtechnik sachlich beschrieben, Dürer setzt ein kompliziertes Zeichensystem aus Haken und kurzen und langen Bogen ein, um den Tierleib zu modellieren und gleichzeitig das Fell des Borstenviehs anschaulich werden zu lassen. Wie in den meisten frühen Kupferstichen ist Dürer noch ganz dem schongauerschen Raumkonzept verhaftet und schichtet Bodenwellen ohne räumliche Übergänge hintereinander, so dass das Schwein im Vordergrund vor einer Art Landschaftsbühne zu stehen scheint.

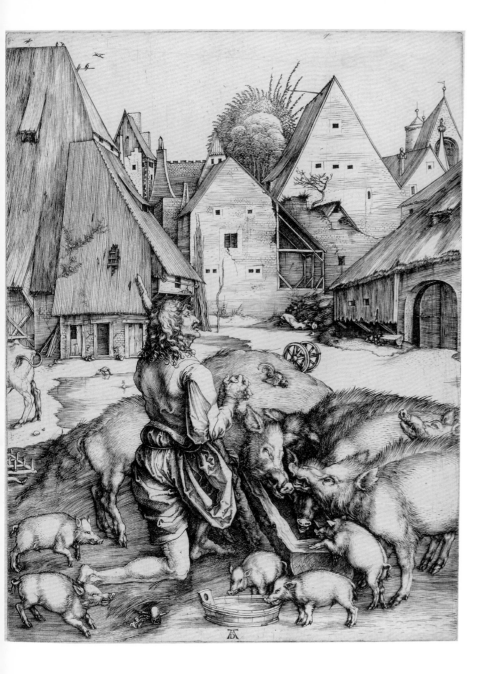

This work represents the first highpoint among Dürer's early engravings. The theme is the biblical parable of the Prodigal Son (Luke 15: 11-32), who squanders his inheritance and sinks into poverty, hiring himself out as a swineherd before eventually returning home, filled with remorse, to be received by his father with open arms. As confirmed by many woodcut illustrations, the narrative's content was thought to be the moral–theological theme of sin and repentance, one of special urgency in the late Middle Ages. But Dürer sets aside this iconographic tradition, which sets the swineherd in an open field, instead choosing as his backdrop a dilapidated farmstead where the Prodigal Son kneels down next to a feeding trough alongside his pigs. Adding a new and decisive scene to the narrative, Dürer shows the son at the moment of dawning self-awareness, addressing a prayerful appeal to God in sight of the village church. The composition's wealth of detail draws on Dürer's studies of nature, carried out intensively in the vicinity of his hometown. Several preliminary drawings of this piece have survived (Winkler 145, 146, 239). Despite perspective discrepancies around the feeding trough and the kneeling figure, Dürer succeeds for the first time in fusing his individual elements into a convincing whole, with foreground, mid–ground, and background joined into a continuum. This richly contrasting early impression from Darmstadt highlights the differentiated engraving technique Dürer employed in order to render with precision the contrasting materials of the depicted objects.

In the 17th century, as indicated by the notation on the back, this print was owned by the important Parisian collector and art dealer Pierre Mariette.

The Prodigal Son
Ca 1496
Engraving
249 : 190 mm
Monogrammed
No watermark
Reverse bears an old inscription in brown ink: Pierre Mariette rue St Jacque a les peransce 164 [final number illegible]

Provenance: acquired in 1802/1803 from Artaria by Ludwig X, Landgrave of Hesse. Inv. no. GR 27

Literature: Bartsch 28; Meder 28 a; Hollstein 28; Schoch et al. 9.

Der verlorene Sohn
um 1496
Kupferstich
249 : 190 mm
monogrammiert
ohne Wasserzeichen
Rückseite alt bezeichnet mit Tinte in Braun: Pierre Mariette rue St Jacque a les peransce 164 [letzte Zahl unleserlich]

Herkunft: 1802/1803 über Artaria an Ludwig X. Landgraf von Hessen.
Inv. Nr. GR 27

Literatur: Bartsch 28; Meder 28 a; Hollstein 28; Schoch u. a. 9.

Mit dieser Arbeit setzt Dürer einen ersten Höhepunkt in seinen frühen Stichwerken. Das Thema ist das biblische Gleichnis aus dem Lukas-Evangelium (Lukas 15, 11-32) vom verlorenen Sohn, der sein Erbteil verprasst, in Armut versinkt, sich als Schweinehirt verdingen muss und schließlich reumütig zum Vater zurückkehrt, von dem er mit offenen Armen empfangen wird. Wie etliche Holzschnittillustrationen belegen, hatte die Erzählung mit ihrem moraltheologischen Gehalt von Sünde und Reue, Buße und Gnade, im Spätmittelalter besondere Aktualität. Doch verlässt Dürer diese ikonographische Tradition, die den Schweinehirt auf offenem Feld zeigt, und wählt stattdessen den Schauplatz eines heruntergekommenen Bauernhofs, wo der verlorene Sohn neben Schweinen am Futtertrog kniet. Hier zeigt Dürer als neue Schlüsselszene des Gleichnisses den Moment der Selbsterkenntnis des schuldbeladenen Sohnes, der im Anblick der Dorfkirche sein Stoßgebet zu Gott richtet. Der Detailreichtum der künstlerischen Komposition basiert auf Dürers Naturstudium. Dies hat er in der Umgebung seiner Heimatstadt intensiv betrieben. Einzelne Vorzeichnungen haben sich erhalten (Winkler 145, 146, 239). Trotz einiger perspektivischer Unstimmigkeiten beim Futtertrog und dem davor Knienden gelingt es Dürer die Einzelelemente seiner Schilderung erstmals zu einem wirklichkeitsnahen Ganzen zusammenzuschließen: Vorder-, Mittel- und Hintergrund entwickeln sich kontinuierlich. Der gegensatzreiche frühe Abdruck aus Darmstadt lässt erkennen, welch differenzierte Stechtechniken Dürer einsetzt, um die unterschiedliche Materialität der Dinge präzise zu beschreiben. Wie die rückseitige Aufschrift belegt, war das vorliegende Exemplar im 17. Jahrhundert im Besitz des bedeutenden Pariser Sammlers und Kunsthändlers Pierre Mariette.

A series of small engravings sharing the same format (see cat. 8 and 9) show exotic individuals, peasants or perhaps travelers in isolated figural groupings. Potential purchasers of such genre scenes, characterized by anecdotal, satirical, or moralizing content were found among the urban public, with its consciousness of social status and keen interest in exotic or foreign modes of behavior. Although this sheet – an immaculate early impression from Darmstadt – also bears the title The Turkish family, the woman's attire in particular, with turban and bared breast, is inconsistent with Islamic dress codes. It seems likely that the young Dürer was inspired by conventional depictions of tramps and "Gypsies," with which he mixed his own observations. This small figural sheet was used by other artists as a prototype for genre scenes.

Eine Reihe kleiner, gleichformatiger Kupferstiche (vgl. Kat. Nr. 8 und Kat. Nr. 9) zeigt Exoten, Bauern oder fahrendes Volk in isolierten Figurengruppen. Potentielle Käufer dieser Genreszenen mit anekdotischem, satirischem oder moralischem Gehalt ist das städtische Publikum mit seinem Standesbewusstsein und ausgeprägten Interesse an fremdartigen oder merkwürdigen Verhaltensweisen. Zwar trägt das Blatt, das in Darmstadt mit einem makellosen frühen Abdruck vorliegt, auch den Titel „Türkenfamilie", doch widerspricht insbesondere das Gewand der Frau mit Turban und freiliegender Brust der islamischen Kleiderordnung. Es ist zu vermuten, dass sich der junge Dürer durch tradierte Bildvorstellungen von Landstreichern und „Zigeunern" anregen ließ und diese mit eigenen Beobachtungen mischte. Die kleinen Figurenblätter fanden auch unter Künstlern als Musterblätter für Genreszenen Verwendung.

The Oriental and His Wife (the Turkish Family)	Der Orientale und sein Weib (Die Türkenfamilie)
Ca 1496	um 1496
Engraving	Kupferstich
108 : 77 mm	108 : 77 mm
Monogrammed	monogrammiert
Watermark 63 (part of an oxhead)	Wasserzeichen 63 (Teile des Ochsenkopfes)
Provenance: acquired in 1802/1803 from Artaria by Ludwig X, Landgrave of Hesse. Inv. no. GR 80	Herkunft: 1802/1803 über Artaria an Ludwig X. Landgraf von Hessen. Inv. Nr. GR 80
Literature: Bartsch 85; Meder 80 a; Hollstein 80; Schoch et al. 12.	Literatur: Bartsch 85; Meder 80 a; Hollstein 80; Schoch u. a. 12.

Young Peasant and His Wife
Ca 1497
Engraving
108 : 79 mm
Monogrammed
No watermark

Provenance: acquired in
1802/1803 from Artaria by
Ludwig X, Landgrave of Hesse.
Inv. no. GR 78

Literature: Bartsch 83; Meder 86
a; Hollstein 86; Schoch et al. 14.

Der junge Bauer und seine Frau
Um 1497
Kupferstich
108 : 79 mm
monogrammiert
ohne Wasserzeichen

Herkunft: 1802/1803 über
Artaria an Ludwig X. Landgraf von
Hessen.
Inv. Nr. GR 78

Literatur: Bartsch 83; Meder 86 a;
Hollstein 86; Schoch u. a. 14.

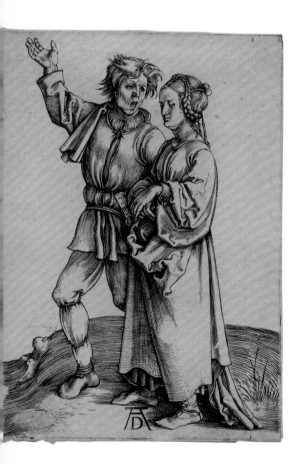

Like the preceding and following catalogue numbers, this sheet, with its youthful peasant couple, is part of a group of small–format satirical and moralizing genre scenes. Dürer aims less at a realistic depiction of milieu, and more at characterizing peasant behavior. By juxtaposing the magniloquent bragging of the oafish youth with the woman's hesitancy, Dürer pointedly accentuates the awkward courtship customs of the peasantry.

8

Wie die vorangegangene und die folgende Katalognummer gehört auch das Blatt mit dem jungen Bauernpaar in die Gruppe der kleinformatigen Genreszenen mit satirisch-moralischem Gehalt. Dürer zielt weniger auf eine reale Milieuschilderung als vielmehr auf eine Charakterisierung bäuerlichen Verhaltens. Das unbeholfene Liebeswerben des Bauernstandes bringt Dürer auf den Punkt, indem er das großsprecherische Imponiergehabe des tölpelhaften Burschen mit dem Zögern der Frau konfrontiert.

This engraving has given rise to conflicting interpretations. The group of three contrasting men has been regarded as an allegory of the social classes, and their conversation interpreted as a conspiratorial gathering in relation to the Peasant's War of 1525. The evidence, however, points toward some variation of the late medieval peasant satire. Dürer has used an objective description to attenuate the exaggerated quality of his theme while introducing the novel motif of three figures engaged in discussion. The Darmstadt version is early and fresh, yet the black of the burr is no longer as strong as in the initial proofs. According to an old notation found on the back, it belonged in the 17th century to the Parisian art dealer and collector Pierre Mariette.

9

Die Dreierkonstellation gab Anlass zu widersprüchlichen Interpretationen. So wollte man in den drei unterschiedlichen Männern eine Allegorie auf die Stände sehen, oder man deutete das Dreiergespräch im historischen Zusammenhang des Bauernkrieges von 1525 als konspirative Zusammenkunft. Die meisten Argumente sprechen hingegen für eine Variante der spätmittelalterlichen Bauernsatire. Dürer hat ihre Drastik sachlich gemildert und als neues Motiv das gemeinsame Diskutieren dargestellt. Das Exemplar in Darmstadt, das nach einer alten Bezeichnung auf der Rückseite im 17. Jahrhundert dem Pariser Kunsthändler und Sammler Pierre Mariette gehörte, ist früh und frisch, jedoch ist die Schwärze des Grats nicht mehr so stark wie bei den allerersten Abzügen.

Three Peasants in Conversation
Ca 1497
Engraving
108 : 78 mm
Monogrammed
No watermark
Reverse bears an old inscription
in brown ink: P. Mariette 1669

Provenance: Pierre Mariette
Collection, Paris; acquired in
1802/1803 from Artaria by
Ludwig X, Landgrave of Hesse.
Inv. no. GR 81

Literature: Bartsch 86; Meder 87
b; Hollstein 87; Schoch et al. 15.

Drei Bauern im Gespräch
um 1497
Kupferstich
108 : 78 mm
monogrammiert
ohne Wasserzeichen
Rückseite alt bezeichnet mit Tinte
in Braun: P. Mariette 1669

Herkunft: Sammlung Pierre
Mariette, Paris; 1802/1803 über
Artaria an Ludwig X. Landgraf von
Hessen.
Inv. Nr. GR 81

Literatur: Bartsch 86; Meder 87 b;
Hollstein 87; Schoch u. a. 15.

This large-format woodcut was produced in connection with Dürer's first trip to Italy, and provides early evidence of his reception of the Italian Renaissance. While no preliminary drawings have survived, this bathing scene must have been preceded by intensive studies of the nude male form. Dürer shows us a medieval urban bathhouse. Depicted wearing only bound loincloths are six men of different ages in various typical poses. They make music, engage in conversation, drink, or pursue their own thoughts. The Men's Bathhouse (a probable counterpart to the pen–and–ink drawing the Women's Bath, dated 1496 (Winkler 152) and now in Bremen) has been regarded as a study of the male nude or an exercise in pure genre, although deeper allegorical significance has also been detected. This woodcut has been associated with the acute risk of syphilis then threatening Nuremberg, which led to a ban on visits to bathhouses in 1496. While interpretations of The Men's Bathhouse as an allegory of the Four Temperaments or the Five Senses are appealing, they too fail to decipher all of its details. In the left foreground behind the stone wall, the choleric type holds a scraper in one hand (touch), the sanguine type delights in the aroma of a flower (smell), while the men behind them gaze into the distance (sight). The melancholic type, meanwhile, listens to music (hearing), and the phlegmatic type drinks wine (taste).

10

Der großformatige Holzschnitt, der im Anschluss an Dürers erste Italienreise entstand, ist ein frühes Zeugnis seiner Auseinandersetzung mit der italienischen Renaissance. Auch wenn sich keine vorbereitenden Aktstudien erhalten haben, ging der Badeszene ein intensives Studium des nackten menschlichen Körpers voraus. Dürer zeigt ein mittelalterliches öffentliches Stadtbad. Nur mit gebundenen Unterhosen bekleidet, haben sich hier sechs Männer unterschiedlichen Alters in typisierenden Posen zusammen gefunden. Sie musizieren, diskutieren, trinken oder hängen ihren Gedanken nach. Man wollte im „Männerbad", das wahrscheinlich ein Pendant zu der 1496 datierten Bremer Federzeichnung „Frauenbad" (Winkler 152) bildet, Aktstudien oder eine rein genremäßige Badeszene, aber auch eine tiefsinnige Allegorie sehen. Zudem wurde der Holzschnitt mit der akuten Syphilisgefahr in Nürnberg in Verbindung gebracht, aufgrund derer im Jahr 1496 der Besuch der Badehäuser verboten wurde. Obgleich damit nicht alle Details entschlüsselt werden können, scheint die These, das „Männerbad" sei eine Allegorie auf die „Vier Temperamente" oder die „Fünf Sinne", bestechend: Vorne an der Mauer hält der Choleriker einen Schaber in der Hand (Gefühl), der Sanguiniker erfreut sich am Duft einer Blume (Geruch), die Männer dahinter blicken in die Ferne (Sehen), der Melancholiker lauscht der Musik (Gehör) und der Phlegmatiker trinkt Wein (Geschmack).

The Men's Bathhouse
Ca 1496/97
Woodcut
394 : 284 mm
Monogrammed
Watermark 53 (large orb)

Provenance: acquired in
1802/1803 from Artaria by
Ludwig X, Landgrave of Hesse.
Inv. no. GR 313

Literature: Bartsch 128; Meder
266 b; Hollstein 266; Schoch et
al. 107.

Das Männerbad
um 1496/97
Holzschnitt
394 : 284 mm
monogrammiert
Wasserzeichen 53 (Großer
Reichsapfel)

Herkunft: 1802/1803 über
Artaria an Ludwig X. Landgraf von
Hessen.
Inv. Nr. GR 313

Literatur: Bartsch 128; Meder 266
b; Hollstein 266; Schoch u. a. 107.

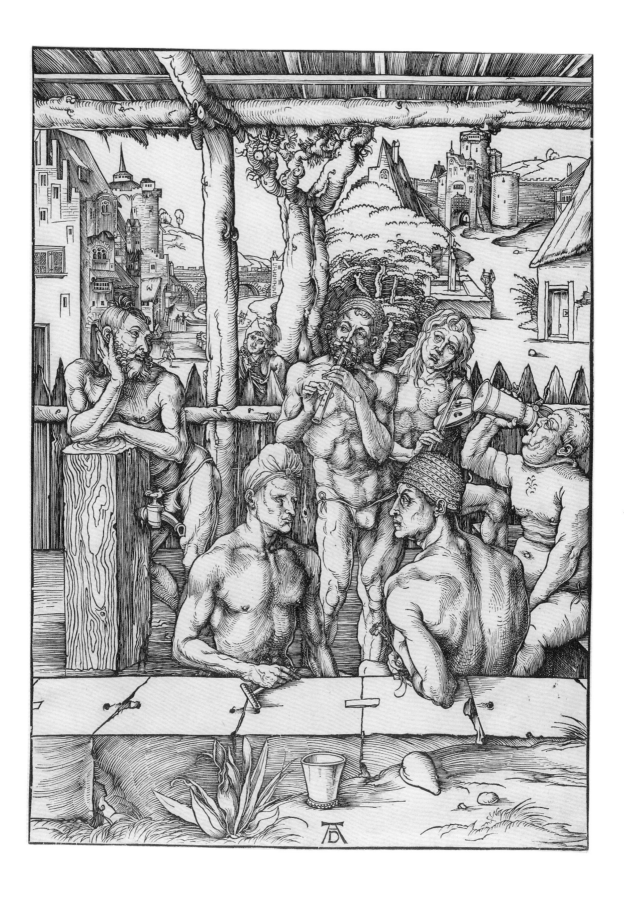

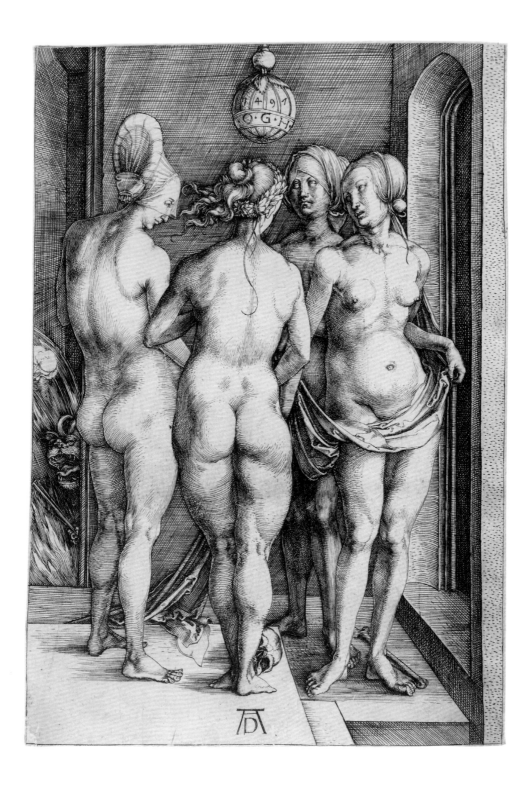

11 This engraving, whose plate was the first to be dated by Dürer, is one of his most enigmatic. In a narrow passageway, four nude women are shown pressed together, forming a small circle. Their full, sensuous bodies are presented to the viewer in side, rear, and frontal views. Suspended above their heads is a sphere that is inscribed with the date 1497 and the mysterious letters "·O·G·H·." Lying at their feet toward the center is a skull, while to the right we see a bone below a stone step that is surmounted by an arched doorway. To the left, the view opens onto a kind of dungeon, from which the figure of a devil ascends between two smoldering fires. A wealth of interpretive attempts have identified the scene as a bordello, a Judgment of Paris, as depicting the goddesses of antiquity, or as representing allegories of the Temperaments, the Seasons, or the Ages of Man. As suggested by the popular title The Four Witches, the sheet has often been connected to the witch hysteria flourishing around 1500. It has been interpreted, for example, as illustrating a tale from the Hexenhammer (Witch Hammer) Malleus Maleficarum, which appeared for the first time in 1487, and which tells how three witches murder a child in its mother's womb. The positioning of the female nudes here is striking, combined with Dürer's knowledge of classical prototypes representing the Three Graces and with the artist's natural studies, pursued privately (see Winkler 152). He plays here with disclosure and concealment, with symbolic codes, in a way that undermines any simple reading and is very much in the spirit of contemporary humanistic and Neoplatonic thought. Dürer seems to draw consciously here on a variety of sources, albeit without wishing to firmly fix the work's significance. Numerous contemporary copies and variants of Dürer's composition testify to the fascination exercised by his fusion of ancient mythology and the moralizing legends of the Middle Ages and Christianity.

Dieser erste, in der Platte datierte Kupferstich Dürers, ist zugleich einer seiner rätselhaftesten. In einem schmalen Durchgangsraum drängen sich vier nackte Frauen zu einem kleinen Reigen zusammen. In Seiten-, Rücken- und Vorderansicht stellen sie ihre sinnlich fülligen Leiber zur Schau. Über ihren Häuptern hängt eine Kugel, auf der die Jahreszahl 1497 und die geheimnisvollen Buchstaben „·O·G·H·" zu lesen sind. In der Mitte zu ihren Füßen liegt ein Totenschädel, rechts ein Knochen vor einer Stufe, die zu einem Türbogen führt. Links öffnet sich der Blick auf eine Art Verließ, aus dem zwischen loderndem Feuer eine Teufelsgestalt emporsteigt. Zu Dürers Kupferstich existiert eine Fülle von Deutungsversuchen beispielsweise als Bordellszene, Parisurteil, antike Göttinnen, Allegorien der Temperamente, Jahreszeiten oder Lebensalter. Wie im populären Titel „Die vier Hexen" anklingt, wurde

Four Nude Women (The Four Witches) 1497 Engraving 191 : 134 mm Monogrammed; on the orb: 1497 ·O·G·H· No watermark	Vier nackte Frauen (Die vier Hexen) 1497 Kupferstich 191 : 134 mm monogrammiert; auf der Kugel: 1497 ·O·G·H· ohne Wasserzeichen
Provenance: acquired in 1802/1803 from Artaria by Ludwig X, Landgrave of Hesse. Inv. no. GR 71	Herkunft: 1802/1803 über Artaria an Ludwig X. Landgraf von Hessen. Inv. Nr. GR 71
Literature: Bartsch 75; Meder 69 c; Hollstein 69; Schoch et al. 17.	Literatur: Bartsch 75; Meder 69 c; Hollstein 69; Schoch u. a. 17.

das Blatt häufig mit dem Hexenwahn um 1500 in Verbindung gebracht. Beispielsweise sah man darin die Umsetzung einer Erzählung aus dem 1487 erstmals erschienenen „Hexenhammer" "Malleus Maleficarum", nach der drei Hexen das Kind einer Schwangeren im Mutterleib abtöteten. Auffällig ist die Positionierung der weiblichen Akte, hier verschmilzt Dürers Kenntnis des antiken Vorbilds der „Drei Grazien" mit seinem privat betriebenen Naturstudium (vgl. Winkler 152). Er sucht das Spiel der Offenlegung und Verhüllung, die symbolische Verschlüsselung, die eine einfache Lesbarkeit untergräbt und ganz dem damaligen Sinn humanistisch-neuplatonischen Gedankenguts entspricht. Dürer scheint bewusst auf mehrere Quellen zuzugreifen, ohne sich auf einen Sinngehalt festlegen zu wollen. Etliche zeitgenössische Kopien und Varianten zu Dürers Kupferstich belegen die Faszination, die seit Anbeginn von seiner Mischung aus antiker Mythologie, moralisierenden Legenden des Mittelalters und Christentum ausging.

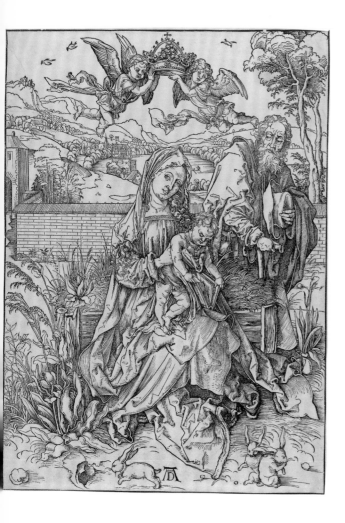

Taking up the medium of the woodcut, with its capacity for larger editions, Dürer returns to his favorite theme, the Holy Family in a Landscape, also the subject of his first monogrammed engraving, the Holy Family with the Dragonfly (see cat. 2). This new type of devotional image, conceived for a bourgeois public, has been expanded here to include a coronation of the Virgin. Seated in a luxuriantly blossoming "hortus conclusus," behind which a panoramic landscape stretches far into the distance, a youthful Mary sits on a grassy bank holding the standing infant Jesus on her knee. In a concealed allusion to the Passion, the child leafs in absorbedly through a book. Observing the two from a respectful distance is a much older Joseph. The precise rendering of the vegetation must have been based on Dürer's nature studies (see Winkler 346). It remains uncertain whether the artist's painstaking description of the richness and beauty of the terrestrial world, including the three hares in the foreground, is an end in itself, or should instead be interpreted symbolically or metaphorically. The woodcut technique used here is highly nuanced: animated contours, the play of fine lines, and the modeling of light and shade by means of hatching suggest that Dürer draws here on all of his experiences with engraving technique, combining them in a novel manner with the comparatively flattened appearance of the woodcut. The wooden block for the Holy Family with Three Hares has survived, and is now found in the Princeton University Art Museum.

Im auflagenstarken Medium des Holzschnitts gestaltet Dürer sein Lieblingsthema der heiligen Familie in der Landschaft, das er in seinem ersten monogrammierten Kupferstich „Heilige Familie mit der Libelle" (vgl. Kat. Nr. 2) ausführte. Dieses neue, für das bürgerliche Publikum erdachte Andachtsbild ist im vorliegenden Fall durch eine Marienkrönung erweitert. Im üppig blühenden „Hortus conclusus", hinter dem sich eine Weltlandschaft erstreckt, sitzt die jugendliche Maria auf einer Rasenbank und hält auf den Knien das stehende Jesuskind, das – als versteckter Hinweis auf die Passion – nachdenklich in einem Buch blättert. In respektvollem Abstand beobachtet der wesentlich ältere Joseph die beiden. Zweifellos basiert die präzise Erfassung der Vegetation auf Studien Dürers nach der Natur (vgl. Winkler 346). Ob der Künstler neben der Fülle und Schönheit der irdischen Welt mit Details, wie den drei Hasen im Vordergrund, auch symbolische bzw. metaphorische Deutungen beabsichtigt, ist unklar. Äußerst differenziert ist das Vokabular der Holzschnitttechnik: Bewegte Umrisse, feines Linienspiel, durch Schraffuren modellierte Licht- und Schattenpartien zeigen, dass Dürer seine Erfahrungen der Kupferstichtechnik einfließen lässt und auf neuartige Weise mit dem eher flächenhaften Erscheinungsbild des Holzschnitts kombiniert. Der Holzstock der „Heiligen Familie mit den drei Hasen" hat sich erhalten und befindet sich heute im Princeton University Art Museum.

The Holy Family with Three Hares
Ca 1497
Woodcut
390 : 282 mm
Monogrammed
No watermark

Provenance: acquired in 1802/1803 from Artaria by Ludwig X, Landgrave of Hesse. Inv. no. GR 287

Literature: Bartsch 102; Meder 212 c; Hollstein 212; Schoch et al. 108.

Die Heilige Familie mit den drei Hasen
um 1497
Holzschnitt
390 : 282 mm
monogrammiert
ohne Wasserzeichen

Herkunft: 1802/1803 über Artaria an Ludwig X. Landgraf von Hessen.
Inv. Nr. GR 287

Literatur: Bartsch 102; Meder 212 c; Hollstein 212; Schoch u. a. 108.

The 1498 edition of The Apocalypse was a bold enterprise: for the first time, an artist designed and printed his own book. Based on the biblical text of the Revelations of St. John, the 28-year-old Dürer published a sequence of woodcuts, encompassing 15 images in two different editions. The first uses the Latin text of the Vulgate, St. Jerome's translation of the Bible, while the second contains a German text drawn from the Bible of Anton Koberger, Dürer's Nuremberg godfather. While it is impossible to determine with precision the sizes of the original editions of the Apocalypse, sales must have been substantial, for as early as 1502, the book was copied and published in Strasbourg in a pirated edition. In 1511, Dürer released a new edition of the Latin version.

THE APOCALYPSE /
DIE APOKALYPSE

Important predecessors of Dürer's Apocalypse include the illustrated bibles of the Middle Ages, such as the Cologne Bible, published by Quentell in 1479, and the 1485 Grüninger Bible of Strasbourg. With his Apocalypse, however, Dürer took the decisive step from mere illustration to visual exegesis: his images always stand on the right hand side of the book, i.e. the more important one. In each case, the text is printed in two columns on the back of the page, so that the illustrative relationship of image to text no longer stands in the foreground. Dürer's focus on visualizing the Apocalypse corresponds to a pronounced contemporary interest in depictions of the End Times. In the late 15th century, many people lived in the expectation that the year 1500 would bring cataclysm and the Last Judgment. For his 15 scenes, which he referred to as "Figures," Dürer selected different events recounted in Revelations. The first seven compositions depict the Last Judgment, while the second half of the sequence is devoted to the battle between the heavenly hosts and the legions of Satan.

Both in terms of content and technique, Dürer set new standards with these woodcuts. Although up to this point, it had been customary for the artist to use a signet only on the most elaborate engravings, here he proudly places his monogram on each wood block. Before Dürer, woodcuts generally consisted mainly of contour lines, which were then colored in to generate a differentiated impression. By contrast, Dürer exploited his knowledge of the engraving medium, transferring its subtle modeling of light and dark areas onto woodcut technique. His lines are no longer simple contours. Instead, they swell and narrow, suggesting volume. Moreover, Dürer organized his compositions in terms of the distribution of light and dark. The novel chiaroscuro effects exploited by his woodcuts use the white of the paper to stand for light, and the dark lines for shadowed areas. This subtle and innovative application of woodcut techniques led Panofsky, for example, to assume (1955, p. 51) that in the case of the Apocalypse, Dürer did not delegate the actual cutting of the woodblocks to an artisan, as was customary at the time, but instead executed them himself for the most part. In principle, these full-page woodcuts are divisible into two different spatial spheres: an upper, celestial region, and a lower terrestrial zone. This approach allows the vision of the Apocalypse, in which the world is thrust out of joint, to be endowed with convincing visual form.

Die Ausgabe der Apokalypse im Jahr 1498 war ein kühnes Unternehmen, denn erstmals gestaltete und verlegte ein Künstler selbst ein Buch. Der 28jährige Dürer veröffentlichte seine 15 Bilder umfassende Holzschnittfolge zum Bibeltext der Offenbarung des Johannes in zwei verschiedenen Buchausgaben: die erste mit dem lateinischen Text der Vulgata, der Bibelübersetzung des Hieronymus, die zweite mit deutschem Text, den er aus der Bibel Anton Kobergers, seines Nürnberger Taufpaten, übernahm. Zwar lässt sich die genaue Auflagenhöhe der Apokalypse nicht feststellen, doch muss der Verkauf sehr erfolgreich gewesen sein, denn bereits 1502 wurde das Buch kopiert und als Raubdruck in Straßburg aufgelegt. 1511 erfolgte durch Dürer eine Neuauflage der lateinischen Ausgabe.

Wichtige Vorläufer von Dürers Apokalypse waren die mittelalterlichen Bilderbibeln. Etwa die Kölner Bibel, die um 1479 bei Quentell erschien, oder die Grüninger Bibel aus Straßburg von 1485. Mit seiner Apokalypse tat Dürer jedoch den entscheidenden Schritt von der Illustration hin zur bildlichen Interpretation: Seine Bilder stehen immer auf der rechten, der wichtigeren Seite des Buches. Der Text ist jeweils in zwei Spalten auf den Rückseiten aufgedruckt, so dass der illustrative Zusammenhang von Bild und Text nicht mehr im Vordergrund steht. Dürers Schwerpunktsetzung auf die bildliche Vision der Apokalypse entspricht dem starken Interesse der Zeit an endzeitlichen Darstellungen. Im ausgehenden 15. Jahrhundert lebte man in der Erwartung, das Jahr 1500 bringe Weltuntergang und Gericht. Dürer traf für seine 15 Blätter, die er Figuren nennt, eine Auswahl aus den Geschehnissen der Offenbarungsgeschichte. Die ersten sieben Blätter zeigen das Strafgericht über die Menschheit, die zweite Hälfte der Folge widmet sich dem Kampf der himmlischen Heerscharen gegen die Mächte des Satans.

Dürer setzte mit seinen Holzschnitten inhaltlich wie technisch neue Maßstäbe. Stolz steht sein Monogramm auf jedem Blatt, bis dato war ein Künstlersignet nur bei anspruchsvollen Kupferstichen üblich gewesen. Vor Dürer bestanden die Holzschnitte meistens aus Umrisslinien, die koloriert werden mussten, um einen differenzierten Bildeindruck zu erzeugen. Dürer hingegen benutzt seine Kenntnisse des Kupferstichs und überträgt dessen modellierende hell-dunkle Linienführung in die Technik des Holzschnitts. Er lässt die Holzschnittlinien an- und abschwellen, so dass die Linien nicht mehr nur Konturlinien sind, sondern auch Volumen darstellen können. Außerdem strukturiert Dürer seine Darstellung über die Hell-Dunkel-Verteilung. Dieses neuartige Chiaroscuro seiner Holzschnitte lässt das weiße Papier für Licht und die schwarzen Linien für Dunkelheit stehen. Der differenzierte und innovative Einsatz der Holzschnitttechnik ließ beispielsweise Panofsky (1977, S. 62) vermuten, dass Dürer das Schneiden der Holzblöcke seiner Apokalypse nicht wie damals üblich einem Formenschneider überließ, sondern zum größten Teil eigenhändig ausführte. Prinzipiell sind die ganzseitigen Holzschnitte in zwei Raumsphären zu unterteilen: den oberen, himmlischen Bereich und die untere, irdische Zone. Auf diese Weise lässt sich die Vision der Apokalypse, in der die Welt aus den Angeln gehoben wird, überzeugend ins Bild bringen.

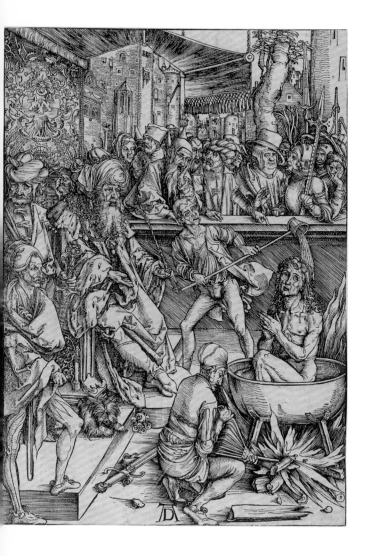

Like a prologue, the first sheet of the series shows the larger frame of the action of John's apocalyptic vision. The Golden Legend recounts that when in Ephesus, John refused to make sacrifices to the heathen gods. He suffered martyrdom for this offense when the Roman Emperor Domitian condemned him to be boiled in oil. When John survived this ordeal unscathed, he was exiled to the island of Patmos, where he transcribed his revelations. Dürer sets the martyrdom in a contemporary town whose architecture reveals influences from his sojourn in Venice. Seated on the left-hand side of the sheet on a canopied throne in front of a balustrade (which holds back the thronging crowds of spectators) is the imposing figure of the emperor, clad in Oriental splendor. With his fixed gaze, he observes the gruesome death sentence he has imposed.

13

Gleich einem Prolog zeigt das erste Blatt die Rahmenhandlung zu den apokalyptischen Visionen des Johannes. Die „Legenda Aurea" berichtet, dass sich Johannes in Ephesus weigerte, den heidnischen Göttern zu opfern. Daraufhin wurde er auf Befehl des römischen Kaisers Domitian mit siedendem Öl gemartert. Da Johannes dies unbeschadet überstand, wurde er auf die Insel Patmos verbannt, wo er seine Offenbarung niederschrieb. Dürer verlegt das Geschehen in eine Stadt seiner Zeit, die Architektur verrät Erinnerungen an seinen ersten Venedigaufenthalt. Vor einer Balustrade, die die dicht gedrängte Zuschauermenge zurückhält, sitzt links auf einem Baldachinthron die imponierende Gestalt des Kaisers in morgenländischer Pracht. Mit starrem Blick verfolgt er die von ihm verhängte grausame Todesstrafe.

The Martyrdom of John the Evangelist
Apocalypse
Original Latin edition of 1498
Woodcut
394 : 284 mm
Monogrammed
No watermark

Provenance: acquired in 1802/1803 from Artaria by Ludwig X, Landgrave of Hesse.
Inv. no.: GR 209

Literature: Bartsch 61; Meder 164; Hollstein 164; Schoch et al. 112.

Die Marter des Evangelisten Johannes
1498 Urausgabe, lateinisch
Holzschnitt
394 : 284 mm
monogrammiert
ohne Wasserzeichen

Herkunft: 1802/1803 über Artaria an Ludwig X. Landgraf von Hessen.
Inv. Nr.: GR 209

Literatur: Bartsch 61; Meder 164; Hollstein 164; Schoch u. a. 112.

John Beholding the Seven
Candelabra
Apocalypse, Figure I
Original Latin edition of 1498
Woodcut
396 : 285 mm
Monogrammed
No watermark

Provenance: acquired in
1802/1803 from Artaria by
Ludwig X, Landgrave of Hesse.
Inv. no. GR 211

Literature: Bartsch 62; Meder
165; Hollstein 165; Schoch et al.
113.

Johannes erblickt die sieben
Leuchter
Apokalypse, I. Figur
1498 Urausgabe, lateinisch
Holzschnitt
396 : 285 mm
monogrammiert
ohne Wasserzeichen

Herkunft: 1802/1803 über
Artaria an Ludwig X. Landgraf von
Hessen.
Inv. Nr. GR 211

Literatur: Bartsch 62; Meder 165;
Hollstein 165; Schoch u. a. 113.

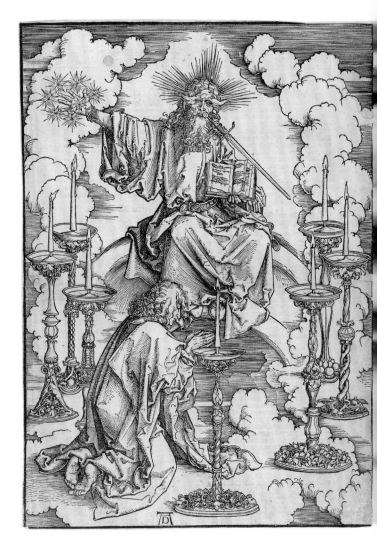

The second sheet of the Apocalypse series depicts
John's first vision (Revelations 1: 12-17). In a state of
rapture, the youthful saint kneels down, absorbed in
prayer. Framed by massive clouds, the Son of Man ap-
pears to him with eyes like flames, a double-
edged sword emerging from his mouth. He
has seven stars in his right hand and an open
book in his left. Ringing the two figures are
seven splendid candelabra, which symbol-
ize the community of the faithful in Asia, to
which these revelations are addressed. The re-
alistic motif of the bare soles of the feet, used often by
Dürer (see cat. 53), was adopted from his predecessor
Martin Schongauer's Death of the Virgin (Lehrs 16).

14

Das zweite Blatt der Apokalypse schildert die erste
Vision des Johannes (Apokalypse I, 12-17). Der Erde
entrückt kniet der jugendliche Heilige im Gebet ver-
sunken. Von gewaltigen Wolken gesäumt erscheint
ihm der Menschensohn mit Augen wie Feuerflam-
men, einem zweischneidigen Schwert, das von seinem
Mund ausgeht, sieben Sternen in der Rechten und in
der Linken das aufgeschlagene Buch. Um beide ste-
hen sieben prachtvolle Leuchter, sie symbolisieren
die Kirchengemeinden Asiens, an die die Offenba-
rung ergeht. Das realistische Motiv der nackten Fuß-
sohlen, das Dürer noch mehrfach verwendet (vgl. Kat.
Nr. 53), übernimmt Dürer aus Martin Schongauers
„Tod Mariens" (Lehrs 16).

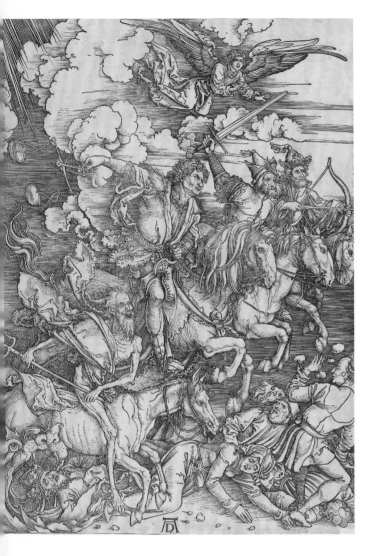

Dürer visualizes the inexorable approach of divine punishment via a dramatic consolidation. While the Four Horsemen of the Apocalypse appear successively in the biblical text (Revelations 6: 1-8), Dürer presents them as a single phalanx which descends without warning on humankind. Victory rides at the head with bow and arrow, followed by the figure bearing the sword of War. The figure bearing the scales stands for Pestilence and Famine, while the fourth, shown astride an emaciated nag, is Death. Yawning open below them is the maw of hell, which devours the fallen. By showing the galloping forward motion of the riders in slightly staggered snapshot–style views, Dürer has invented a compelling image of the waves of pitiless violence which roll over the Earth as divine retribution.

In dramatischer Verdichtung führt Dürer die Unaufhaltsamkeit des göttlichen Strafgerichts vor Augen. Treten im Bibeltext (Apokalypse VI, 1-8) die vier apokalyptischen Reiter nach einander auf, so formiert Dürer diese in seinem Holzschnitt zur Phalanx, die über die Menschheit hereinbricht. An ihrer Spitze jagt der Reiter mit Pfeil und Bogen, er steht für den Sieg; ihm folgt mit dem Schwert der Krieg; der Reiter mit der Waage steht für Teuerung und Hungersnot; der vierte Reiter auf einer Schindmähre ist der Tod. Unter ihm öffnet sich der Höllenrachen, der die Gestürzten verschlingen wird. Indem Dürer die vorwärts stürmenden Reiter in minimal zeitversetzten Momentaufnahmen ihres Galopps hintereinander schaltet, findet er ein überzeugendes Bild für die Welle von unerbittlicher Gewalt, die als Strafe über die Erde hinwegrollt.

The Four Horsemen of the Apocalypse
Apocalypse, **Figure III**
Original Latin edition of 1498
Woodcut
396 : 283 mm
Monogrammed
No watermark

Provenance: acquired in 1802/1803 from Artaria by Ludwig X, Landgrave of Hesse. Inv. no. GR 215

Literature: Bartsch 64; Meder 167; Hollstein 167; Schoch et al. 115.

Die apokalyptischen Reiter
Apokalypse, III. Figur
1498 Urausgabe, lateinisch
Holzschnitt
396 : 283 mm
monogrammiert
ohne Wasserzeichen

Herkunft: 1802/1803 über Artaria an Ludwig X. Landgraf von Hessen.
Inv. Nr. GR 215

Literatur: Bartsch 64; Meder 167; Hollstein 167; Schoch u. a. 115.

Four Angels Staying the Winds /
The Sealing of the Elect
Apocalypse, Figure V
Original Latin edition of 1498
Woodcut
393 : 285 mm
Monogrammed
No watermark

Provenance: acquired in
1802/1803 from Artaria by
Ludwig X, Landgrave of Hesse.
Inv. no. GR 219

Literature: Bartsch 66; Meder
169; Hollstein 169; Schoch et al.
117.

Vier Engel, die Winde aufhaltend
/ Die Versiegelung der
Auserwählten
Apokalypse, V. Figur
1498 Urausgabe, lateinisch
Holzschnitt
393 : 285 mm
monogrammiert
ohne Wasserzeichen

Herkunft: 1802/1803 über
Artaria an Ludwig X. Landgraf von
Hessen.
Inv. Nr. GR 219

Literatur: Bartsch 66; Meder 169;
Hollstein 169; Schoch u. a. 117.

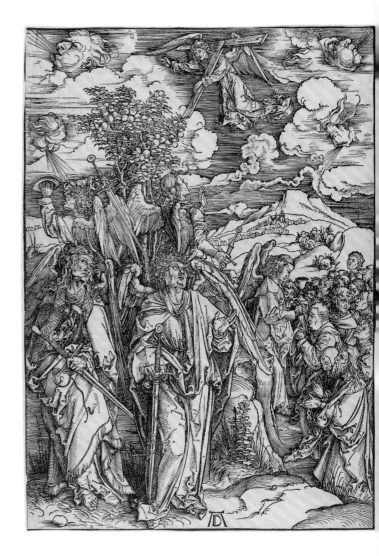

This scene interrupts the unfolding action of divine punishment with a tranquil pause. In order to allow the ceremony of the sealing of the Just Souls to proceed undisturbed, God sends four angels down to earth to tame the four winds (Revelations 7: 1). Dürer groups these imposing heavenly beings around a hill, upon which grows a fruit–bearing tree. The angels have already calmed two of the winds; the other two are being admonished to still themselves. Kneeling on the right hand side in front of a distant view of a tranquil mountainous landscape is the multitude of the elect; each is singled out by an angel who touches his or her forehead with a cross.

16

Die Szene unterbricht den Ablauf der göttlichen Strafgerichte durch eine Ruhepause. Um die Zeremonie der Bezeichnung der Gerechten ungestört stattfinden zu lassen, sendet Gott vier Engel auf die Erde, die die vier Winde in Zaum halten (Apokalypse VII, 1). Dürer gruppiert die imposanten himmlischen Wesen um einen Hügel, auf dem ein früchtetragender Baum wächst. Die Engel haben zwei Winde bereits besänftigt, zweien wird Einhalt geboten. Vor einem weiten Ausblick in eine ruhige Gebirgslandschaft kniet rechts die Menge der Auserwählten und wird von einem Engel mit einem Kreuz auf der Stirn ausgezeichnet.

The Sun–clad Woman with the
Seven–headed Dragon
Apocalypse, Figure IX
Original Latin edition of 1498
Woodcut
394 : 283 mm
Monogrammed
No watermark

Provenance: 1802/1803 acquired
from Artaria by Ludwig X,
Landgrave of Hesse.
Inv. no. GR 229

Literature: Bartsch 71; Meder
173; Hollstein 173; Schoch et
al. 121.

Das Sonnenweib und der
siebenköpfige Drache
Apokalypse, IX. Figur
1498 Urausgabe, lateinisch
Holzschnitt
394 : 283 mm
monogrammiert
ohne Wasserzeichen

Herkunft: 1802/1803 über
Artaria an Ludwig X. Landgraf
von Hessen.
Inv. Nr. GR 229

Literatur: Bartsch 71; Meder 173;
Hollstein 173; Schoch u. a. 121.

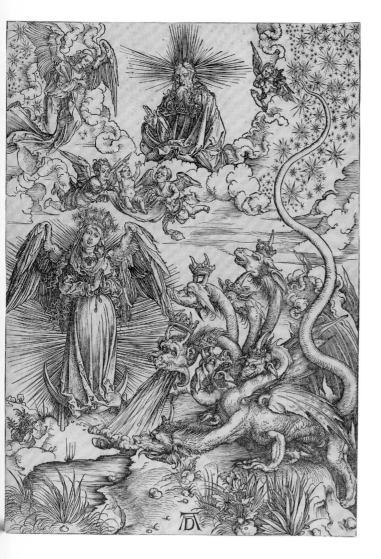

In the second half of the Apocalypse, Dürer succeeds in dramatizing the narrative by telescoping several stages of John's vision into a single image. In the zone of heaven, God the Father watches over the battle between good and evil that takes place on the Earth. The Apocalyptic Woman appears "clothed with the sun, with the moon under her feet and on her head a crown of twelve stars" (Revelations 12: 1). God has given her wings with which to fly away from evil (Revelations 12: 14), embodied here as a dragon with "seven heads and ten horns and seven crowns on his heads" (Revelations 12: 3). The monster's seven bizarre animal heads can be interpreted as representing the Seven Deadly Sins. Following a centuries–long tradition, Dürer identifies the Apocalyptic Woman with the Virgin Mary, mother of the Redeemer. Angelic putti rescue her child from the ravenous dragon, transporting it into celestial custody (Revelations 12: 4-5).

Indem Dürer in der zweiten Hälfte seiner Apokalypse mehrere Etappen der Visionen des Johannes in einem Bild zusammenfasst, kann er die Erzählung zusätzlich dramatisieren. In der Himmelszone wacht Gottvater mit seinen Mitstreitern über den auf der Erde stattfindenden Kampf zwischen Gut und Böse. Das apokalyptische Weib erscheint „mit der Sonne bekleidet, und der Mond unter ihren Füßen und auf ihrem Haupt eine Krone von zwölf Sternen" (Apokalypse XII, 1). Gott hat ihr Flügel verliehen, damit sie vor dem Bösen flüchten kann (Apokalypse XII, 14). Das Böse figuriert als Drache, der „sieben Häupter und zehn Hörner und auf seinen Häuptern sieben Kronen" (Apokalypse XII, 3) hat. Die sieben bizarren Tierköpfe des Untiers sind als Hinweis auf die sieben Todsünden lesbar. Wie seit Jahrhunderten üblich hat Dürer das Apokalyptische Weib mit Maria, der Mutter des Erlösers, gleichgesetzt. Engelputti retten ihr Kind vor dem gefräßigen Drachen in die himmlische Obhut (Apokalypse XII, 4-5).

17

This sheet illustrates the brief textual passage: "And there was war in heaven: Michael and his angels fought against the dragon; and the dragon fought and his angels, and prevailed not" (Revelations 12: 7-8). With consummate control, Dürer dramatizes the scene by exploiting the light–dark contrasts so characteristic of the woodcut medium. Suspended above a tranquil, sun–drenched landscape is a leaden sky, made dark as night by horizontal parallel lines. Taking place there is a pitiless battle between the heavenly hosts and the monsters of Satan. The powerful, infuriated angels are apparently prevailing, and seem quite capable of exterminating the devil's spawn. The artist found inspiration for the monumental figure of Michael in the Cologne Bible and in the works of Martin Schongauer (Lehrs 63 and 54). It is believed that this sheet was the last of the 15 woodcuts of the series to be executed.

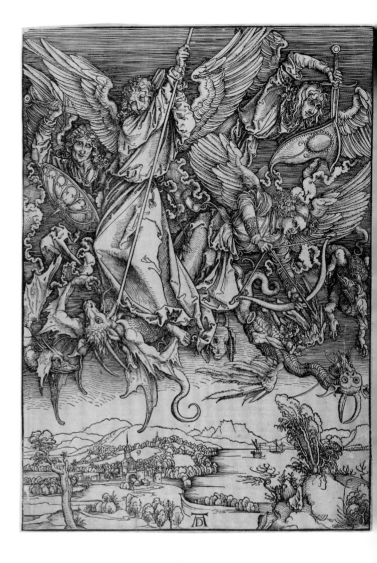

18

Das Blatt bezieht sich auf die kurze Textstelle: „Und es erhob sich ein Streit im Himmel: Michael und seine Engel stritten wider den Drachen. Und der Drache stritt und seine Engel und siegten nicht..." (Apokalypse XII, 7-8). Souverän nutzt Dürer das Hell-Dunkel-Spiel des Holzschnitts, um die Szene zu dramatisieren. Über einer von der Sonne beschienenen, friedlichen Landschaft hängt ein tiefer Himmel, durch horizontale Parallellinien nachtschwarz verdunkelt. Hier findet ein erbitterter Kampf der himmlischen Heerscharen gegen die Monster des Satans statt. Offensichtlich obsiegen die gewaltigen, aufgebrachten Engel und können die Teufelsbrut vernichten. Anregung für die monumentale Gestalt Michaels fand Dürer in der Kölner Bibel und bei Martin Schongauer (Lehrs 63 und 54). Man nimmt an, dass Dürer das Blatt als den letzten der 15 Holzschnitte dieser Serie entworfen hat.

The Archangel Michael Battling the Dragon
Apocalypse, Figure X
Original Latin edition of 1498
Woodcut
394 : 285 mm
Monogrammed
No watermark

Provenance: acquired in 1802/1803 from Artaria by Ludwig X, Landgrave of Hesse.
Inv. no. GR 231

Literature: Bartsch 72; Meder 174; Hollstein 174; Schoch et al. 122.

Michaels Kampf mit dem Drachen
Apokalypse, X. Figur
1498 Urausgabe, lateinisch
Holzschnitt
394 : 285 mm
monogrammiert
ohne Wasserzeichen

Herkunft: 1802/1803 über Artaria an Ludwig X. Landgraf von Hessen.
Inv. Nr. GR 231

Literatur: Bartsch 72; Meder 174; Hollstein 174; Schoch u. a. 122.

Medieval theology regarded Samson, a biblical hero from the Book of Judges, as prefiguring Christ. Typological parallels were drawn between his battle with the lion and Christ's victory over Satan. The motif of Samson kneeling on the lion, his right leg pressed into the beast's neck, is found in an engraving by Israhel van Meckenem (Lehrs 5). Dürer's Samson is also strongly reminiscent of works from classical antiquity, for instance representations of the struggle between Hercules and the Nemean lion. In his engravings, Dürer often utilizes classical ideals of beauty for Christian themes. New here is the depiction of Samson as an emblem of *fortitudo* in a large–format individual woodcut. For this reason,

19

Samson Slaying the Lion
Ca 1497/98
Woodcut
382 : 278 mm
Monogrammed
Watermark 53 (large orb)
Sheet trimmed at the corners

Provenance: acquired in 1802/1803 from Artaria by Ludwig X, Landgrave of Hesse. Inv. no. GR 293

Literature: Bartsch 2; Meder 107 a-b; Hollstein 107; Schoch et al. 127.

Samson tötet den Löwen
um 1497/98
Holzschnitt
382 : 278 mm
monogrammiert
Wasserzeichen 53 (Großer Reichsapfel)
An den Ecken beschnitten

Herkunft: 1802/1803 über Artaria an Ludwig X. Landgraf von Hessen. Inv. Nr. GR 293

Literatur: Bartsch 2; Meder 107 a-b; Hollstein 107; Schoch u. a. 127.

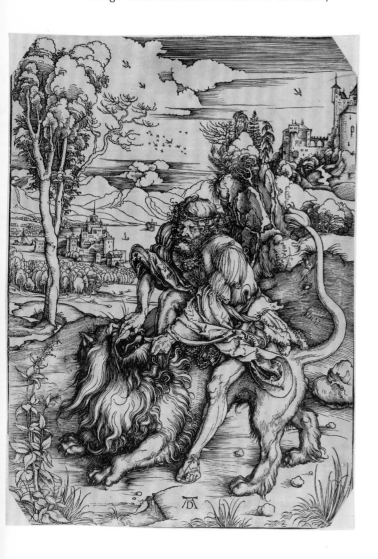

the sheet represents a substantial leap in the quality of his woodcut technique. Dürer's cutting is extremely refined, precise, and formally elaborate. It is virtually impossible to speak here of simple contour lines. Swelling and subsiding, his intricate, intersecting hatching lines are highly descriptive, while also convincingly modeling the forms and successfully differentiating a wide range of materials.

Die mittelalterliche Theologie verstand Samson als Präfiguration Christi und setzte typologisch den Löwenkampf des biblischen Helden aus dem Buch der Richter mit dem Sieg Christi über den Satan gleich. Das Motiv des auf dem Löwen sitzenden Samsons, der sein rechtes Bein der Bestie in den Nacken stemmt, findet sich in einem Kupferstich von Israhel van Meckenem (Lehrs 5). Zudem erinnert Dürers Samson stark an antikische Darstellungen, etwa an Herkules' Kampf mit dem Nemeischen Löwen. In seinen Kupferstichen hat Dürer häufig das klassische Schönheitsideal für ein christliches Thema verwertet, neu ist, dass er hier Samson als Sinnbild der „fortitudo" im großformatigen Einblattholzschnitt gestaltet und damit einen bemerkenswerten Qualitätssprung in der Holzschnitttechnik vollzieht. Dürers Schnitttechnik ist extrem verfeinert, präzise und formenreich. Man kann kaum mehr von einfachen Konturlinien sprechen. An- und abschwellend, in komplizierten Kreuzlagen sind die Linien beschreibend und modellierend, sie differenzieren die unterschiedlichen Materialien.

There have been numerous attempts to interpret this engraving, but none have been as comprehensive or insightful as the one offered by Erwin Panofsky (Panofsky 1955, p. 96f.), who deciphered it with reference to the 15th-century doctrine of the Virtues. In a chamber furnished in early Germanic style, a well–nourished man dozes on a bench, warmed by a nearby tiled stove. Seated on a thick pillow and wearing a housecoat and sleeping cap, he is the very image of comfort. Lurking behind the man is a hovering dragon which blows evil thoughts into the sleeper's ear through a bellows. Dominating the foreground of the composition and standing in classical contrapposto is a female nude. Of particular interest to Dürer was her statuesque monumentality, which anticipates the idealized nude Eve of 1504 (cat. 32). Presumably the subject of the sleeper's dream, she stands before the viewer as a physically existent form. Embodying classical beauty, she wears her long hair loose, a cloth covering her pubic area. Her right hand raised, she turns toward the sleeping man. The Amor which busies itself with stilts at her feet implies that it is Venus who appears in the loafer's dream. In the context of late medieval notions of morality, the idler – who sleeps instead of working or praying – personifies indolence or "Acedia," which numbers among the Seven Deadly Sins. This early Darmstadt exemplar demonstrates Dürer's graphic precision in the rendering of various materials such as wood, tile, textiles, hair, and skin.

20

Der Kupferstich wurde vielfach gedeutet, besonders umfassend und einleuchtend von Erwin Panofsky (Panofsky 1977, S. 96f.): Er sah das Blatt in Verbindung mit der Tugendlehre des 15. Jahrhunderts. In einer altdeutsch eingerichteten Stube döst ein wohlgenährter Mann sitzend auf einer Bank hinter seinem wärmenden Kachelofen, wo er es sich in Hausman-

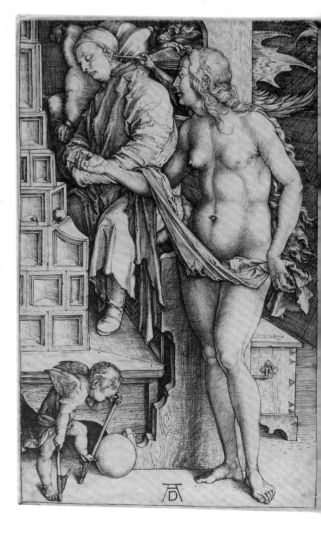

tel und Schlafkappe auf dicken Kissen bequem gemacht hat. Von hinten pirscht sich fliegend ein teuflischer Drache heran, um dem Schläfer mit dem Blasebalg böse Gedanken ins Ohr zu blasen. Bild beherrschend im Vordergrund steht eine weibliche Aktfigur im antiken Kontrapost. Auf ihrer statuenhaften Monumentalität, die den Idealakt der Eva von 1504 (Kat. Nr. 32) vorwegnimmt, lag Dürers besonderes Interesse. Physisch real steht das vermeintliche Traumgesicht dem Betrachter vor Augen. Die antike Schönheit trägt das lange Haar offen, ein Tuch verhüllt die Scham, mit der Rechten wendet sie sich zum Schläfer. Der zu ihren Füßen mit Stelzen hantierende kleine Amor legt nahe, dass es sich um Venus handelt, die dem Faulenzer im Traum erscheint. Im Kontext der spätmittelalterlichen Moralvorstellungen wird der Müßiggänger, der schläft anstatt zu arbeiten oder zu beten, zur Personifikation der Trägheit, der „acedia", die zu den sieben Todsünden zählt. Der frühe Abzug des Darmstädter Exemplars verdeutlicht Dürers graphische Präzision bei der bildlichen Beschreibung der verschiedenen Materialien, wie Holz, Kacheln, Kleiderstoff, Haar oder Haut.

The Temptation of the Idler (The Dream of the Doctor)
Ca 1498
Engraving
191 : 122 mm
Monogrammed
Watermark 62 (oxhead)

Provenance: acquired in 1802/1803 from Artaria by Ludwig X, Landgrave of Hesse. Inv. no. GR 72

Literature: Bartsch 76; Meder 70 a; Hollstein 70; Schoch et al. 18.

Die Versuchung des Müßiggängers (Der Traum des Doktors)
um 1498
Kupferstich
191 : 122 mm
monogrammiert
Wasserzeichen 62 (Ochsenkopf)

Herkunft: 1802/1803 über Artaria an Ludwig X. Landgraf von Hessen.
Inv. Nr. GR 72

Literatur: Bartsch 76; Meder 70 a; Hollstein 70; Schoch u. a. 18.

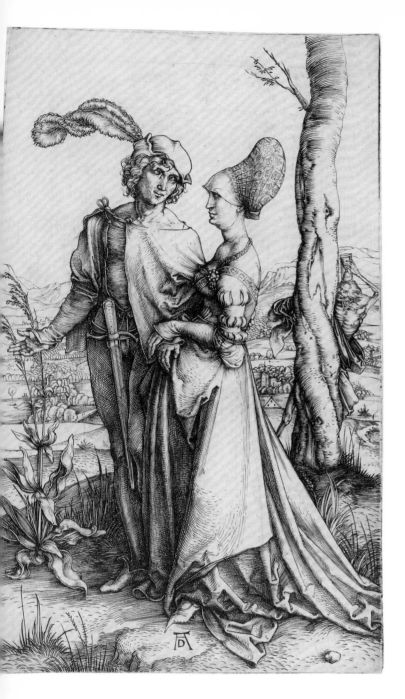

The large format and the differentiated and disciplined application of graphic resources distinguish this sheet from Dürer's smaller genre depictions of couples which date from 1496 (see cat. 7, 8). In a richly–detailed, hilly landscape, a stylish youth with a jaunty feathered cap, his sword dangling down at his waist, pays his respects to a woman who is no longer young. Unseen by the two, and raising an hourglass menacingly as a symbol of transitoriness, Death observes the lovers' idyll from behind a gnarled tree trunk. His presence locates the scene in the tradition of the memento mori. But Dürer inserts yet another level of significance, for the attire worn by the object of the youth's affections, including her jewelry, and in particular her bonnet, identify her as a married woman from Nuremberg's upper classes. The joys of love are hence converted into a "dangerous liaison," and Dürer's engraving becomes a warning against the sin of adultery. Using psychology and empathy, Dürer admonishes the viewer to lead a life of chastity and virtue.

21

Das größere Format sowie der differenzierte und disziplinierte Einsatz der graphischen Mittel unterscheiden das Blatt von Dürers kleinen Genreblättern mit Paardarstellungen des Jahres 1496 (vgl. Kat. Nr. 7 und Kat. Nr. 8). In einer detailreich gestalteten Hügellandschaft macht ein fescher Jüngling mit keckem Federhut und vor dem Schritt sitzendem Kreuzschwert einer nicht mehr ganz jungen Dame seine Aufwartung. Drohend das Stundenglas als Symbol der Vergänglichkeit erhoben, beobachtet für beide unsichtbar der Tod hinter einem knorrigen Baumstamm das Liebesidyll, das damit in die ikonographische Tradition der „Memento mori"-Darstellungen rückt. Doch gibt Dürer noch eine weitere Bedeutungsebene, denn die Angebetete ist durch ihre elegante Kleidung mit Schmuck und insbesondere durch ihre Haube als verheiratete Frau der Nürnberger Oberschicht gekennzeichnet. Damit wird das Liebesglück zur „gefährlichen Liebschaft" und Dürers Kupferstich zur Warnung vor der Todsünde des Ehebruchs. In einfühlsam psychologischer Weise zeigt Dürer eine moralische Mahnung zu einem Leben in Keuschheit und Tugendhaftigkeit.

Young Couple Threatened by
Death (The Promenade)
Ca 1498
Engraving
195 : 121 mm
Monogrammed
No watermark
Reverse bears an old inscription
in brown ink: P. Mariette 1662

Provenance: Pierre Mariette
Collection, Paris; acquired in
1802/1803 from Artaria by
Ludwig X, Landgrave of Hesse.
Inv. no. GR 89

Literature: Bartsch 94; Meder 83
b-c; Hollstein 83; Schoch et al. 19.

Das Liebespaar und der Tod (Der
Spaziergang)
um 1498
Kupferstich
195 : 121 mm
monogrammiert
ohne Wasserzeichen
Rückseite alt bezeichnet mit Tinte
in Braun: P. Mariette 1662

Herkunft: Sammlung Pierre
Mariette, Paris; 1802/1803 über
Artaria an Ludwig X. Landgraf von
Hessen.
Inv. Nr. GR 89

Literatur: Bartsch 94; Meder 83
b-c; Hollstein 83; Schoch u. a. 19.

The Madonna with the Monkey	Maria mit der Meerkatze
Ca 1498	um 1498
Engraving	Kupferstich
189 : 122 mm	189 : 122 mm
Monogrammed	monogrammiert
Watermark 20 (high crown)	Wasserzeichen 20 (Hohe Krone)
Provenance: acquired between	Herkunft: Erworben zwischen
1830 and 1875.	1830 und 1875.
Inv. no. GR 41	Inv. Nr. GR 41
Literature: Bartsch 42; Meder 30	Literatur: Bartsch 42; Meder 30 a;
a; Hollstein 30; Schoch et al. 20.	Hollstein 30; Schoch u. a. 20.

Here, the young Dürer again takes up his favorite theme of the Virgin Mary in a landscape. In comparison with his engraving Holy Family with the Dragonfly of 1495 (cat. 2), we see him progressively distancing himself from the late Gothic style, and orienting himself instead toward the Italian Renaissance. This development may be seen in connection with his artistic development as a whole, but it may also have been conditioned by marketing considerations. Striking here is the mastery of the burin work through which Dürer distinguishes a variety of objects and materials, at the same time creating a highly convincing three-dimensional setting. The Virgin Mary sits on a grassy bank, her left hand supported by a book, the Holy Scripture. She gazes lovingly downward at the naked infant Jesus, who rests in her lap. The child holds a small songbird on his leg. He attempts to charm it using a drained nursing pouch as a "pacifier." An unsettling counterpart to this innocent child's play is the mask–like expression of the monkey seen chained up on the grassy bank. In Christian iconography, this creature stands for evil, and is occasionally associated with the Synagogue. The monkey – which Dürer studied from life – may also stand for the principle of imitation, or "mimesis." The scene includes additional naturalistic elements. Along the horizon line we find a river landscape, with its half–timbered Frankish "Weiherhaus" (pond house). Found in the vicinity of Nuremberg, it was also the subject of a watercolor executed by Dürer in 1496 (Winkler 115). The results of other nature studies can be seen in the cloud formations.

22

Im Vergleich zu dem um 1495 entstandenen Kupferstich der „Heiligen Familie mit der Libelle" (Kat. Nr. 2) entfernt sich der junge Dürer bei dieser erneuten Gestaltung seines Lieblingsthemas der Muttergottes in der Landschaft allmählich vom „spätgotischen" Stil und orientiert sich an der italienischen Renaissance. Das mag im Zusammenhang mit der künstlerischen Weiterentwicklung stehen, kann aber auch marktstrategisch bedingt sein. Auffallend ist die Souveränität der Strichführung, mit der Dürer jetzt unterschiedliche Stoffe und Materialien sowie das Raumgefüge realitätsnah wiedergeben kann. Maria sitzt auf einer Rasenbank, ihre Linke hat sie auf ein Buch – die heilige Schrift – gestützt. Liebevoll schaut sie zum nackten Jesusknaben auf ihrem Schoß, der einen kleinen Singvogel an den Beinen festhält und diesen mit seinem „Schnuller", einem getränkten Saugbeutelchen, zu locken versucht. Zu Füßen der Madonna ist eine Meerkatze an die Rasenbank gekettet, ihr maskenhafter starrer Blick bildet einen beunruhigenden Gegenpart zum unschuldigen Spiel des Kindes. In der christlichen Ikonographie steht die Meerkatze für das Böse oder sie wird mit der Synagoge in Verbindung gebracht. Darüber hinaus mag das Äffchen, das Dürer nach der Natur studiert hat, auch für das Prinzip der Nachahmung, die „Mimesis", stehen. Weitere naturalistische Elemente finden sich in der Darstellung. So entfaltet sich bis zum Horizont eine weite Flusslandschaft, in der aus der Umgebung Nürnbergs etwa das fränkische „Weiherhaus" mit Fachwerk eingebunden ist, wovon Dürer 1496 ein Aquarell anfertigt hatte (Winkler 115). Weitere Naturstudien sind in die Wolkenformation eingeflossen.

The drama takes place against a backdrop formed by a steeply rising landscape topped by fortifications reminiscent of the castle of Nuremberg. A sea monster, half human and half fish, is seen carrying off a young woman. Armed with a tortoise–shell shield and a jawbone, antlers growing from his forehead, the bearded merman glides across the waves, holding his beautiful prize tightly in his grip. Seemingly resigned to her fate, the young woman reclines on the monster's scaly tail, only her gaze betraying her distress. She gazes backward yearningly at her companions, who flee the water in panic. One woman collapses in despair, while a male figure dressed in Oriental garb rushes toward the water's edge. The composition cannot be associated with any known myth, whether from classical antiquity or from the northern sagas. The scene illustrates no known textual source. Instead, Dürer presents us with a non–specific interpretation of the theme of abduction. He has, however, borrowed the figure of the recumbent female nude from classical prototypes, known to him in particular through the engravings of Italian Renaissance artists like Andrea Mantegna. Comparisons with preceding depictions of female nudes, for example those found in Four Nude Women (cat. 11), clearly demonstrate that in The Sea Monster, Dürer renounces all bodily individuality in favor of an idealized version of beauty, one that is moreover subject to rational construction and measurement. His burin technique too has been systematized to perfection, with spatial recession arranged in a schematically balanced alternation of bright and dark strata. Dürer has skillfully integrated the white areas of the paper into his depictions of clouds and waves. Having mastered this effect, Dürer exploits it frequently in subsequent works, for example the Apocalypse (cat. 13–18) and Nemesis (cat. 28).

23

Vor einer Landschaftskulisse mit einer Festungsanlage, die an die Nürnberger Burg erinnert, ereignet sich das Drama. Ein Seeungeheuer, halb Mensch halb Fisch, entführt eine nackte junge Frau. Bewaffnet mit einem Schildkrötenpanzer und einem Kieferknochen gleitet der bärtige Meermann, auf dessen Stirn ein Geweih wächst, durch die Fluten, während er seine schöne Beute fest im Griff hält. Sich offensichtlich ihrem Schicksal ergebend, ruht die junge Frau auf dem Schuppenschwanz des Ungeheuers, nur ihr Blick verrät Pein. Sehnsuchtsvoll schaut sie zurück zu den Gespielinnen, die in Panik aus dem Wasser flüchten. Verzweifelt ist eine Frau am Ufer zusammengebrochen, während ein Orientale gestikulierend herbeieilt. Kein Mythos, weder aus der Antike noch aus der nördlichen Sagenwelt, lässt sich mit Dürers Darstellung eindeutig verbinden. Es handelt sich um keine bildliche Illustration zu einer konkreten Vorlage, vielmehr deutet alles auf eine unspezifische Auslegung des Entführungsthemas hin. Dabei greift Dürer in der ruhenden nackten Frauengestalt ein antikes Bildmuster auf, das ihm insbesondere durch Stiche italienischer Renaissancekünstler, beispielsweise Mantegna, bekannt war. Gerade im Vergleich mit den vorangehenden weiblichen Aktdarstellungen, etwa den „Vier nackten Frauen" (Kat. Nr. 11), wird deutlich, wie sehr Dürer im „Meerwunder" jede körperliche Individualität ausblendet zu Gunsten eines idealisierten Schönheitsideals, das rational begründet und messbar sein soll. Auch Dürers Stichtechnik ist perfekt systematisiert, schematisch ausgeglichen erschließen abwechselnd helle und dunkle Schichten den Tiefenraum. Gekonnt integriert Dürer das Weiß des unberührten Blatts in die Formation der Wolken und Wellen. Diesen Effekt beherrscht Dürer nunmehr souverän und nutzt ihn häufig als Gestaltungsfaktor, etwa in der „Apokalypse" (Kat. Nrn. 13-18) oder auch der „Nemesis" (Kat. Nr. 28).

The Sea Monster	Das Meerwunder
Ca 1498	um 1498
Engraving	Kupferstich
255 : 192 mm	255 : 192 mm
Monogrammed	monogrammiert
Watermark 20 (high crown with the rare scroll 20a)	Wasserzeichen 20 (Hohe Krone mit dem seltenen Schnörkel 20a)
Provenance: acquired in 1802/1803 from Artaria by Ludwig X, Landgrave of Hesse. Inv. no. GR 67	Herkunft: 1802/1803 über Artaria an Ludwig X. Landgraf von Hessen. Inv. Nr. GR 67
Literature: Bartsch 71; Meder 66 a; Hollstein 66; Schoch et al. 21.	Literatur: Bartsch 71; Meder 66 a; Hollstein 66; Schoch u. a. 21.

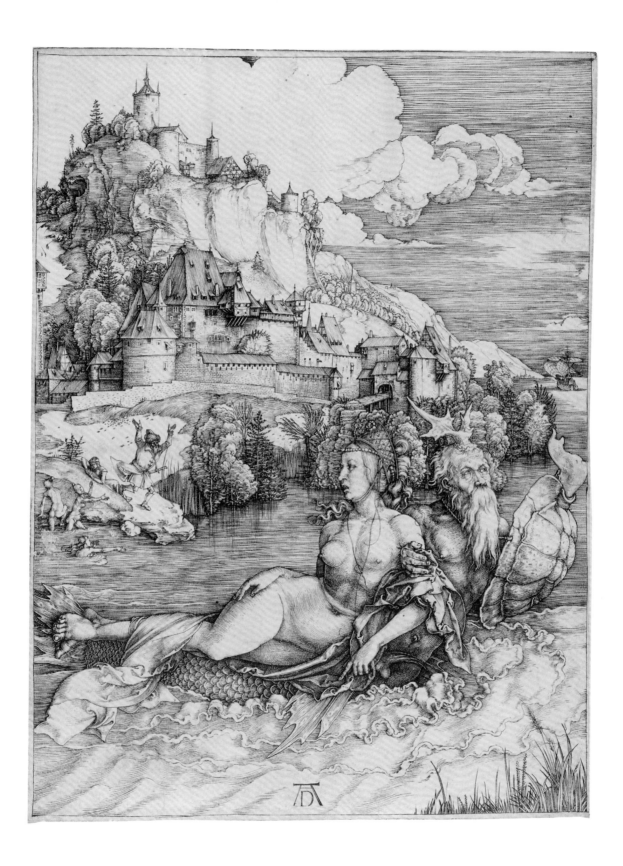

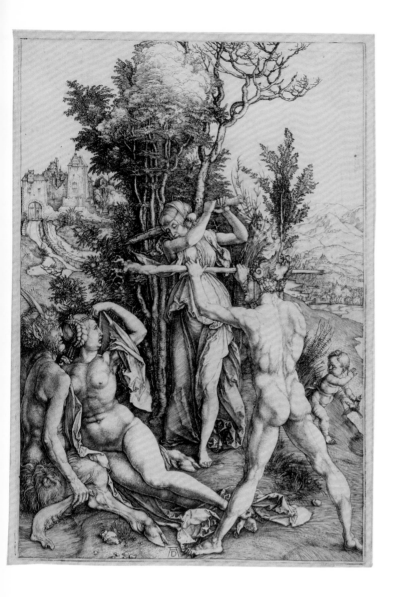

A nude male figure seen from behind stands with wide outspread legs in the foreground of a scene of conflict. He holds an uprooted sapling in front of him defensively, while a female figure in antique–style dress raises a wooden club, preparing to strike. The target of her fury is a nude woman shown seated on the ground, who has apparently just been caught engaging in amorous play with a satyr. Dürer assembled this enigmatic composition from numerous motifs of antique and Italian sources, elements he had used previously in other contexts. Erwin Panofsky's pioneering interpretation of Dürer's montage of images (Panofsky 1955, p. 73–76) identifies the subject as "Hercules at the Crossroads." In the contrasting female figures, he perceived personifications of "Virtue" and "Vice" between which the hero Hercules must now choose. In the Hercules theme, Dürer characteristically fuses mythology with moralizing allegory. He aims here to develop a dramatic scene in the style of the Quattrocento, one whose pictorial and body languages combine to express a high degree of pathos. Increasingly, Dürer refines the modeling of his nude figures; the rapidity of his progress becomes clearly evident when this work is compared with the Sea Monster (cat. 23).

24

Eine nackte männliche Rückenfigur steht gespreizt im Vordergrund einer Kampfszene und hält in den erhobenen Armen ein ausgerissenes Baumstämmchen schützend vor sich, während eine antikisch gewandete Frauengestalt zum Schlag mit einem Holzknüppel ausholt. Ihre Wut richtet sich gegen eine am Boden sitzende Nackte, die sie beim Liebesspiel mit einem Satyr ertappt hat. Die rätselhafte Darstellung kombiniert Dürer aus unterschiedlichen Motivzitaten, die er aus antiken und italienischen Vorbildern übernommen hat und bereits in andere Bildzusammenhänge einsetzte. Wegweisend interpretierte Panofsky (1930, S. 166) Dürers pathetische Bildmontage als „Herkules am Scheideweg" und sah in den gegnerischen Frauengestalten die Personifikationen von „Tugend" und „Laster", zwischen denen sich der Held Herkules zu entscheiden hat. In dem Herkulesthema verbindet Dürer auf charakteristische Weise Mythologie und moralische Allegorie. Sein Ziel war es, im Stile des Quattrocento eine dramatische Komposition zu entwickeln, die ein Höchstmaß an Pathos in Bild- und Körpersprache vorführt. Dürer verfeinert die Körpermodellierung der Aktfiguren zunehmend, wie etwa der Vergleich mit dem „Meerwunder" (Kat. Nr. 23) deutlich werden lässt.

Hercules at the Crossroads (Envy; The Large Satyr)
Ca 1498
Engraving
320 : 225 mm
Monogrammed
Watermark 158 (little tankard)

Provenance: acquired in 1802/1803 from Artaria by Ludwig X, Landgrave of Hesse. Inv. no. GR 69

Literature: Bartsch 73; Meder 63, 2 b; Hollstein 63; Schoch et al. 22.

Hercules am Scheidewege (Die Eifersucht; Der große Satyr)
um 1498
Kupferstich
320 : 225 mm
monogrammiert
Wasserzeichen 158 (Krüglein)

Herkunft: 1802/1803 über Artaria an Ludwig X. Landgraf von Hessen. Inv. Nr. GR 69

Literatur: Bartsch 73; Meder 63, 2 b; Hollstein 63; Schoch u. a. 22.

Dürer does not present us with the lacerated Man of Sorrows, streaming with blood, so typical of Late Medieval depictions of the Passion. Rather, he exploits the theme of the isolated nude figure in order to amalgamate classical formulae for pathos with Christian iconography. While the face of the figure of Christ, with his crown of thorns, expresses suffering and pain, his athletic body seems uninjured. The Savior stands alongside the Cross in a classical contrapposto pose, the vanquished instruments of his martyrdom lying at his feet. His hands, with their stigmata, are raised. This gesture – which embodies not torment, but instead redemption – conveys the essence of the Christian promise of salvation: it is a sign of sacrifice, prayer, and victory in one. By depicting Christ as an idealized and heroic nude figure, he turns toward the Italian Renaissance reception of antiquity, as embodied, for example, in the muscular nude figures of Mantegna and Giovanni Bellini.

25

Dürer zeigt nicht den blutüberströmten, geschundenen Schmerzensmann der spätmittelalterlichen Passionsdarstellungen. Vielmehr nutzt er das Thema der isolierten Aktfigur, um die antike Pathosformel mit der christlichen Ikonographie zu verschmelzen. Während das Antlitz des dornengekrönten Christus Leiden und Schmerz zum Ausdruck bringt, scheint sein athletischer Körper unversehrt zu sein. Im klassischen Kontrapost steht der Heiland am Kreuzesstamm, zu seinen Füßen liegen die überwundenen Marterwerkzeuge, die Hände mit den Wundmalen hat er erhoben. Dieser Gestus, der nicht Pein, sondern die Erlösung verbildlicht, transportiert die Summe christlicher Heilsbotschaft, er ist Opfer-, Gebets und Siegeszeichen zugleich. Indem Dürer Christus in idealer, heroischer Nacktheit vorführt, rekurriert er auf die Antikerezeption des italienischen Quattrocentos, beispielhaft verkörpert in den muskulösen Aktfiguren Mantegnas oder Giovanni Bellinis.

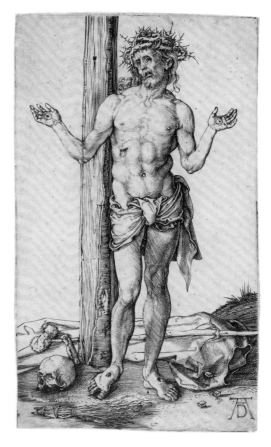

The Man of Sorrows with Outspread Arms	Der Schmerzensmann mit ausgebreiteten Armen
Ca 1500	um 1500
Engraving	Kupferstich
114 : 70 mm	114 : 70 mm
Monogrammed	monogrammiert
No watermark	ohne Wasserzeichen
Provenance: acquired in 1802/1803 from Artaria by Ludwig X, Landgrave of Hesse. Inv. no. GR 20	Herkunft: 1802/1803 über Artaria an Ludwig X. Landgraf von Hessen. Inv. Nr. GR 20
Literature: Bartsch 20; Meder 20 b; Hollstein 20; Schoch et al. 26.	Literatur: Bartsch 20; Meder 20 b; Hollstein 20; Schoch u. a. 26.

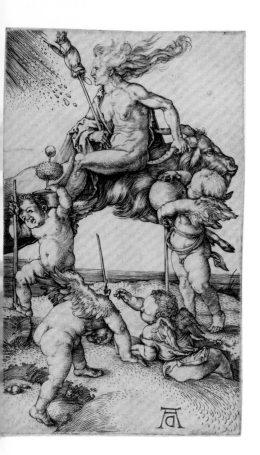

The hailstorm breaking out on the upper left identifies this naked hag – who rides through the air straddling a Billy goat and carrying a distaff – as a "weather witch." Mysterious, nonetheless, is the nature of the not yet satisfactorily deciphered activity of the quartet of winged amoretti seen below. Supported on a staff, the one on the left carries a potted plant on his back, while another performs a somersault at his feet. His neighbor reaches for his stilts, while a fourth inserts a finger into a circular vessel that is balanced on his stilt. Indispensable for an understanding of the scene are its allusions to the theme of the "World Turned Upside Down," recognizable through a number of details such as the somersault, the witch, who is seated backwards, her hair, which blows against the direction of movement, and not least Dürer's inverted monogram. This engraving has been interpreted as a moralizing embrace of classical antiquity, and has been seen as a depiction of the influence of maleficent magic on the four elements or the seasons of the year. Sexual and astrological commentary have also been proposed. The sheet's tiny dimensions must be read as a reference to its intended status. Especially when compared to the large-format depictions of witches at the time, with their atmospheres of anxiety, Dürer's little scene seems to have been meant as a playfully ironic commentary on the witch hysteria so rampant during his own lifetime.

26

Das von links oben einbrechende Unwetter mit Hagelschlag macht die nackte Alte, die rittlings mit Spinnrocken und wehenden Haaren auf einem Bock durch die Lüfte reitet, zur „Wetterhexe". Jedoch rätselhaft und bis heute nicht eindeutig entschlüsselt ist das Treiben der vier geflügelten Amoretten am Boden. Auf einen Stecken gestützt trägt der Linke eine Topfpflanze auf dem Rücken, ihm zu Füßen schlägt ein anderer einen Purzelbaum, während sein Nachbar nach seinem Stecken greift und der Vierte seine Finger in ein Kugelgefäß steckt, das er auf seinem Stecken balanciert. Wegweisend für das Verständnis des Blattes erkannte man in mehreren Details Anspielungen auf das Thema der „verkehrten Welt": der Purzelbaum, die verkehrt herum sitzende Hexe sowie ihr gegen die Bewegungsrichtung flatterndes Haar und nicht zuletzt das seitenverkehrte Dürermonogramm. Man interpretierte Dürers Kupferstich als moralisierende Antikenrezeption, sah in ihm die Verbildlichung des Einflusses des Schadenzaubers auf die vier Elemente oder Jahreszeiten, las in ihm eindeutig sexuelle oder astrologische Kommentare. Unabhängig davon muss das sehr kleine Format auch als Hinweis auf den Stellenwert des Blattes gesehen werden. Gerade im Vergleich mit anderen zeitgenössischen, großformatigen, Angst einflößenden Hexenvisionen erscheint Dürers kleiner Kupferstich wie ein spielerisch ironischer Kommentar auf den kursierenden Hexenwahn seiner Gegenwart.

The Witch	Die Hexe
Ca 1500	um 1500
Engraving	Kupferstich
116 : 72 mm	116 : 72 mm
Monogrammed with mirror reversed D	monogrammiert mit spiegelverkehrtem D
No watermark	ohne Wasserzeichen
Provenance: acquired in 1802/1803 from Artaria by Ludwig X, Landgrave of Hesse. Inv. no. GR 63	Herkunft: 1802/1803 über Artaria an Ludwig X. Landgraf von Hessen. Inv. Nr. GR 63
Literature: Bartsch 67; Meder 68, 1 a; Hollstein 68; Schoch et al. 28.	Literatur: Bartsch 67; Meder 68, 1 a; Hollstein 68; Schoch u. a. 28.

27

The theme of this engraving goes back to an account from the Golden Legend. When the Roman general Placidus tries to slay a stag during a hunt, the crucified Christ appears to him in the creature's antlers and speaks to the hunter through its mouth, saying "Eustace, why are you hunting me, believe me, I am Christ, and have long hunted for you." Placidus then converts to Christianity, taking the Greek name Eustace. The Saint – who was the patron of the hunt and numbered among the 14 auxiliary saints – enjoyed great popularity in the 15th century. The large dimensions of this work, which surpass those of Dürer's other engravings, underscore its exceptional artistic ambition. Within the overflowing wealth of forms depicted in the landscape setting, the protagonists (the kneeling saint and miraculous stag), become almost ancillary figures. In the foreground stand the horse and the hunter's five greyhounds, all but one depicted in strict profile views, almost without overlapping, and in a variety of decorative poses. All landscape details are rendered with the exactitude of precise nature studies, and viewers may have difficulty focusing on individual

motifs within such bewildering abundance. Dürer's focus here is less on modulated contour lines than on an uncommonly fine and intricate engraving technique which renders with precision the characteristics of the most diverse materials, whether animal hide, grass, water, or tree bark. Demonstrating his technical mastery here on a large scale, Dürer exalts the vastness of divine creation in an elaborate landscape that is reminiscent of a tapestry.

Das Thema geht auf einen Bericht aus der „Legenda Aurea" zurück: Als der römische Feldherr Placidus auf der Jagd einen Hirsch erlegen wollte, erschien im Geweih des Hirsches das Kreuz Christi und durch den Mund des Tieres sprach Christus zu dem Jäger: „Eustachius, was jagst du mich, glaube mir, ich bin Christus und habe lange nach dir gejagt.". Darauf bekehrte sich Placidus zum Christentum und nahm den griechischen Namen Eustachius an. Der Heilige, der als Jagdpatron zu den 14 Nothelfern zählt, genoss im 15. Jahrhundert große Popularität. Bereits das große Format, das alle anderen Kupferstiche Dürers übertrifft, unterstreicht den künstlerischen Anspruch des Blattes. Im überbordenden Formenreichtum der Naturschilderung werden die Protagonisten, der kniende Heilige und der wunderbare Hirsch, fast zur Nebensache. Im Vordergrund stehen das Pferd und die fünf Windhunde des Jägers, die Dürer bis auf eine Ausnahme in strenger Seitenansicht und ohne Überschneidungen dekorativ in verschiedenen Posen in Szene setzt. Mit derselben Genauigkeit präziser Naturstudien sind sämtliche Details der Landschaft erfasst, so dass der Betrachter die Einzelmotive in der Fülle kaum wahrnehmen kann. Dürers Augenmerk liegt weniger auf der modulierenden Konturlinie als auf einer ungemein dichten und feinen Stechtechnik, durch die er die Beschaffenheit der unterschiedlichsten Materialien, wie Fell, Gras, Wasser, Rinde, präzise abbildet. Mit stecherischer Meisterschaft im großen Format verherrlicht Dürers bildteppichartige Landschaft den Reichtum der göttlichen Schöpfung.

Saint Eustace
Ca 1501
Engraving
356 : 260 mm
Monogrammed
Watermark 158 (small tankard)

Provenance: acquired in 1802/1803 from Artaria by Ludwig X, Landgrave of Hesse. Inv. no. GR 56

Literature: Bartsch 57; Meder 60 c; Hollstein 60; Schoch et al. 32.

Der heilige Eustachius
um 1501
Kupferstich
356 : 260 mm
monogrammiert
Wasserzeichen 158 (Krüglein)

Herkunft: 1802/1803 über Artaria an Ludwig X. Landgraf von Hessen. Inv. Nr. GR 56

Literatur: Bartsch 57; Meder 60 c; Hollstein 60; Schoch u. a. 32.

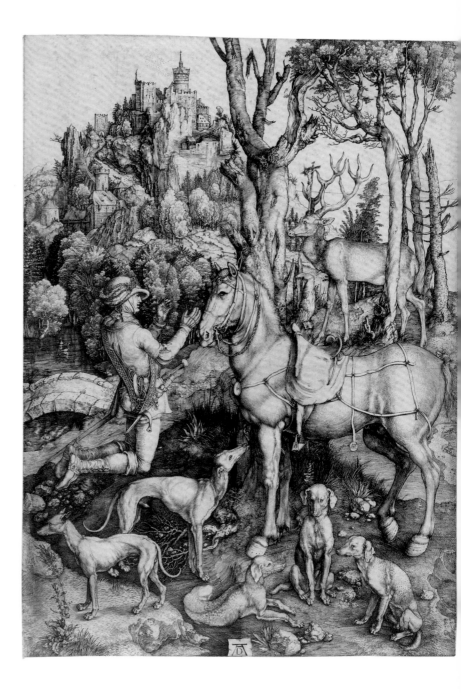

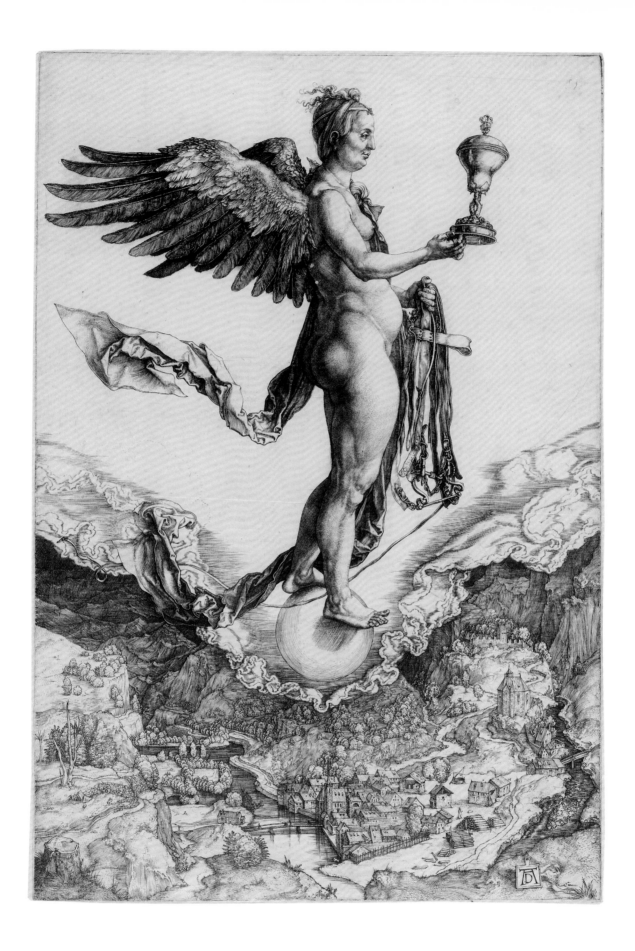

Among Dürer's engravings, only St. Eustace has larger dimensions; this makes Nemesis one of his key programmatic print works. In the journal he kept during his journey through the Netherlands, Dürer refers to the title of this engraving. In the Middle Ages, no antique images of Nemesis, the Greek goddess of fate, were known. This allowed Dürer to devise an independent creation by combining various iconographic elements, including those of Fortuna, not far distant from his own subject in thematic terms. This composition has often been related to concrete historical events. It has been seen as alluding to the defeat of Maximilian I in the 1499 war with Switzerland, and interpreted in connection with a poem by Angelo

28

Poliziano, which the poet dedicated in 1482 to Lorenzo the Magnificent. Dürer's Nemesis is a winged female nude shown standing in a strict profile on a sphere – the traditional attribute of fickle fortune – high above a panoramic landscape which has been identified as a view of hermitages in the Isarco Valley. While she presents a late–Gothic pear goblet in her right hand, her lowered left hand holds a bridle and reins, emblems of her retributive justice. Through a number of contrasting elements (articulated with particular force in the full, black exemplar from Darmstadt), Dürer heightens the goddess' monumentality. The dark, plump forms of her body stand out strongly against the pristine white paper. Her ample physique contrasts with the tiny panoramic landscape seen in the distance. In spite of her heaviness, Nemesis floats above the pale, ruffled edge of a cloudbank, which sinks downward, casting dark shadows onto the Alpine landscape. With this intrusion of the divine sphere of the heavens into the terrestrial world, Dürer returns to a pictorial structure familiar from the Apocalypse series (cat. 13–18). Apparently, Nemesis is intended as a humanistic counterpart to John's Revelations. The figure of the female nude testifies eloquently to Dürer's artistic reflections. Like the preceding sheet (cat. 27), Nemesis dates from the period of Dürer's intensive nature studies. The severe facial profile has been shaped systematically on the basis of idealized measurements and proportional studies (see Winkler p. 266). Still, the figure's thick, matronly proportions can hardly be traced back to classical prototypes. Dürer seems to want to thematize the goddess' ambivalent role between seduction and discipline. The collage of naturalistic and fantastic details typifies Dürer's novel approach to artistic creation, which occupies a transitional position between late medieval and humanistic models of the image.

Unter Dürers Kupferstichen ist nur der „Heilige Eustachius" von größerem Format, was „Nemesis" zu einem der programmatischen Hauptblätter macht. Im Tagebuch der niederländischen Reise erwähnt Dürer den Titel des Stichs. Da im Mittelalter das Bild der griechischen Schicksalsgöttin Nemesis unbekannt war, konnte Dürer eine eigene Kreation ersinnen, in die er verschiedene ikonographische Elemente, etwa die der inhaltlich nahe stehenden Fortuna einfließen ließ. Immer wieder brachte man Dürers Darstellung in Bezug zu konkreten historischen Ereignissen. Man sah darin eine Anspielung auf die Niederlage Maximilians I. im Schweizer Krieg von 1499 oder erkannte die Verbindung zu einem Gedicht von Angelo Poliziano, das er 1482 Lorenzo il Magnifico widmete. Dürers „Nemesis" steht in strenger Profilansicht als nackte geflügelte Frau auf einer Kugel, dem traditionellen Attribut des wandelbaren Glücks, hoch über einer Weltlandschaft, die sich als Ansicht von Klausen im Eisacktal identifizieren lässt. Während sie in der Rechten einen spätgotischen Birnpokal präsentiert, hält sie in der gesenkten Linken zum Zeichen ihrer ausgleichenden Gerechtigkeit Zügel und Zaumzeug. Durch mehrere gegensätzliche Faktoren, die der volle, schwarze Abdruck des Darmstädter Exemplars besonders wirkungsvoll zur Geltung bringt, steigert Dürer die Monumentalität der Göttin: Dunkel stehen ihre prallen, schweren Körperformen vor dem weißen unbearbeiteten Papier. Ihre üppige Gestalt kontrastiert zu der winzigen Überschaulandschaft in der Tiefe. Trotz ihrer Schwere schwebt „Nemesis" über dem sich kräuselnden hellen Wolkensaum, der sich mit dunklen Schatten über die Alpenlandschaft senkt. In diesem Einbrechen der göttlichen Himmelsphäre in die irdische Welt greift Dürer auf die bekannte Bildform der „Apokalypse" (Kat. Nrn. 13-18) zurück. „Nemesis" scheint als humanistisches Gegenbild zur Offenbarung des Johannes gemeint zu sein. Gerade in der weiblichen Aktfigur wird Dürers künstlerische Reflektion nachvollziehbar. Wie das vorangegangene Blatt (Kat. Nr. 27) gehört „Nemesis" technisch in die Zeit intensiver Naturstudien. Dabei verweist ihre strenge Profilansicht auf eine systematische Darstellung, die auf idealen Vermessungs- und Proportionsstudien basiert (vgl. Winkler 266). Allerdings sind die matronenhaft dicken Proportionen kaum einem antiken Ideal geschuldet. Dürer scheint damit die zwiespältige Rolle der Göttin zwischen Verführung und Disziplinierung thematisieren zu wollen. In dieser Collage aus naturalistischen und fantastischen Details liegt Dürers Neu-Schöpfung, die eine Nahtstelle zwischen Spätmittelalter und humanistischen Bildvorstellungen besetzt.

Nemesis (The Large Fortune)	Nemesis (Das große Glück)
Ca 1501	um 1501
Engraving	Kupferstich
335 : 260 mm	335 : 260 mm
Monogrammed	monogrammiert
Watermark 20 (high crown)	Wasserzeichen 20 (Hohe Krone)
Provenance: acquired in 1802/1803 from Artaria by Ludwig X, Landgrave of Hesse. Inv. no. GR 73	Herkunft: 1802/1803 über Artaria an Ludwig X. Landgraf von Hessen. Inv. Nr. GR 73
Literature: Bartsch 77; Meder 72, 2 a; Hollstein 72; Schoch et al. 33.	Literatur: Bartsch 77; Meder 72, 2 a; Hollstein 72; Schoch u. a. 33.

29

Beginning in the 15th century, engravers were often commissioned with depicting escutcheons, and Dürer too executed a number of them. His engraving of 1503 was intended to recreate and revive heraldic formal language. He unites a variety of motifs, among them the disparate couple, death and the maiden, and the dance of death. From them, Dürer devises a striking memento mori, one referring to the ephemerality of youthful beauty and worldly status symbols. This vanitas allegory has been perceived as alluding on a number of different levels to current historical events in Nuremberg. Yet the composition with escutcheon may have served the 32–year–old Dürer primarily as a showpiece, allowing him to display his technical virtuosity. Only brilliant early impressions such as the present one display his burin work in all its fineness and subtlety. A flexible graphic vocabulary permits Dürer to model objects in three dimensions while rendering various materials in a highly nuanced manner.

Seit dem 15. Jahrhundert sind Wappendarstellungen unter Stechern eine viel geübte Aufgabe, die auch Dürer mehrfach ausgeführt hat. Mit seinem Kupferstich des Jahres 1503 intendiert er eine Neuschöpfung und Belebung der heraldischen Formensprache. Er verbindet verschiedene Themenkomplexe, wie das ungleiche Paar, den Tod und das Mädchen, als auch Motive des Totentanzes. Daraus gestaltet Dürer ein eindrucksvolles Memento mori, das auf die Vergänglichkeit jugendlicher Schönheit und weltlicher Statussymbole verweist. Verschiedentlich wurden in Dürers Vanitasallegorie aktuelle Anspielungen auf historische Geschehnisse in Nürnberg gesehen. Doch dürfte das Wappenblatt in erster Linie als Schaustück für die technische Virtuosität des 32jährigen Dürers gedient haben. Nur die brillanten frühen Abdrucke, wie der vorliegende, zeigen die Arbeit des Grabstichels in all ihrer Feinheit und Dichte. Dank seines graphischen Vokabulars gelingt es Dürer auf einzigartige Weise, Gegenstände plastisch zu modellieren und ihre Materialien differenziert zu beschreiben.

Coat of Arms with a Death's Head	Das Wappen mit dem Totenkopf
1503	1503
Engraving	Kupferstich
220 : 160 mm	220 : 160 mm
Monogrammed, dated	monogrammiert, datiert
Watermark 20 (high crown)	Wasserzeichen 20 (Hohe Krone)
Provenance: acquired in 1802/1803 from Artaria by Ludwig X, Landgrave of Hesse. Inv. no. GR 95	Herkunft: 1802/1803 über Artaria an Ludwig X. Landgraf von Hessen. Inv. Nr. GR 95
Literature: Bartsch 101; Meder 98 a; Hollstein 98; Schoch 37. Antwerp 1970, 51.	Literatur: Bartsch 101; Meder 98 a; Hollstein 98; Schoch 37. Antwerpen 1970, 51.

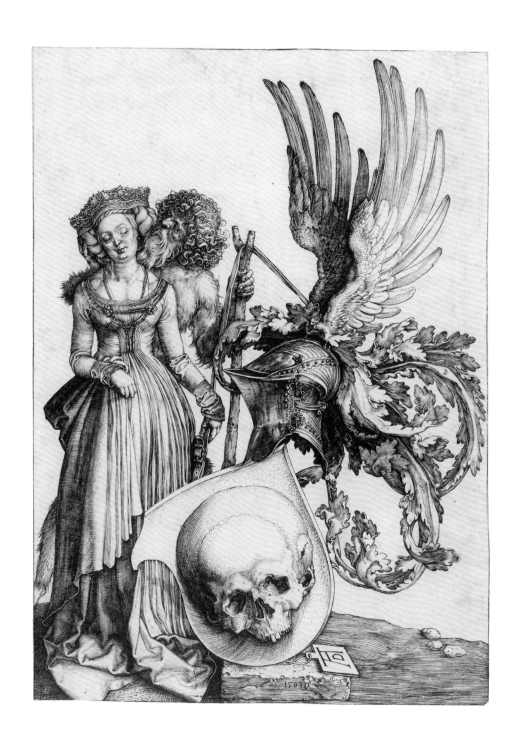

No other saint was depicted more frequently by Dürer (see cat. 66). With his images of St. Christopher, executed in a variety of techniques, formats, media, and hence varying costs, Dürer met the demand for images of saints, whose popularity reached a

30

highpoint in the 15th and 16th centuries. Whoever gazed in the morning upon an image of St. Christopher – who numbered among the 14 auxiliary saints – was said to enjoy protection against fatal accidents for the rest of the day. Originating in the 13th century, the legend of the giant Christopher recounts how he served God by carrying pilgrims across a raging river. When doing so, he met Christ, who had taken the guise of a child. Burdened by the child's growing weight, Christopher nearly collapses into the turbulent waters. Once they have reached the opposite shore, Christ reveals himself, instructing Christopher to bury one end of his walking staff in the ground. The next morning, it began to put out green, living shoots. Dürer's woodcut shows Christopher wading into the river bearing Christ (seen here as a child) on his shoulders. On the far side of the river glows the lantern of the hermit whose counsel prompted the giant to take up his task. Doubtless, this print was available cheaply, for its theme is elaborated in fairly simple terms. In order to effectively heighten the drama, Dürer requires just a few details, including the billowing garments, their movements echoed by the migrating birds. The presence on the wooden block of these small elements representing a flock of birds prevented the paper from sinking into the indentations of the sky zone, thereby ensuring a trouble-free printing process and allowing production of a larger print run.

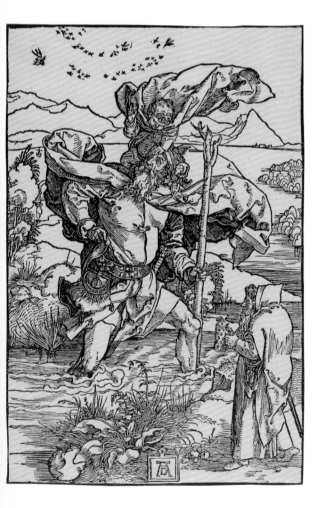

St. Christopher with the Bird
Migration
Ca 1503/04
Woodcut
210 : 140 mm
Monogrammed
No watermark

Provenance: acquired in 1802/1803 from Artaria by Ludwig X, Landgrave of Hesse. Inv. no. GR 289

Literature: Bartsch 104; Meder 222 a; Hollstein 222; Schoch et al. 133.

Der heilige Christophorus mit dem Vogelzug
um 1503/04
Holzschnitt
210 : 140 mm
monogrammiert
ohne Wasserzeichen

Herkunft: 1802/1803 über Artaria an Ludwig X. Landgraf von Hessen. Inv. Nr. GR 289

Literatur: Bartsch 104; Meder 222 a; Hollstein 222; Schoch u. a. 133.

Keinen anderen Heiligen stellte Dürer häufiger dar (vgl. Kat. Nr. 66). Mit seinen Christophorus-Bildern in unterschiedlichen Techniken, Formaten, Ausführungen und damit auch Preisklassen entsprach Dürer der Nachfrage nach Bildern des Heiligen, dessen Popularität im 15. und 16. Jahrhundert einen Höhepunkt erreichte. Der morgendliche Blick auf das Bild des zu den 14 Nothelfern zählenden Christophorus sollte den Tag über vor tödlichen Unfällen schützen. Die Heiligenlegende entstand im 13. Jahrhundert und erzählt, dass der Riese Christophorus Gott dadurch diente, dass er Pilger durch einen reißenden Fluss trug. Dabei traf er auf Christus, verborgen in der Gestalt eines Kindes. Unter der Last des Kindes drohte Christophorus im tosenden Fluss zusammenzubrechen. Am anderen Ufer offenbarte sich Christus und befahl ihm seinen Stab in den Boden zu stecken, dieser war am nächsten Morgen ergrünt. Dürers Holzschnitt zeigt Christophorus, der mit dem Christuskind unter Mühen durch den Fluss watet. Mit einer Laterne leuchtet vom anderen Ufer der Einsiedler, auf dessen Rat der Riese zu seiner Aufgabe gefunden hatte. Das Blatt war zweifellos wohlfeil zu erwerben, denn die bildliche Ausgestaltung des Themas ist relativ schlicht. Gekonnt sind wenige Details genutzt, um die Dramatik der Szene zu unterstreichen, etwa die stark gebauschten Gewänder, deren Bewegung vom Vogelzug aufgegriffen wird. Dank der kleinen, auf der Holzplatte stehenden Elemente, die den Vogelschwarm bilden, sank das Papier beim Druck nicht in die großen, tief liegenden Flächen der Himmelszone ein, was einen reibungslosen Druckverlauf und damit eine hohe Auflage des Andachtsbildes gewährleistete.

This engraving occupies a key position vis-à-vis Dürer's reception of classical antiquity and the Italian Renaissance. Dürer shows Apollo intent upon the act of aiming and releasing an arrow at an unseen target. His athletic form – which threatens to burst the boundaries of the small composition – echoes the curved shape of his bow. The energetic movements of the sun god are further heightened by his windblown hair and by the fluttering end of his garment. Seated at Apollo's feet, her body soft and girlish, is his sister Diana. She gently strokes the stag she has coaxed with a handful of grass. Also surviving is an engraving bearing the same title by Jacopo de' Barbari, a recognized theoretician of human proportions who lived in Nuremberg between 1500 and 1503. He shows the planetary god in a celestial sphere adopting the pose of the Apollo Belvedere, while his sister is seen from the back. Engaging now in artistic competition with de' Barbari, Dürer realizes the theme of the ideally proportioned nude figure in a way that is far more earthbound. His Apollo and Diana are human beings of flesh and blood rather than cosmic, luminous entities. Using a highly nuanced engraving technique, Dürer not only differentiates with precision the differing appearances of the male and female nudes, but also effectively characterizes their gender roles: Apollo's lust for action contrasts with Diana's dreamy passivity.

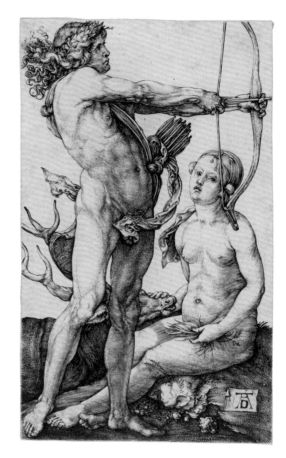

31

Der Kupferstich nimmt eine Schlüsselstellung in Dürers Auseinandersetzung mit der Antike und der italienischen Renaissance ein. Dürer zeigt Apollo in Konzentration auf das zielgenaue Ausrichten eines Schusses. Sein athletischer Körper, der den kleinen Bildausschnitt zu sprengen scheint, wiederholt die Biegung des Bogens. Wehendes Haar und flatternder Gewandzipfel unterstreichen die energische Bewegung des Sonnengottes zusätzlich. Ihm zu Füßen sitzt seine Schwester Diana mit mädchenhaft weichen Körperformen. Sanft streichelt sie einen Hirsch, den sie mit einem Grasbüschel angelockt hat. Von Jacopo de'Barbari, der von 1500-1503 in Nürnberg lebte und ein anerkannter Theoretiker der menschlichen Proportionsstudien war, existiert ein gleichnamiger Kupferstich. Er zeigt in einer Himmelssphäre den Planentengott in der Pose des Apolls vom Belvedere und seine Schwester Diana als Rückenfigur. Im künstlerischen Wettstreit mit Jacopo de'Barbari setzt Dürer das Thema der idealproportionierten Aktfigur mit seinem Kupferstich weit diesseitsbezogener um. Sein Apollo und seine Diana sind weniger kosmische Lichtgestalten als vielmehr Menschen aus Fleisch und Blut. Mit einer sehr feinen Stechtechnik differenziert Dürer nicht nur präzise das unterschiedliche körperliche Erscheinungsbild des männlichen und weiblichen Akts, sondern charakterisiert auch die Rollen der Geschlechter, aktiver Tatdrang bei Apollo steht gegen das passive Träumen bei Diana.

Apollo and Diana	Apollo und Diana
Ca 1503/04	um 1503/04
Engraving	Kupferstich
115 : 70 mm	115 : 70 mm
Monogrammed	monogrammiert
No watermark	ohne Wasserzeichen
Provenance: acquired in 1802/1803 from Artaria by Ludwig X, Landgrave of Hesse. Inv. no. GR 64	Herkunft: 1802/1803 über Artaria an Ludwig X. Landgraf von Hessen. Inv. Nr. GR 64
Literature: Bartsch 68; Meder 64 a; Hollstein 64; Schoch et al. 38.	Literatur: Bartsch 68; Meder 64 a; Hollstein 64; Schoch u. a. 38.

The brilliance of this version of the print makes it clear that Dürer took advantage of the theme in order to showcase his technical virtuosity, capable now of the finest modulations, in a tour de force of the art of engraving. In his representation of the Fall from Grace, psychological and narrative elements retreat in favor of the complex pictorial program through which Dürer certifies his artistic ambitions just a year before his second journey to Venice. The first human couple is shown standing without overlapping against a dark forest background. The radiant white of the flesh is reminiscent of marble statues. The model for Adam is the Apollo Belvedere, while the pale, alabaster–like form of Eve varies the pose of the Venus de Medici. Encouraged by the treacherous serpent, Eve offers the forbidden fruit from the Tree of Knowledge to Adam, who grasps a branch of a mountain ash – a symbol of life – for support. Hanging from this branch is a tablet containing Dürer's signature in Latin, watched over by a parrot, here emblematizing wisdom. The explosiveness and danger of Adam's decision is suggested by the distant view of a mountain goat preparing to leap from a rocky cliff into the depths. Visible in the twilight setting are a variety of creatures, interpretable in a number of ways based on the intricate iconography of animals. Among them are an elk, an ox, a hare, and a cat. According to medieval teachings of the "four humors," this quartet emblematizes the Four Temperaments, namely the Melancholic, Phlegmatic, Sanguine, and Choleric types. By placing a mouse in front of Adam's feet, and hence directly in front of the cat, Dürer alludes playfully to the tension between the sexes. The feline has yet to attack; despite the evidence of tragedy, a paradisiacal condition still prevails. The idealized proportions of the nude figures were constructed according to Vitruvius' classical canon. Beginning in 1500, Dürer worked with precise measurements in an attempt to establish the laws of proportions for representing the human form. Having begun in the period of his first Italian journey in 1495, Dürer's studies in proportion now acquire a new quality. In his Adam and Eve, the nudity of the progenitors of humankind is not a defect, but instead a result of the artist's powers of reason. Also surviving are various drawings which served as preparatory studies for the execution of this engraving (Winkler 333-336).

32

Die Brillanz des vorliegenden Abzugs verdeutlicht, dass Dürer das Thema nutzt, um mit der Modulation feinster Stichlagen ein stecherisches Meisterstück vorzulegen. In der Darstellung des Sündenfalls treten erzählerische oder psychologische Momente zurück zugunsten eines komplexen Bildprogramms, mit dem Dürer ein Jahr vor seiner zweiten Reise nach Venedig seinen künstlerischen Anspruch untermauert. Ohne Überschneidung hat Dürer das erste Menschenpaar vor das Dunkel des Waldes gestellt. Das strahlende Weiß ihres Inkarnats erinnert an Marmorfiguren: Vorbild für Adam ist der „Apoll vom Belvedere", der noch hellere „Alabasterleib" der Eva variiert das Haltungsschema der „Venus von Medici". Unterstützt durch die listige Schlange reicht Eva die verbotene Frucht vom Baum der Erkenntnis an Adam, der sich haltsuchend an den Ast der Bergesche, Symbol des Lebens, klammert. Hier hängt Dürers Signaturtafel in lateinischer Sprache, bewacht vom Papagei, als Sinnbild der Weisheit. Die Brisanz und Gefahr von Adams Entscheidung verbildlicht der Ausblick in die Ferne, wo auf einem Felsen eine Bergziege zum Sprung in die Tiefe angesetzt hat. Im Dämmerlicht des Waldes bewegt sich allerlei Getier, wobei die vielschichtige Typologie der Tierwelt-Ikonographie eine Fülle von Interpretationsmöglichkeiten eröffnet. Erwähnt seien Elch, Rind, Kaninchen und Katze, die nach der mittelalterlichen Lehre für die „vier Säfte des Lebens" stehen und die vier Temperamente verkörpern: den Melancholiker, den Phlegmatiker, den Sanguiniker und den Choleriker. Indem Dürer eine Maus vor Adams Füße und damit vor die Katze setzt, verweist er spielerisch auf die Spannung zwischen den Geschlechtern. Die Katze hat noch nicht zugepackt, noch herrscht ein paradiesischer Zustand, doch wird das tragische Ende nicht ausbleiben. Die idealen Proportionen der Aktfiguren von Adam und Eva sind nach dem klassischen Kanon des Vitruv konstruiert. Seit 1500 arbeitet Dürer mit exakten Vermessungen, um die Gesetzte für die Maßverhältnisse des menschlichen Körpers zu ergründen. Damit gewinnen Dürers Proportionsstudien, deren Anfänge in der Zeit der ersten Italienreise 1495 liegen, eine neue Qualität. In Dürers Sündenfall ist die Nacktheit des ersten Menschenpaares kein Makel, sondern Ergebnis der schöpferischen Vernunft des Künstlers. Verschiedene Zeichnungen haben sich als unmittelbare Vorarbeiten Dürers zu „Adam und Eva" erhalten (Winkler 333-336).

Adam and Eve
1504
Engraving
251 : 190 mm
On the signature tablet: ALBERT 9/DVRER/NORICUS/FACIEBAT/ [Dürer's monogram] 1504
Watermark 62 (oxhead)

Provenance: acquired in 1802/1803 from Artaria by Ludwig X, Landgrave of Hesse. Inv. no. GR 1

Literature: Bartsch 1; Meder 1, 2 a; Hollstein 1; Schoch et al. 39.

Adam und Eva
1504
Kupferstich
251 : 190 mm
Auf dem Signaturtäfelchen: ALBERT 9/DVRER/ NORICUS/FACIEBAT/ [Dürermongramm].1504
Wasserzeichen 62 (Ochsenkopf)

Herkunft: 1802/1803 über Artaria an Ludwig X. Landgraf von Hessen. Inv. Nr. GR 1

Literatur: Bartsch 1; Meder 1, 2 a; Hollstein 1; Schoch u. a. 39.

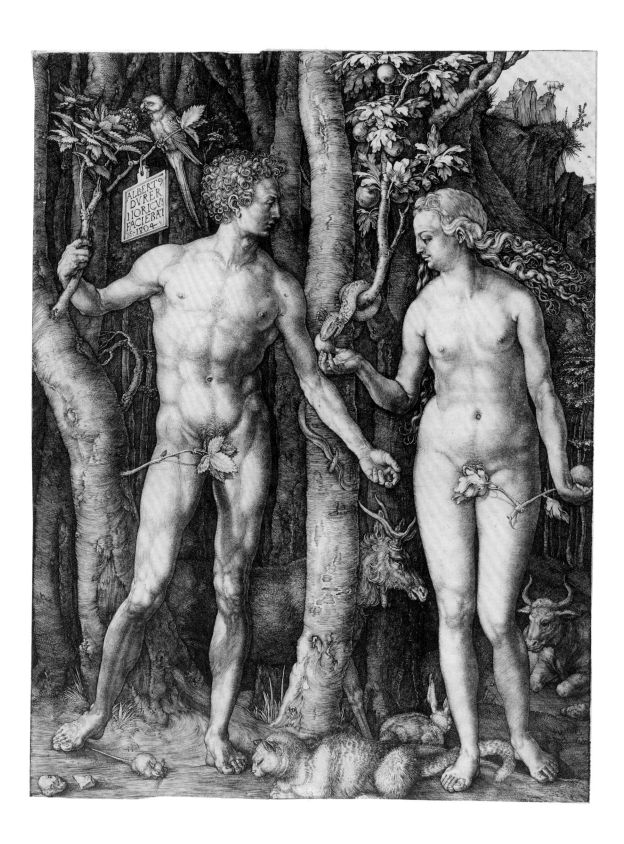

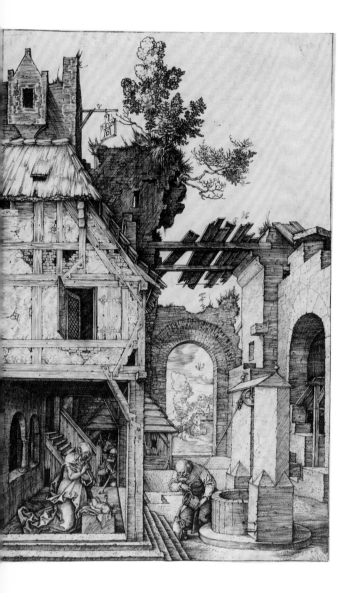

In this devotional image, Dürer combines various architectural elements into an imposing setting. The Christmas drama plays itself out in the interior of a steeply ascending structure almost like an ancillary scene. Many details are interpretable in Christological terms: the building's interior signals the collapse of the Old Covenant, while the freshly sprouting foliage heralds the new beginning brought about by the birth of the Christ child. The well can be read as a Marian symbol, its pure water an allusion to the Sacrament of Baptism. The sensitive depiction of the events places the scene – interpretable as a New Year's greeting on the basis of the panel suspended above, which contains the year and the artist's monogram – in close proximity to the Life of the Virgin (cat. 45 – 53).

Dürer nutzt das Andachtsbild zur Kombination unterschiedlicher architektonischer Versatzstücke, aus denen er eine imposante Bühne konstruiert. Gleich einer nebensächlichen Staffage spielt im Innern des hochaufragenden Ensembles die Weihnachtsszene. Viele Details sind christologisch zu deuten: So künden die Gebäuderuinen vom Zerbrechen des alten Bundes, während die frisch sprießenden Blätter auf den Neubeginn durch das neugeborene Christuskind verweisen. Der Brunnen ist als Mariensymbol und sein reines Wasser als Anspielung auf das Sakrament der Taufe lesbar. Die gefühlvolle Schilderung des Geschehens rückt den Stich, der wegen der über der Szene hängenden Tafel mit Jahreszahl und Monogramm auch als Neujahrsgruß interpretiert wurde, in die Nähe des „Marienlebens" (vgl. Kat. Nrn. 45-53).

The Birth of Christ	Die Geburt Christi
1504	1504
Engraving	Kupferstich
183 : 120 mm	183 : 120 mm
Monogrammed, dated	monogrammiert, datiert
Watermark 62 (oxhead)	Wasserzeichen 62 (Ochsenkopf)
Provenance: acquired in 1802/1803 from Artaria by Ludwig X, Landgrave of Hesse. Inv. no. GR 2	Herkunft: 1802/1803 über Artaria an Ludwig X. Landgraf von Hessen. Inv. Nr. GR 2
Literature: Bartsch 2; Meder 2 b; Hollstein 2; Schoch et al. 40.	Literatur: Bartsch 2; Meder 2 b; Hollstein 2; Schoch u. a. 40.

34

As recounted in the Golden Legend, Mary Magdalene went into the wilderness intending to do penance for her sinful life. She remained there for a period of 30 years, where she survived without earthly sustenance, cared for by angels. Every day at the hours of prayer, she was borne aloft by the angels, allowing her to listen to the songs of the heavenly hosts with her own ears. The cutting technique of this block is less virtuosic than that of the woodcut Samson Slaying the Lion (cat. 19), for example, yet the composition realizes its theme convincingly. Encircled and lifted heavenward by the angels, the saint's nude form, which resembles a flower, is shown against a pale landscape that is indicated by just a few lines. With this woodcut too, Dürer accommodates the demand for affordable devotional images. As a rule, such relatively simple images (see cat. 30) were executed by workshop assistants. As master artist, of course, Dürer assumed responsibility for each composition, as certified by his monogram, here taking the form simultaneously of trademark and seal of approval.

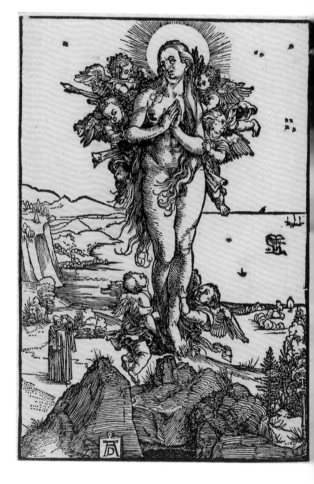

Wie die „Legenda Aurea" berichtet, ging Maria Magdalena, um ihr sündiges Leben zu büßen, in die Wildnis, wo sie für dreißig Jahre von Engeln umsorgt wurde, so dass sie ohne jegliche irdische Nahrung auskam. Täglich zu den sieben Gebetsstunden entrückten die Engel die Heilige in die Lüfte, damit sie dem Gesang der himmlischen Heerscharen mit eigenen Ohren lauschen konnte. Die Schnitttechnik des Blatts ist weniger virtuos als etwa bei dem Holzschnitt „Samson tötet den Löwen" (Kat. Nr. 19), gleichwohl bringt die Komposition das Thema überzeugend zur Umsetzung. Vom Reigen der Engel empor getragen entfaltet sich die nackte Gestalt der Heiligen gleich einer Blume vor der hellen, mit wenigen Linien fixierten Landschaft. Auch mit diesem Blatt bediente Dürer die Nachfrage nach preisgünstigen Andachtsbildern. Diese in der Ausführung eher schlicht gestalteten Werke (vgl. Kat. Nr. 30) waren meist Produkte von Werkstattmitarbeitern. Dass Dürer als Meister selbstverständlich auch für diese Arbeiten die Verantwortung und den Vertrieb übernahm, belegt sein Monogramm, das hier als Schutzmarke und Gütesiegel zugleich fungiert.

The Ecstasy of St. Mary
Magdalene
Ca 1504/05
Woodcut
213 : 144 mm
Monogrammed
Watermark 169 (scales in circle)

Provenance: acquired in
1802/1803 from Artaria by
Ludwig X, Landgrave of Hesse.
Inv. no. GR 3152

Literature: Bartsch 121; Meder
237 c; Hollstein 237; Schoch et
al. 139.

Die Verzückung der heiligen
Maria Magdalena
um 1504/05
Holzschnitt
213 : 144 mm
monogrammiert
Wasserzeichen 169 (Waage im
Kreis)

Herkunft: 1802/1803 über
Artaria an Ludwig X. Landgraf von
Hessen.
Inv. Nr. GR 3152

Literatur: Bartsch 121; Meder 237
c; Hollstein 237; Schoch u. a. 139.

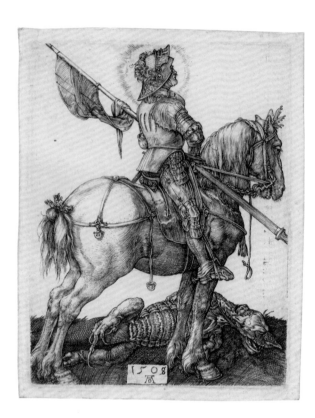

St. George became popular in the Middle Ages through the Golden Legend. For this composition, Dürer chooses the humanistic type of saintly image that came into fashion around 1500. Unlike medieval versions, this print does not show the dragon slayer in action, but instead after combat, as a victorious hero. Shown mounted on his horse and glorying in his triumph over the vanquished serpent, the figure of St. George, seen diagonally and from the rear, fills the space of the page. In grateful communion with God, the devout knight raises his eyes to gaze into the distance. Like the engravings The Small Horse (cat. 36) and The Large Horse (cat. 37), this small image is an outgrowth of Dürer's studies in equine proportion. Dürer subsequently changed the date of the sheet from 1505 to 1508. It is believed he did so to clearly position St. George chronologically after the two studies of horses, both executed in 1505.

35

Durch die „Legenda Aurea" war der heilige Georg im Mittelalter populär geworden. Jedoch wählt Dürer bei seiner Darstellung das um 1500 neu in Mode gekommene, humanistische Bild des Heiligen, das den Drachentöter nicht wie im Mittelalter in Aktion, sondern als siegreichen Helden nach dem Kampf zeigt. Den Blattraum ausfüllend schräg von hinten gesehen triumphiert der heilige Georg auf seinem Pferd über den erlegten Drachen. In dankbarer Zwiesprache mit Gott richtet der gläubige Ritter seinen Blick in die Ferne. Wie die Kupferstiche „Das Kleine Pferd" (Kat. Nr. 36) und „Das Großen Pferd" (Kat. Nr. 37) ist das kleine Heiligenbild Ausdruck von Dürers Proportionsstudien zu Pferden. Im Nachhinein korrigierte Dürer das Datum von 1505 auf 1508. Man vermutete, dass Dürer damit dem Reiterheiligen in der Chronologie seiner Stiche zu Pferdeproportionen eine Position deutlich nach seinen zwei Pferdedarstellungen der Jahre 1505 zuweisen wollte.

St. George on Horseback
1505/08
Engraving
106 : 83 mm
Monogrammed, dated: 1508
(corrected from 1505)
No watermark
Reverse bears an old inscription
in brown ink: P. Mariette 1663

Provenance: Pierre Mariette
Collection, Paris; acquired in
1802/1803 from Artaria by
Ludwig X, Landgrave of Hesse.
Inv. no.: GR 53

Literature: Bartsch 54; Meder 56
b-c; Hollstein 56; Schoch et al. 41.
Antwerp 1970, 72.

Der heilige Georg zu Pferd
1505/08
Kupferstich
106 : 83 mm
monogrammiert, datiert: 1508
(korrigiert aus 1505)
ohne Wasserzeichen
Rückseite alt bezeichnet mit Tinte
in Braun: P. Mariette 1663

Herkunft: Sammlung Pierre
Mariette, Paris; 1802/1803 über
Artaria an Ludwig X. Landgraf von
Hessen.
Inv. Nr.: GR 53

Literatur: Bartsch 54; Meder 56
b-c; Hollstein 56; Schoch u. a. 41.
Antwerpen 1970, 72.

Beginning in 1500, concurrently with his proportional studies of the human nude (see cat. 32), Dürer also undertook studies devoted to the systematized representation of horses. His mathematical construction of the equine form is oriented toward Leonardo da Vinci's studies, where the length of the animal's head forms the basis of an ideal figure. In the Small Horse, conceived as a counterpart to the Large Horse (see cat. 37), the length of the body is equal to three heads. Seen in a strict profile view, its right hoof raised, the splendid animal is set against the imposing frame formed by a stone archway that is shown in a perspective view. In this exemplary version from Darmstadt, Dürer engraved the dark stonework using strictly parallel and crosshatched lines, very much in contrast to the muscular body of the horse. Pulsing with life, it is modeled using fine parallel arcs and delicate dotting. The proudly raised head, glossy coat, and whinnying mouth suggest that the stallion is bursting with health and vitality. Striding alongside and behind the animal is an armed knight with a fantastic helmet and winged shoes. This figure has prompted speculations that the scene must be something more than a model for ideal depictions of horses, perhaps even a depiction of Perseus, Mercury, or Alexander the Great.

Parallel zu den Proportionsstudien der menschlichen Aktfigur (vgl. Kat. Nr. 32) unternahm Dürer seit 1500 auch Studien zur Systematisierung der Darstellung des Pferdes. Die mathematische Konstruktion des Pferdes orientiert sich an Proportionsstudien Leonardo da Vincis, wobei die Kopflänge des Pferdes die Grundlage seiner Idealfigur angibt. Beim „Kleinen Pferd", das als Gegenstück zu dem „Großen Pferd" (Kat. Nr. 37) konzipiert wurde, wird die Körperlänge aus der dreifachen Kopflänge gebildet. In strenger Profilansicht mit erhobener rechter Vorderhand steht das prächtige Warmblut vor dem imposanten Rahmen einer perspektivisch angelegten Bogenarchitektur. Wie der vorzügliche Darmstädter Abdruck erkennen lässt, hat Dürer das dunkle Mauergestein aus strengen Parallel- und Kreuzschraffen gestochen, ganz im Gegensatz zu dem muskulösen von pulsierendem Leben durchdrungenen Pferdekörper, den er aus feinen Parallelbögen und zarten Punktierungen modelliert hat. Wie der stolz erhobene Kopf, das glänzende Fell und das flehende Maul schließen lassen, strotzt der Hengst vor Gesundheit und Kraft. Hinter dem eleganten Tier schreitet ein bewaffneter Ritter mit phantastischem Helm und geflügelten Schuhen, der Anlass gab, die Szene außer als Musterblatt idealer Pferdedarstellung auch mythologisch, als Perseus, Merkur oder Alexander den Großen, zu deuten.

The Small Horse 1505 Engraving 163 : 118 mm Monogrammed, dated Watermark 62 (oxhead) Provenance: acquired in 1802/1803 from Artaria by Ludwig X, Landgrave of Hesse. Inv. no. GR 91 Literature: Bartsch 96; Meder 93 a; Hollstein 93; Schoch et al. 42.	Das Kleine Pferd 1505 Kupferstich 163 : 118 mm monogrammiert, datiert Wasserzeichen 62 (Ochsenkopf) Herkunft: 1802/1803 über Artaria an Ludwig X. Landgraf von Hessen. Inv. Nr. GR 91 Literatur: Bartsch 96; Meder 93 a; Hollstein 93; Schoch u. a. 42.

The Large Horse
1505
Engraving
166 : 119 mm
Monogrammed, dated
Watermark 62 (oxhead)

Provenance: acquired in
1802/1803 from Artaria by
Ludwig X, Landgrave of Hesse.
Inv. no. GR 92

Literature: Bartsch 97; Meder 94
a; Hollstein 94; Schoch et al. 43.

Das Große Pferd
1505
Kupferstich
166 : 119 mm
monogrammiert, datiert
Wasserzeichen 62 (Ochsenkopf)

Herkunft: 1802/1803 über
Artaria an Ludwig X. Landgraf von
Hessen.
Inv. Nr. GR 92

Literatur: Bartsch 97; Meder 94 a;
Hollstein 94; Schoch u. a. 43.

While Dürer's Small Horse (cat. 36) shows a stallion in an idealized profile view, his Large Horse is rendered in a demanding foreshortened perspective. The massive form of this powerful heavy horse, seen at an angle from behind, seems almost to burst the boundaries of the composition. A nuanced play of lines is used to underscore the sturdy musculature beneath the animal's glossy coat. A typical warhorse of the period, it wears a stable halter and is led by a halberdier in fantastic attire. As in the case of the Small Horse, various pictorial elements have given rise to interpretations based on mythology, with the knight identified as Hercules, or the horse as Bucephalos, Alexander the Great's favorite steed. The realism of Dürer's Large and Small Horse, engraved before the artist's second Italian journey, set a standard for numerous Italian imitators.

Wird im „Kleinen Pferd" (Kat. Nr. 36) der Hengst in idealer Profilansicht erfasst, so gibt Dürer das „Große Pferd" in anspruchsvoller Verkürzung wieder. Der von schräg hinten gesehene massige Leib des mächtigen Kaltblüters scheint das Blattformat zu sprengen. Differenzierte Stichlagen unterstreichen die prallen Muskelpakete unter dem glänzenden Fell. Das typische Kampfpferd der Zeit trägt ein Stallhalfter und wird von einem phantastisch gewandeten Hellebardenträger begleitet. Wie beim „Kleinen Pferd" gaben auch hier die Bildelemente Anlass zu mythologischen Deutungsversuchen, man sah in der Konstellation eine Herkulesszene oder wiederum Bukephalos, das Lieblingspferd Alexanders des Großen. Unabhängig davon dürfte der Realismus dieser Pferdedarstellung, die Dürer wie das „Kleine Pferd" vor seiner zweiten italienischen Reise gestochen hatte, maßgeblich gewesen sein, dass das „Große Pferd" etliche italienische Nachahmer fand.

37

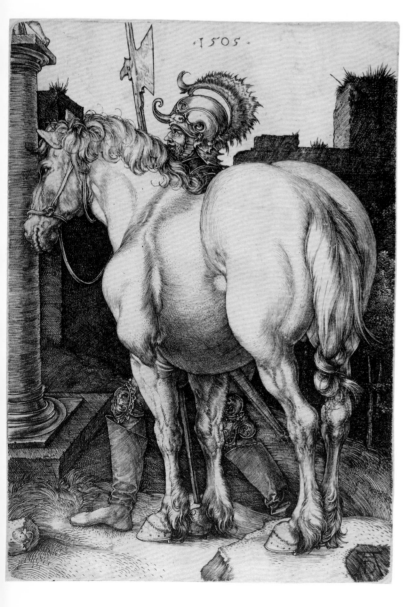

Shortly before his second Italian journey, and doubtless with some awareness of the preferences of his Italian target public, Dürer executed this engraving, based on the pagan natural deities of antiquity. This richly burred exemplar from Darmstadt endows the composition with a special luminosity. Set against the dark undergrowth of the forest, a goat-legged satyr blows into his shawm. Reclining at his feet is a nude woman who holds a child tenderly in her lap with her left hand, her right holding a gnarled tree branch. Particularly in contrast to the shaggy animal pelt upon which she is seated, her skin appears pale and smooth. Although her human form identifies her as a nymph, the scene has not been related to any specific mythological narrative. Erwin Panofsky perceived in The Satyr's Family a "nostalgia for the idyllic," and interpreted the sheet as a counterpart to one having equal dimensions, Dürer's Apollo and Diana (cat. 31), which he interpreted as embodying a "nostalgia for the Olympian" (Panofsky 1955, p. 87). For Rainer Schoch (Schoch et al. 44), this small sheet, with its depiction of an originary and paradisiacal existence, is first and foremost an outgrowth, both artistically and in terms of content, of the engraving Adam and Eve (cat. 32).

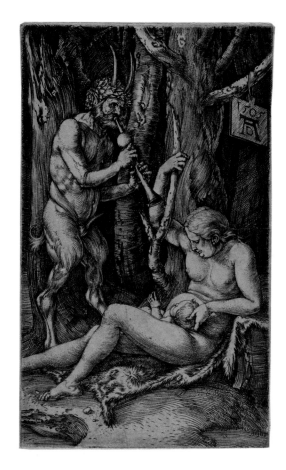

Zweifellos in Kenntnis der Vorlieben seines italienischen Zielpublikums entwickelte Dürer kurz vor seiner zweiten Italienreise den Kupferstich mit heidnischen Naturgottheiten der Antike. Der gratreiche frühe Abzug des Darmstädter Exemplars verleiht dem Blatt eine besondere Leuchtkraft. Vor dem dunklen Dickicht des Waldes bläst ein bocksbeiniger Satyr die Schalmei. Ihm zu Füßen ruht eine Nackte, die in ihrem Schoß zärtlich mit der Linken ein Kind hält, während ihre Rechte den knorrigen Ast eines Baumes umfasst. Gerade im Gegensatz zu dem zotteligen Tierfell, auf das sie sich gebettet hat, erscheint ihre Haut hell und glatt. Auch wenn ihre menschliche Gestalt sie als Nymphe auszeichnet, lässt sich der Szene keine konkrete mythologische Erzählung zuweisen. Erwin Panofsky sah in der „Satyrfamilie" die „Sehnsucht nach dem Idyllischen", und deutete sie als Gegenstück zu dem gleich großen Blatt „Apollo und Diana" (Kat. Nr. 31), das er als „die Sehnsucht nach dem Olympischen" interpretierte (Panofsky 1977, S. 117). Für Rainer Schoch (Schoch u. a. 44) ist das kleine Blatt, das die ursprüngliche, paradisische Existenz darstellt, in erster Linie ein künstlerisches wie inhaltliches „Nebenprodukt" des programmatischen Stiches „Adam und Eva" (Kat. Nr. 32).

Satyr and Nymph (The Satyr's Family) 1505 Engraving 116 : 71 mm Monogrammed, dated Watermark 62 (oxhead)	Satyr und Nymphe (Die Satyrfamilie) 1505 Kupferstich 116 : 71 mm monogrammiert, datiert Wasserzeichen 62 (Ochsenkopf)
Provenance: acquired in 1802/1803 from Artaria by Ludwig X, Landgrave of Hesse. Inv. no. GR 65	Herkunft: 1802/1803 über Artaria an Ludwig X. Landgraf von Hessen. Inv. Nr. GR 65
Literature: Bartsch 69; Meder 65 a; Hollstein 65; Schoch et al. 44.	Literatur: Bartsch 69; Meder 65 a; Hollstein 65; Schoch u. a. 44.

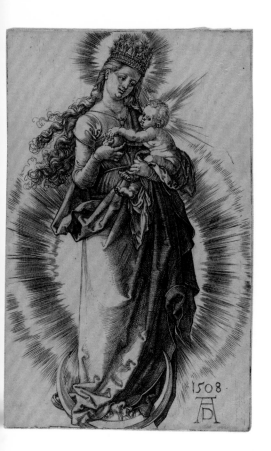

This small sheet exemplifies Dürer's market-oriented engravings production. The year 1508 brought Dürer's workshop an abundance of prestigious painting commissions, leading to the relative neglect of print media. No woodcut is dated 1508, and the year saw the production of only two new pages of the engraved Passion (see cat. 69-75). Presumably, Dürer wanted to revive the printing arm of his enterprise by executing a new variant of the highly marketable motif of the Mother of God, here adorned with a 12-pointed crown. Dürer's composition shows clear evidence of his growing understanding of spatial perspective, which he had deepened during his second Italian journey. The sickle with the moon's face is positioned at the lower edge of the image in such a way that the Madonna seems to be floating above the world while standing on a real surface. Apparently, Dürer based the backdrop, composed of a perforated and radiant aureole, on real sunlight. By this means, the figural group composed of mother and child seems to be set within a three-dimensional space.

39

Das kleine Blatt ist ein Beispiel für Dürers marktorientierte Kupferstichproduktion. Das Jahr 1508 bescherte der Dürer-Werkstatt eine Fülle von prestigeträchtigen Gemäldeaufträgen, weshalb die Entwicklung neuer Werke im Medium der Druckgraphik etwas ins Hintertreffen geriet. Auf das Jahr 1508 datiert kein Holzschnitt, lediglich zwei neue Blätter zur Kupferstich-Passion (vgl. Kat. Nrn. 13-18) sind entstanden. So ist zu vermuten, dass Dürer seinen druckgraphischen Vertrieb beleben wollte, indem er eine neue Variante des gut verkäuflichen Muttergottesmotivs, diesmal mit einer 12sternigen Krone erarbeitete. Dürers Darstellung lässt seine auf der zweiten Italienreise weiter gewachsenen Kenntnisse zur Raumperspektive deutlich werden. Die Sichel mit dem Mondgesicht wurde so am unteren Plattenrand plaziert, dass der Madonna alles Schwebende genommen wird und sie wie auf einer realen Standfläche postiert erscheint. Offensichtlich hat Dürer den sie hinterfangenden, mehrfach gebrochenen Strahlenkranz dem echten Sonnenlicht nachempfunden. Durch ihn wird die Mutterkindgruppe in einen dreidimensionalen Tiefenraum eingebunden.

The Virgin Mary with a Crown
of Stars
1508
Engraving
116 : 73 mm
Monogrammed, dated
Watermark 62 (oxhead)

Provenance: acquired in
1802/1803 from Artaria by
Ludwig X, Landgrave of Hesse.
Inv. no. GR 30

Literature: Bartsch 31; Meder 32,
2 b; Hollstein 32; Schoch et al. 62.

Maria mit der Sternenkrone
1508
Kupferstich
116 : 73 mm
monogrammiert, datiert
Wasserzeichen 62 (Ochsenkopf)

Herkunft: 1802/1803 über
Artaria an Ludwig X. Landgraf von
Hessen.
Inv. Nr. GR 30

Literatur: Bartsch 31; Meder 32, 2
b; Hollstein 32; Schoch u. a. 62.

S even sheets in this series of woodcuts were produced simultaneously with or immediately after The Apocalypse (cat. 13–18). In 1510, Dürer executed four additional dated sheets, as well as the title image. The extended period of time it took to produce this sequence of 12 woodcuts (ca 1496/97 to 1511) explains their stylistic and structural heterogeneity. The early works in the series seem dependent upon a somewhat medieval formal language, while the later ones are dominated by Renaissance stylistic elements. For the publication, Dürer attached interconnected verse narratives in hexameters composed by Benedikt Schwalbe (Latinized Chelidonius), a monk from the Cloister of St. Egidius in Nuremberg. Appearing in 1511 simultaneously with the book edition of the Large Passion were the Life of The Virgin (cat. 45–53), the Small Passion (cat. 54–64), and the new Latin edition of The Apocalypse.

THE LARGE PASSION /
DIE GROSSE PASSION

Sieben Blätter der Holzschnittserie entstanden gleichzeitig oder direkt nach der „Apokalypse" (Kat. Nrn. 13-18), vier weitere Blätter, die datiert sind, sowie das Titelbild schuf Dürer 1510. Die lange Zeitspanne der Entstehung der Folge von 12 Holzschnitten (um 1496/97 bis 1511) begründet auch die stilistischen Unterschiede in der künstlerischen Gestaltung der Blätter. Die frühen Arbeiten scheinen noch mehr einer mittelalterlichen Formensprache verhaftet zu sein, während in den späteren Blättern renaissancehafte Elemente dominieren. Zur Veröffentlichung ließ Dürer von Benedikt Schwalbe (latinisiert Chelidonius), einem Mönch aus dem Kloster St. Egidien in Nürnberg, einen Text in zusammenhängenden Verserzählungen in Hexametern hinzufügen. Im Jahr 1511 erschien die Buchausgabe der „Großen Passion" gleichzeitig mit dem „Marienleben" (Kat. Nrn. 45-53), der „Kleinen Passion" (Kat. Nrn. 54-64) und der lateinischen Neuausgabe der „Apokalypse".

40

As in The Apocalypse, Dürer subdivides each image into two zones. Here, the upper one is tranquil and empty, the lower one thronged with the animated group of Apostles that is crowded around a table laid with the Passover meal. In this sheet, among those produced after the second Italian journey, Dürer uses parallel hatching to create a gray intermediate tone, through which he differentiates a scale of values ranging from white to black, allowing him to attain both quasi–painterly and spatial effects. Symmetrical along a central axis and structured according to centralized perspective, the composition is oriented toward Christ, who embraces John, his favorite disciple, in one arm. This motif draws on the devotional sculptures, common during the Middle Ages, which featured figural representations of Christ and John together. As the first image in the series, this figural constellation assumes the character of an appeal: believers were expected to immerse themselves in religious contemplation, empathizing with the mystic experience of Christ's imminent ordeal.

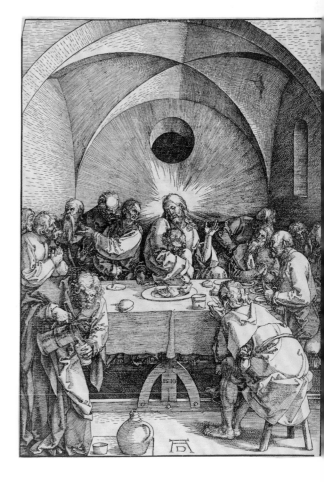

Wie in der „Apokalypse" (Kat. Nrn. 13-18) teilt Dürer das Bild in zwei Zonen, wobei die obere ruhig und leer ist, während sich in der unteren die bewegten Apostelgruppen um die zum Passahmahl gedeckte Tafel drängen. In dem Blatt, das zu den nach der zweiten Italienreise entstandenen Arbeiten der Folge gehört, erzielt Dürer durch Parallelschraffuren einen grauen Mittelton, von dem ausgehend er seine Skala zwischen Weiß und Schwarz ausdifferenziert, wodurch er sowohl malerische wie räumliche Wirkungen erzielen kann. Zentralperspektivisch und achsensymmetrisch ist die Komposition auf Christus ausgerichtet, der in seinem Arm den Lieblingsjünger Johannes hält. Hier verweist Dürer auf die Christus-Johannes-Gruppen der mittelalterlichen plastischen Andachtsbilder. Als erstes Bild der Passion gewinnt diese Figurenkonstellation appellativen Charakter: Der Gläubige soll sich in religiöse Selbsterfahrung versenken und im mystischen Erleben den bevorstehenden Leidensweg Christi nachempfinden.

The Last Supper	Das letzte Abendmahl
1510	1510
Large Passion, 2	Große Passion, 2
Woodcut	Holzschnitt
398 : 287 mm	398 : 287 mm
Monogrammed, dated	monogrammiert, datiert
Text edition of 1511	Textausgabe 1511
Watermark 259 (tower with crown and flower)	Wasserzeichen 259 (Turm mit Krone und Blume)
Provenance: acquired in 1802/1803 from Artaria by Ludwig X, Landgrave of Hesse. Inv. no. GR 104	Herkunft: 1802/1803 über Artaria an Ludwig X. Landgraf von Hessen. Inv. Nr. GR 104
Literature: Bartsch 5; Meder 114; Hollstein 114; Schoch et al. 155.	Literatur: Bartsch 5; Meder 114; Hollstein 114; Schoch u. a. 155.

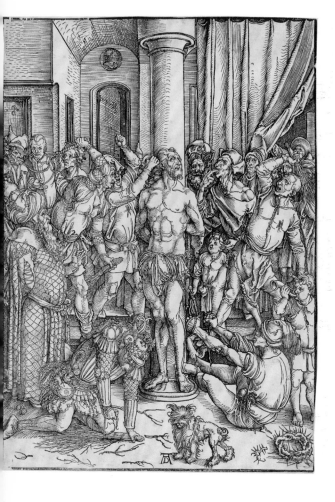

The Flagellation
Ca 1496/97
Large Passion, 5
Woodcut
382 : 275 mm
Monogrammed
Precedes text
No watermark

Provenance: acquired in
1802/1803 from Artaria by
Ludwig X, Landgrave of Hesse.
Inv. no. GR 110

Literature: Bartsch 8; Meder 117;
Hollstein 117; Schoch et al. 158.

Die Geißelung Christi
um 1496/97
Große Passion, 5
Holzschnitt
382 : 275 mm
monogrammiert
Vor dem Text
ohne Wasserzeichen

Herkunft: 1802/1803 über
Artaria an Ludwig X. Landgraf von
Hessen.
Inv. Nr. GR 110

Literatur: Bartsch 8; Meder 117;
Hollstein 117; Schoch u. a. 158.

Although the Gospels refer to the Flagellation only with a single word (Matthew 27: 26; Mark 15: 15; John 19: 1), the scene is particularly well-suited to displaying Christ's trials and sufferings vividly before the believer's eyes. For this reason, the theme was depicted quite frequently (see cat. 71). This sheet is among the earliest of the series. When compared to the later woodcuts, for example The Last Supper (see cat. 40), stylistic differences become evident. Dürer does not yet use light and shade in order to articulate the image in spatial or quasi–painterly terms. Instead he illuminates the scene with a unified mid–tone. Sharply contrasting with the frenzied turmoil of the jeering crowd is the serenity radiated by the figure of Christ, who holds himself erect against the martyr's column. By turning toward the viewer's right, the Savior effects a transition to the succeeding page of the Passion sequence. Precedents for the figures striking and mocking Christ can be found in earlier depictions of the Passion story from the Upper Rhine region, including those of Schongauer or the Master of the Karlsruhe Passion. The figure of Christ, his hands bound behind his back, corresponds to the same iconographic tradition.

Zwar wird in den Evangelien die Geißelung nur mit einem Wort beschrieben (Matthäus 27, 26; Markus 15, 15; Johannes 19, 1) gleichwohl eignet sich die Szene besonders gut, den betrachtenden Gläubigen Leiden und Schmerzen Christi anschaulich werden zu lassen, weshalb das Thema häufig dargestellt wurde (vgl. Kat. Nr. 71). Das Blatt gehört zu den frühesten Arbeiten der Folge. Im Vergleich zu den späteren Holzschnitten, etwa dem Abendmahl (Kat. Nr. 40), werden die stilistischen Unterschiede deutlich. Dürer nutzt noch nicht Licht und Schatten, um das Bild räumlich oder malerisch zu strukturieren, vielmehr hat er die Szene einheitlich mittelhell beleuchtet. Unter den Schlagenden und Spottenden finden sich bekannte Figuren oberrheinischer Passionsdarstellungen, etwa von Schongauer oder von dem Meister der Karlsruher Passion, wie auch der Christus mit hinter dem Rücken gebundenen Händen dieser Darstellungstradition entspricht. Spannungsvoll ist der Gegensatz zwischen dem wilden Getümmel der johlenden Menge zu der Ruhe ausstrahlenden aufrechten Haltung von Christus an der Martersäule. Mit seiner Wendung nach rechts leitet der Heiland über zum nächsten Blatt der Passionsfolge.

Christst Bearing the Cross
Ca 1498/99
Large Passion, 7
Woodcut
388 : 282 mm
Monogrammed
Precedes text
Watermark 53 (large orb)

Provenance: acquired in
1802/1803 from Artaria by
Ludwig X, Landgrave of Hesse.
Inv. no. GR 115

Literature:
Bartsch 10; Meder 119; Hollstein
119; Schoch et al. 160.

Die Kreuztragung Christi
um 1498/99
Große Passion, 7
Holzschnitt
388 : 282 mm
monogrammiert
Vor dem Text
Wasserzeichen 53 (Großer
Reichsapfel)

Herkunft: 1802/1803 über
Artaria an Ludwig X. Landgraf von
Hessen.
Inv. Nr. GR 115

Literatur: Bartsch 10; Meder 119;
Hollstein 119; Schoch u. a. 160.

42 The figure of Christ, shown here collapsing under the weight of the cross, supports himself with great effort on one arm, his suffering gaze directed toward the kneeling figure of Veronica, who offers him her veil. Standing on the right hand side is the figure of a soldier seen from behind, a counterpart to the pairing of Christ and Veronica, who are united in a silent communion. Within the woodcut's lively interplay of light and dark areas, this paler trio of figures stands out against the darker mass of mourners, tormentors, and curious onlookers, set in the background, which pours forth from the city gates. For the individual figures, the young Dürer draws on his own technical inventions used in other contexts. On the whole, however, this woodcut is reminiscent of an engraving of Christ Bearing the Cross by his predecessor Schongauer (Lehrs 26).

Mühsam stützt sich der unter der Kreuzeslast zusammengebrochene Christus auf seinen Arm, während er seinen Blick schmerzvoll zur knienden Veronika wendet, die ihm das Schweißtuch reicht. Als Pendant zu der in stummer Zwiesprache verbundenen Christus-Veronika-Gruppe steht rechts die Rückenfigur des am Strick ziehenden Soldaten. Im lebhaften Hell-Dunkel-Spiel des Holzschnitts sind die drei Gestalten hell hervorgehoben aus der dunkleren Masse der Trauernden, Peiniger und Schaulustigen, die aus dem Stadttor quillt. Zwar greift der junge Dürer hier in einzelnen Gestalten auf eigene Figurfindungen aus anderen Zusammenhängen zurück, doch erinnert der Holzschnitt insgesamt an den Kupferstich der „Kreuztragung" von seinem Vorbild Schongauer (Lehrs 26).

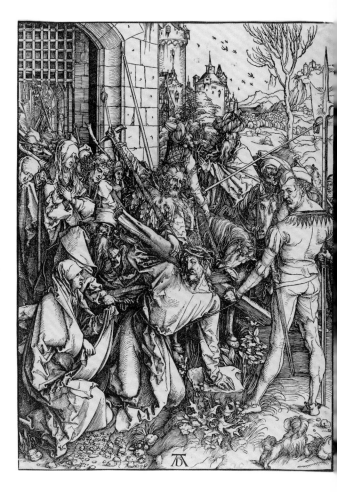

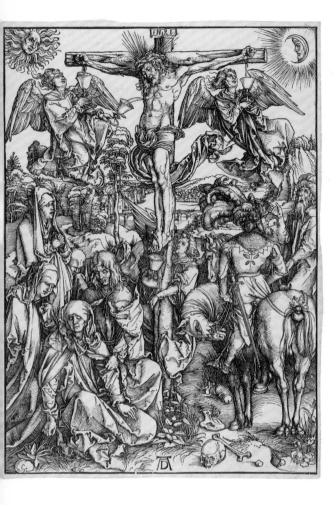

Dürer's composition – in which the sun and moon represent the mourning cosmos, while angels capture the Savior's blood in chalices – corresponds to the Christian iconography of Christ on the cross as found in works by Schongauer and Wolgemut. Although Christ's head falls onto his chest, his muscular, youthful body makes a dignified and even triumphant impression. To the left of the cross, Mary sinks down in silent grief; standing beside her is John with Mary's female companions. The richly figured pictorial field is traversed by a dynamic interplay of blacks and whites. The atmosphere is one of rising turmoil, emphasized by the wealth of forms and their restless interior lines. The mood seems emblematic of the furor of the elements during the crucifixion of the Son of God (see Small Passion cat. 61; Engraved Passion cat. 73).

43

Dürers Darstellung mit Sonne und Mond, die für den trauernden Kosmos stehen und den Engeln, die Christi Blut in Kelchen auffangen, entspricht der christlichen Bildtradition des Gekreuzigten etwa bei Schongauer oder Wolgemut. Auch wenn Christi Haupt auf die Brust gesunken ist, wirkt der Gekreuzigte mit seinem muskulösen, jugendlichen Körper würdevoll und sieghaft. Links vom Kreuz ist Maria in stiller Trauer niedergesunken, bei ihr stehen Johannes und ihre Begleiterinnen. Ein dynamisches Wechselspiel zwischen Schwarz und Weiß überzieht das figurenreiche Bildfeld. Der Eindruck von Aufgewühltheit stellt sich ein, was auch durch die Fülle der Formen und ihre unruhigen Binnenzeichnungen unterstrichen wird. Diese Stimmung scheint den Aufruhr der Elemente zu versinnbildlichen, der während der Kreuzigung des Gottessohnes einsetzte (vgl. „Kleine Passion" Kat. Nr. 61; „Kupferstich-Passion" Kat. Nr. 73).

Christ Crucified	Christus am Kreuz
Ca 1498	um 1498
Large Passion, 8	Große Passion, 8
Woodcut	Holzschnitt
388 : 280 mm	388 : 280 mm
Monogrammed	monogrammiert
Precedes text	Vor dem Text
No watermark	ohne Wasserzeichen
Provenance: acquired in 1802/1803 from Artaria by Ludwig X, Landgrave of Hesse. Inv. no. GR 118	Herkunft: 1802/1803 über Artaria an Ludwig X. Landgraf von Hessen. Inv. Nr. GR 118
Literature: Bartsch 11; Meder 120; Hollstein 120; Schoch et al. 161. Antwerp 1970, 42.	Literatur: Bartsch 11; Meder 120; Hollstein 120; Schoch u. a. 161. Antwerpen 1970, 42.

The Lamentation
Ca 1498/99
Large Passion, 9
Woodcut
391 : 284 mm
Monogrammed
Text edition of 1511
No watermark

Provenance: acquired in
1802/1803 from Artaria by
Ludwig X, Landgrave of Hesse.
Inv. no. GR 125

Literature: Bartsch 13; Meder
122; Hollstein 122; Schoch et al.
162.

Die Beweinung Christi
um 1498/99
Große Passion, 9
Holzschnitt
391 : 284 mm
monogrammiert
Textausgabe 1511
ohne Wasserzeichen

Herkunft: 1802/1803 über
Artaria an Ludwig X. Landgraf von
Hessen.
Inv. Nr. GR 125

Literatur: Bartsch 13; Meder 122;
Hollstein 122; Schoch u. a. 162.

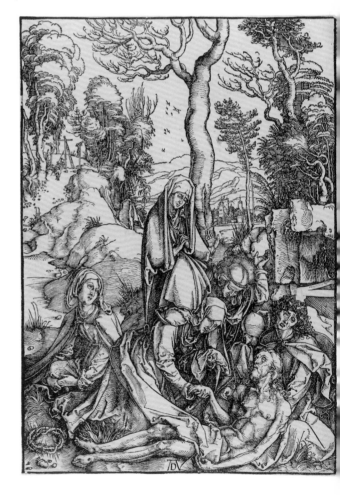

Although the Lamentation is not recounted in the Gospels, it nonetheless constitutes a well-established station of the Passion narrative. Of special importance for the pictorial arts of the Middle Ages were the lacerated body and wounds of the Savior and the bitter grief of his mother Mary. In this early woodcut from the series, Dürer gives the scene, set in a landscape, a centralized structure. Above the body of Christ, shown lying in John's arms along the lower edge of the picture, Dürer groups the mourners into a pyramid at whose apex the Virgin Mary stands next to a tree, with four female companions at her feet. Both through expressive body language and through the emotion etched onto the faces of the mourners, Dürer invites the beholder to engage in empathetic suffering.

Zwar wird die Beweinung von den Evangelien nicht geschildert, doch gehört sie als feste Station in den Ablauf der Passionsgeschichte. Der geschundene Leib, die Wunden des Heilands und das schmerzliche Leid seiner Mutter Maria waren für die mittelalterliche Bildkunst von besonderer Bedeutung. In diesem frühen Holzschnitt der Folge strukturiert Dürer die Szene in der Landschaft durch einen zentralen Aufbau: Über dem Leichnam Christi, der am unteren Blattrand in den Armen von Johannes liegt, gruppiert Dürer die Gruppe der Trauernden als pyramidale Komposition, an der Spitze die neben einem Baum stehende Maria und ihr zu Füßen vier Begleiterinnen. Sowohl über ihre expressive Körpersprache als auch durch die schmerzerfüllten Gesichter der Trauernden lädt Dürer den Betrachter zum einfühlenden Mitleid ein.

Dürer published more books in 1511 than in any other year, among them the 18 woodcuts narrating The Life of the Virgin, with a title and a final page. Most of the woodcuts were produced between 1502 and 1505, i.e. in the years following the Apocalypse and prior to Dürer's second Italian journey. The Life of the Virgin reveals Dürer's fondness for cheerful and idyllic depictions of the ordinary and the everyday. Striking here is the fineness of the cutting technique, through which he achieves almost painterly tonal gradations. As in the case of the Large Passion (cat. 40–44), the accompanying Latin verses were composed by the monk Benedikt Schwalbe (Latinized as Chelidonius) of the Cloister of St. Egidius in Nuremberg. Marcanton Raimondi copied the series in engraved form.

THE LIFE OF THE VIRGIN / MARIENLEBEN

1511, im Jahr seiner meisten Buchveröffentlichungen, publizierte Dürer auch die 18 Holzschnitte über das Leben Mariens mit einem Titel- und einem Schlussblatt. Die Mehrzahl der Holzschnitte war zwischen 1502 und 1505 entstanden, also in den Jahren nach der „Apokalypse" (Kat. Nrn. 13-18) und vor der zweiten Italienreise. Das „Marienleben" offenbart Dürers Neigung zur heiter-idyllischen Schilderung des Allgemeinen und Alltäglichen. Auffällig ist die Feinheit der Holzschnitttechnik, mit der Dürer malerische Tonabstufungen erzielt. Wie bei der „Großen Passion" (Kat. Nrn. 40-44) verfasste die lateinischen Verse der Mönch Benedikt Schwalbe (latinisiert Chelidonius) aus dem Kloster St. Egidien in Nürnberg. Marcanton Raimondi stach die Serie in Kupfer nach.

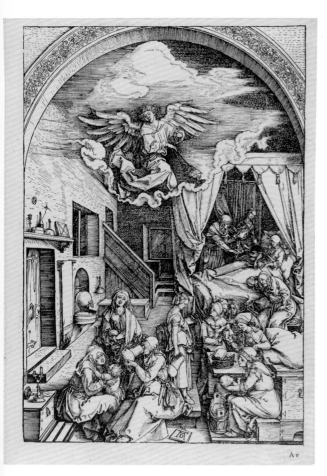

A v

The Birth of the Virgin	Die Geburt Mariens
Ca 1503	um 1503
The Life of the Virgin, 5	Marienleben, 5
Woodcut	Holzschnitt
298 : 210 mm	298 : 210 mm
Monogrammed	monogrammiert
Latin book edition of 1511	Lateinische Buchausgabe 1511
Watermark 127 (flower on triangle)	Wasserzeichen 127 (Blume auf Dreieck)
Provenance: acquired in 1802/1803 from Artaria by Ludwig X, Landgrave of Hesse. Inv. no. GR 246	Herkunft: 1802/1803 über Artaria an Ludwig X. Landgraf von Hessen. Inv. Nr. GR 246
Literature: Bartsch 80; Meder 192; Hollstein 192; Schoch et al. 170.	Literatur: Bartsch 80; Meder 192; Hollstein 192; Schoch u. a. 170.

Dürer uses realistic detail to convey the bustling activity in the hall–style bedchamber. Above, the room gives way to a celestial realm. An angel hovers over the scene, indicating that no ordinary soul is being born there. Lying in bed toward the rear is an exhausted Anna, surrounded by anxious and attentive helpers. In the right foreground, the newborn Mary is shown held above a washtub, while a female servant brings her cradle. Several noblewomen are among the visitors. After the birth labors and safe delivery, a cheerful atmosphere prevails; the company passes around tankards and mugs.

45

Dürer zeigt mit realistischen Einzelheiten das rege Treiben in der saalartigen Wochenstube. Nach oben verliert sich der Raum in himmlischen Sphären. Als Hinweis, dass hier kein gewöhnlicher Mensch geboren wurde, schwebt ein Engel über der Szene. Hinten im Bett liegt die ermattete Anna von sorgenden Helferinnen umgeben. Vorne rechts wird die neugeborene Maria über einen Waschzuber gehalten, eine Dienerin bringt ihre Wiege herbei. Unter den Frauen befinden sich auch einige vornehme Besucherinnen. Nach getaner Arbeit und der glücklich verlaufenen Geburt herrscht eine fröhliche Stimmung; Krug und Becher werden herumgereicht.

The betrothal between Mary and a distinctly older Joseph takes place in front of a temple beneath a rounded arch. The view leads into the temple's interior, its architecture reminiscent of an early Gothic church. The high priest is shown joining the couple's hands. Dürer has clad the attending company in the contemporary patrician garb of the free imperial city of Nuremberg.

46

Die Vermählung von Maria mit dem deutlich älteren Joseph findet vor dem Tempel unter einem Rundbogen statt. Der Blick führt in den Tempel, dessen Architektur an eine frühgotische Kirche erinnert. Der Hohepriester legt die Hände der Brautleute ineinander. Die anwesende Gemeinde kleidet Dürer in der zeitgenössischen Tracht der reichstädtischen Nürnberger Gesellschaft.

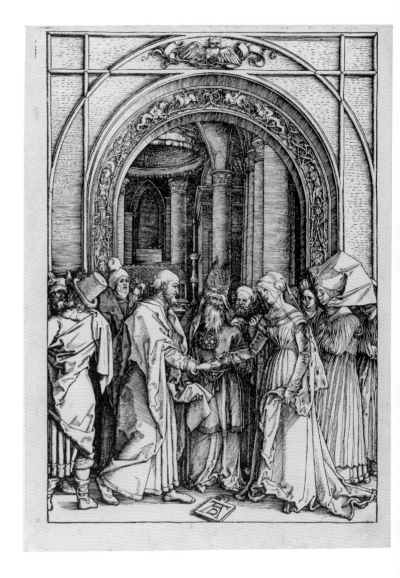

The Betrothal of the Virgin
Ca 1504
The Life of the Virgin, 7
Woodcut
294 : 208 mm
Monogrammed
Latin book edition of 1511
Watermark 127 (flower on triangle)

Provenance: acquired in 1802/1803 from Artaria by Ludwig X, Landgrave of Hesse.
Inv. no. GR 251

Literature: Bartsch 82; Meder 194; Hollstein 194; Schoch et al. 172.

Die Verlobung Mariens
um 1504
Marienleben, 7
Holzschnitt
294 : 208 mm
monogrammiert
Lateinische Buchausgabe 1511
Wasserzeichen 127 (Blume auf Dreieck)

Herkunft: 1802/1803 über Artaria an Ludwig X. Landgraf von Hessen.
Inv. Nr. GR 251

Literatur: Bartsch 82; Meder 194; Hollstein 194; Schoch u. a. 172.

The Annunciation
Ca 1503
The Life of the Virgin, 8
Woodcut
296 : 210 mm
Monogrammed
Latin book edition of 1511
Watermark 127 (flower on
triangle)

Provenance: acquired in
1802/1803 from Artaria by
Ludwig X, Landgrave of Hesse.
Inv. no. GR 254

Literature: Bartsch 83; Meder
195; Hollstein 195; Schoch et al.
173.

Mariä Verkündigung
um 1503
Marienleben, 8
Holzschnitt
296 : 210 mm
monogrammiert
Lateinische Buchausgabe 1511
Wasserzeichen 127 (Blume auf
Dreieck)

Herkunft: 1802/1803 über
Artaria an Ludwig X. Landgraf von
Hessen.
Inv. Nr. GR 254

Literatur: Bartsch 83; Meder 195;
Hollstein 195; Schoch u. a. 173.

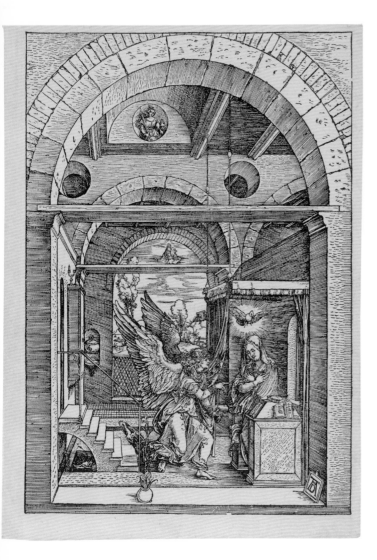

The hall's architecture – laid out in a strictly central-
ized perspectival scheme based on Italian prototypes
– dominates the image, endowing the depicted
events with a solemn and sublime atmosphere.
The relatively small Annunciation group is
composed of Mary and the Archangel Ga-
briel, his animated form derived from north-
ern Italian models. Traditional iconographi-
cal details such as the lily bouquet and water
kettle allude to Mary's virginity. The depiction
of Judith with the head of Holofernes on a medallion
beneath the roof truss is a prefiguration of Mary, who
vanquishes the devil. The latter is present in the form
of the badger, an emblem of evil, seen chained up be-
neath the staircase.

47

Die streng zentralperspektivisch angelegte Hallen-
architektur, die auf italienische Vorbilder zurückgeht,
beherrscht den Bildeindruck und verleiht dem Ge-
schehen eine feierlich erhabene Stimmung. Im Ver-
hältnis klein ist die Verkündigungsgruppe mit Maria
und dem Erzengel Gabriel, dessen bewegte Gestalt
wiederum oberitalienischen Vorbildern folgt. Tra-
ditionelle ikonographische Details wie Lilienstrauß
oder Wasserkessel verweisen auf die Jungfräulichkeit
Mariens. Die Darstellung der Judith mit dem Haupt
des Holofernes im Medaillon unter dem Dachstuhl
gilt als Präfiguration Mariens, die den Teufel besiegt
hat. Dieser liegt in Gestalt eines Dachses, als Sinnbild
des Bösen, angekettet unter der Treppe.

Mary is shown in the mountains, paying a visit to Elizabeth, now pregnant with John the Baptist. As the two women embrace, their children leap for joy in their wombs. Dürer's composition is celebrated in particular for its mountainous landscape, rendered economically in a glistening light with just a few lines. Dürer draws here on impressions gathered when crossing the Alps in the years 1494/95.

48

Maria besucht die schwangere Elisabeth, die Mutter des Johannes des Täufers, im Gebirge. Als sich die beiden Frauen umarmen, hüpfen ihre Kinder vor Freude im Leib. Berühmt ist Dürers Blatt insbesondere wegen der Gebirgslandschaft, die mit sparsamen Strichen im gleißenden Licht wiedergegeben wird. Hier hat Dürer Eindrücke seiner eigenen Alpenüberquerung der Jahre 1494/95 einfließen lassen.

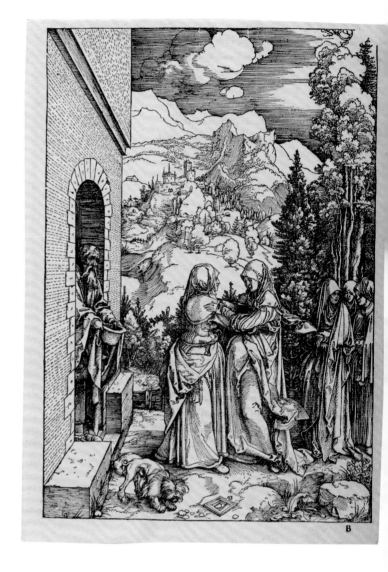

The Visitation	Die Heimsuchung
1503/04	1503/04
The Life of the Virgin, 9	Marienleben, 9
Woodcut	Holzschnitt
297 : 210 mm	297 : 210 mm
Monogrammed	monogrammiert
Latin book edition of 1511	Lateinische Buchausgabe 1511
Watermark 259 (crowned tower)	Wasserzeichen 259 (Bekrönter Turm)
Provenance: acquired in 1802/1803 from Artaria by Ludwig X, Landgrave of Hesse. Inv. no. GR 256	Herkunft: 1802/1803 über Artaria an Ludwig X. Landgraf von Hessen. Inv. Nr. GR 256
Literature: Bartsch 84; Meder 196; Hollstein 196; Schoch et al. 174.	Literatur: Bartsch 84; Meder 196; Hollstein 196; Schoch u. a. 174.

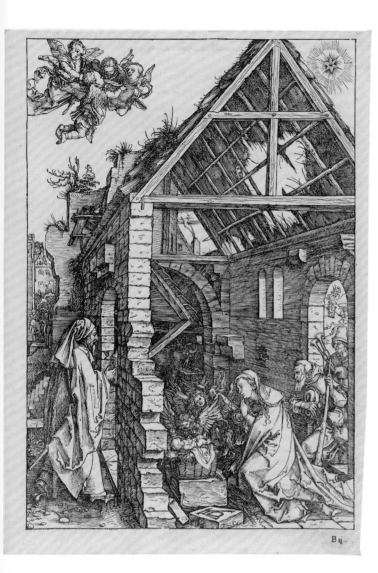

Christ's birth is shown here as described in the Gospel of St. Luke. The scene is set in a decaying house, where the child lies in swaddling clothes on a bed of straw. The source for the motif of the wall that has been broken away is Schongauer's Birth of Christ (Lehrs 5). Dürer's composition is based on an idiosyncratic perspectival view: on the left-hand side, outside of the narrow and elongated house, stands Joseph, facing Mary and the child within. The lantern held in his hand casts its glow into the interior, while the shepherds enter from behind Mary. Visible in the distance through the arched doorway is the Annunciation to the Shepherds.

49

Dürer schildert Christi Geburt nach dem Lukas-Evangelium und zeigt ein zerfallenes Haus, in dem das Kind in einer Windel auf Stroh gebettet liegt. Vorbild für das Motiv der abgebrochenen Mauer ist Schongauers „Geburt Christi" (Lehrs 5) aus seinem unvollendet gebliebenen „Marienleben". Dürer wählt für seine Komposition eine eigenwillige perspektivische Ansicht: Links steht Joseph gegenüber von Maria und dem Kind außerhalb des schmalen lang gestreckten Hauses. Er leuchtet mit seiner Laterne in den Raum hinein, während hinter Maria die Hirten eintreten. Durch den Torbogen in der Ferne ist die Verkündigung zu sehen.

The Birth of Christ (The Adoration of the Shepherds) 1502/03 The Life of the Virgin, 10 Woodcut 295 : 210 mm Monogrammed Latin book edition of 1511 No watermark	Die Geburt Christi (Anbetung der Hirten) 1502/03 Marienleben, 10 Holzschnitt 295 : 210 mm monogrammiert Lateinische Buchausgabe 1511 ohne Wasserzeichen
Provenance: acquired in 1802/1803 from Artaria by Ludwig X, Landgrave of Hesse. Inv. no. GR 258	Herkunft: 1802/1803 über Artaria an Ludwig X. Landgraf von Hessen. Inv. Nr. GR 258
Literature: Bartsch 85; Meder 197; Hollstein 197; Schoch et al. 175.	Literatur: Bartsch 85; Meder 197; Hollstein 197; Schoch u. a. 175.

The Flight into Egypt
Ca 1504
The Life of the Virgin, 14
Woodcut
297 : 209 mm
Monogrammed
Latin book edition of 1511
No watermark

Provenance: acquired in
1802/1803 from Artaria by
Ludwig X, Landgrave of Hesse.
Inv. no. GR 267

Literature: Bartsch 89; Meder
201; Hollstein 201; Schoch et al.
179.

Die Flucht nach Ägypten
um 1504
Marienleben, 14
Holzschnitt
297 : 209 mm
monogrammiert
Lateinische Buchausgabe 1511
ohne Wasserzeichen

Herkunft: 1802/1803 über
Artaria an Ludwig X. Landgraf von
Hessen.
Inv. Nr. GR 267

Literatur: Bartsch 89; Meder 201;
Hollstein 201; Schoch u. a. 179.

Joseph obeys God's behest to escape Herod's death decree by fleeing into Egypt with Mary and the Christ Child. As is often the case, the composition was inspired by a Schongauer. Dürer adopts elements from an engraving with the same title (Lehrs 7), including the lizard, the exotic date palm, and the dragon tree. The effect is not merely of individual trees, but instead of a dense forest through which Joseph leads the mother and child, who ride on a donkey, accompanied here for the first time by an ox. Dürer constructs his image in a way that underlines the ties binding the little family together. Mary is seen from behind. She holds the child concealed in her lap, so that only his cloaked head peeps out. Her gaze is directed at Joseph, who is about to cross a bridge; he turns back with a grave expression, regarding the pair whose safety has been entrusted to him.

50

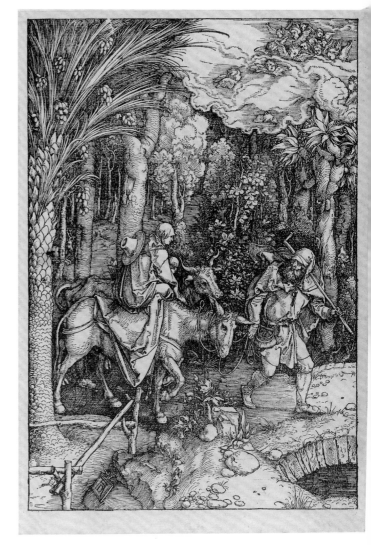

Joseph folgt Gottes Geheiß und flieht mit Maria und dem Kind vor dem Tötungsbefehl des Herodes nach Ägypten. Wie so häufig ist das Blatt von Schongauer anregt. Dürer greift Elemente aus dessen gleichnamigen Kupferstich (Lehrs 7) auf, wie die Eidechsen, die exotische Dattelpalme und den Drachenbaum. Dabei bemüht er sich, nicht einzelne Bäume, sondern einen dichten Wald darzustellen. Durch diesen führt Joseph Mutter und Kind auf einem Esel, der hier erstmals von einem Ochsen begleitet wird. Dürer nutzt seinen Bildaufbau, um die innige Beziehung der kleinen Familie zu unterstreichen: Maria ist vom Rücken her zu sehen. Verborgen in ihrem Schoß hält sie das Kind, so dass nur sein verhülltes Köpfchen hervorlugt. Maria schaut nach vorne zu Joseph, der auf eine Brücke zugeht, während er seinen ernsten Blick zurück auf seine Schutzbefohlenen wendet.

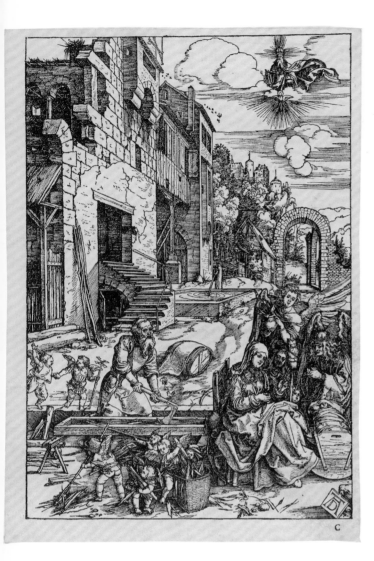

The Apocrypha tell of the sojourn of the Holy Family in Egypt, where the Virgin and Joseph earned their subsistence by working with her hands. As in the preceding sheet, Dürer depicts an idyll. The scene, with its picturesque ruins, is set beneath an open sky against the backdrop of a mountaintop castle. Mary is busy with distaff and spindle. Using her foot, she gently rocks the nearby cradle where the infant Jesus lies asleep. Crowding attentively around her are three adult angels; one holds some lilies of the valley, a symbol of the Virgin. Joseph is busy with his carpentry, while a troop of eager putti gather the woodchips as they fall to the ground.

51

Die Apokryphen berichten vom Aufenthalt der Heiligen Familie in Ägypten, wo sie sich von ihrer Hände Arbeit ernährt. Wie beim vorangehenden Blatt zeigt Dürer eine Idylle. Die Szene spielt unter freiem Himmel in malerischer Ruinenkulisse mit Blick auf einen Burgberg: Maria spinnt mit Spinnrocken und Wirte. Mit dem Fuß schaukelt sie sanft die neben ihr stehende Wiege, in der das Jesuskind schlummert. Um sie drängen sich aufmerksam drei erwachsene Engel, als Mariensymbol hält der eine einen Maiglöckchenstrauß. Auch Joseph geht seiner Zimmermannstätigkeit nach, während eine Schar eifriger Putten die abfallenden Späne aufsammelt.

The Sojourn in Egypt
Ca 1502
The Life of the Virgin, 15
Woodcut
295 : 210 mm
Monogrammed
Latin book edition of 1511
No watermark

Provenance: acquired in 1802/1803 from Artaria by Ludwig X, Landgrave of Hesse. Inv. no. GR 269

Literature: Bartsch 90; Meder 202; Hollstein 202; Schoch et al. 180.

Der Aufenthalt in Ägypten
um 1502
Marienleben, 15
Holzschnitt
295 : 210 mm
monogrammiert
Lateinische Buchausgabe 1511
ohne Wasserzeichen

Herkunft: 1802/1803 über Artaria an Ludwig X. Landgraf von Hessen. Inv. Nr. GR 269

Literatur: Bartsch 90; Meder 202; Hollstein 202; Schoch u. a. 180.

Christ Taking Leave of His Mother
Ca 1504
The Life of the Virgin, 17
Woodcut
296 : 209 mm
Monogrammed
Latin book edition of 1511
Watermark 259 (crowned tower)

Provenance: acquired in
1802/1803 from Artaria by
Ludwig X, Landgrave of Hesse.
Inv. no. GR 274

Literature: Bartsch 92; Meder
204; Hollstein 204; Schoch et al.
182.

Christus nimmt Abschied von
seiner Mutter
um 1504
Marienleben, 17
Holzschnitt
296 : 209 mm
monogrammiert
Lateinische Buchausgabe 1511
Wasserzeichen 259 (Bekrönter
Turm)

Herkunft: 1802/1803 über
Artaria an Ludwig X. Landgraf von
Hessen.
Inv. Nr. GR 274

Literatur: Bartsch 92; Meder 204;
Hollstein 204; Schoch u. a. 182.

Dürer's composition conveys separation and parting. A wooden doorpost bisects the sheet vertically, separating the sorrowing group, composed of Mary, Martha, and Mary Magdalene, from the Son of God, who departs now for Jerusalem where he will endure the ordeal of the Passion. The imploring gesture of Mary, who collapses in despair, is for naught. Jesus turns and directs his gaze at his mother one last time. In Christ's raised hand, Panofsky perceived an allusion to the "Noli me tangere" motif (Panofsky 1955, p. 140).

52

Dürers Bildkomposition signalisiert Trennung und Abschied: Ein hölzerner Türpfosten durchschneidet die Blattmitte und separiert die Trauergruppe mit Maria, Martha und Maria Magdalena vom Gottessohn, der nach Jerusalem gehen und die Passion auf sich nehmen wird. Das Flehen der niedergesunkenen Maria bleibt vergebens. Ein letztes Mal wendet sich Jesus im Gehen zur Mutter zurück. In seiner erhobenen Hand erkannte Panofsky eine Anspielung auf das „Noli me tangere"-Motiv (Panofsky 1977, S. 135).

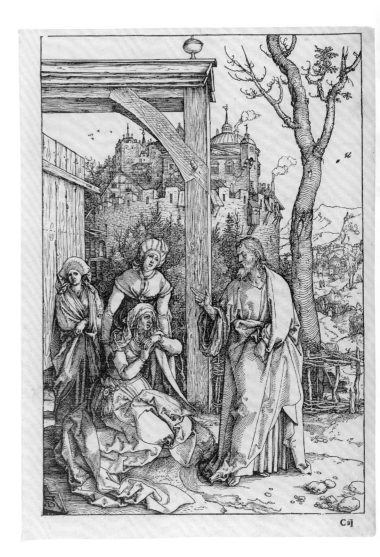

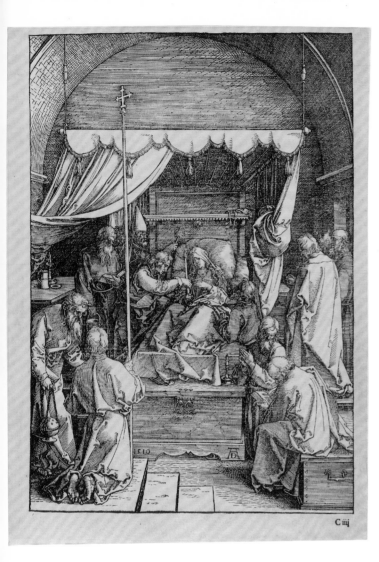

The Golden Legend recounts how the Apostles were summoned at Mary's request to her deathbed from all corners of the globe. In this strongly foreshortened view, Dürer shows the Virgin Mary lying on a canopied bed which projects forward into a barrel–vaulted chamber. Once again, Dürer has drawn on a compositional device that originates with Martin Schongauer, in this case his Death of the Virgin Mary (Lehrs 16) from the 1470s. By distributing the 12 apostles symmetrically in small groups along the sides of the bed, leaving an unobstructed view of the reclining Virgin, Dürer ensures that the scene radiates a serene solemnity, despite the numerous figures it contains. He uses dense hatching lines to shroud the chamber in a muted light, illuminating only a few white surfaces. At the center of the composition is the face of the Virgin. The apostles bid her farewell, performing medieval rites for the dying: Peter sprinkles Mary with holy water, John hands her the death candle, another holds an incense burner, others read the Commendatio Animae, a prayer for the dying. This woodcut was produced after Dürer's second Italian journey, and hence just one year before the Life of the Virgin appeared.

53

Die „Legenda aurea" berichtet, dass auf Wunsch Mariens die Apostel aus allen Erdteilen an ihr Sterbebett gerufen wurden. In starker Verkürzung zeigt Dürer die Gottesmutter in einem Baldachinbett, das in den tonnengewölbten Raum hineinragt. Mit dieser Bildkomposition bezieht sich Dürer einmal mehr auf Martin Schongauer, hier auf dessen „Marientod" (Lehrs 16) aus den 1470er Jahren. Indem Dürer die 12 Apostel entlang der Bettseiten symmetrisch zu kleinen Gruppen ordnet und den Blick auf das Sterbebett frei lässt, vermittelt die Szene trotz der vielen Personen eine feierliche Ruhe. Durch dichte Schraffuren hüllt Dürer den Raum in gedämpftes Licht, aus dem wenige weiße Flächen aufleuchten. Im Zentrum steht das Antlitz der sterbenden Gottesmutter. Für sie vollziehen die Abschied nehmenden Apostel die mittelalterlichen Sterberiten: Petrus besprengt Maria mit Weihwasser, Johannes reicht ihr die Sterbekerze, einer hält ein Weihrauchgefäß, etliche lesen die Sterbegebete („commendatio animae"). Der Holzschnitt ist erst nach Dürers zweiter Italienreise und damit nur ein Jahr vor dem Erscheinen des „Marienlebens" entstanden.

The Death of Mary	Der Tod Mariens
1510	1510
The Life of the Virgin, 18	Marienleben, 18
Woodcut	Holzschnitt
288 : 206 mm	288 : 206 mm
Monogrammed	monogrammiert
Latin book edition of 1511	Lateinische Buchausgabe 1511
Watermark 259 (crowned tower)	Wasserzeichen 259 (Bekrönter Turm)
Provenance: acquired in 1802/1803 from Artaria by Ludwig X, Landgrave of Hesse. Inv. no. GR 276	Herkunft: 1802/1803 über Artaria an Ludwig X. Landgraf von Hessen. Inv. Nr. GR 276
Literature: Bartsch 93; Meder 205; Hollstein 205; Schoch et al. 183.	Literatur: Bartsch 93; Meder 205; Hollstein 205; Schoch u. a. 183.

In 1511, alongside three large books (The Apocalypse, cat. 13-18; the Large Passion, cat. 40–44; and the Life of the Virgin cat. 45–53), Dürer also released the Small Passion in a Latin book edition produced by his own Nuremberg publishing house. In contrast to the large folio editions of the other volumes, the Small Passion has a page size of only approximately 21.3 x 15.5 cm. The uncut prints still in existence confirm that Dürer always printed four blocks on each sheet of handmade paper. As with the Life of the Virgin and the Large Passion, the accompanying Latin verses are the work of the monk Cheledonius (actually Benedikt Schwalbe). Dürer adopted these texts from the Passio Jesu Christi (Strasbourg, 1507), illustrated by Johannes Wechtlin, albeit without depending on Wechtlin's woodcuts. In Dürer's book edition, the images are printed on the prominent right–hand side, with the corresponding text passages appearing on the left. The text arrangement, with its 20 verses, follows the picture format.

With its 37 woodcuts, the Small Passion is Dürer's most extensive print series. Given the stylistic unity of the sequence as a whole, it is thought that all of the woodcuts were produced within a period of two or three years beginning in 1509. Dürer regarded the Passion story as one of his greatest artistic challenges, and in the Small Passion, he turns toward the theme with a conspicuous delight in storytelling. He spans the spectrum from Adam and Eve's Fall from Grace to the Last Judgment, expanding the Passion narrative into an all-encompassing cycle of the Christian doctrine of salvation.

THE SMALL PASSION /
DIE KLEINE PASSION

Dürer always concentrates on an incisive and essential statement of his theme. Featured are just a few protagonists, who appear relatively large within the small format. Dürer exploits a subtle system of illumination to guide the viewer's gaze toward the vital aspect of each scene. Using intersecting and parallel hatching, he lays down a gray middle tone as a foundation on which to plastically model the brightly lit figures. The varied resources utilized in Dürer's mature print masterworks did not fail to impress his public. The woodcuts of The Small Passion were enormously popular, and were frequently copied.

Neben den drei großen Büchern, der „Apokalypse" (Kat. Nrn. 13-18), der „Großen Passion" (Kat. Nrn. 40-44) und dem „Marienleben" (Kat. Nrn. 45-53), publizierte Dürer 1511 auch die „Kleine Passion" als lateinische Buchausgabe im eigenen Verlag in Nürnberg. Im Gegensatz zu den drei im Großfolio gedruckten Büchern hat die „Kleine Passion" eine Seitengröße von lediglich rund 21,3 x 15,5 cm. Noch vorhandene unzerschnittene Bogen belegen, dass Dürer immer vier Stöcke auf ein Blatt Büttenpapier druckte. Wie beim „Marienleben" und der „Großen Passion" stammen die begleitenden lateinischen Verse von dem Mönch Cheledonius, eigentlich Benedikt Schwalbe. Dürer hat diese Texte aus der 1507 in Straßburg erschienenen von Johannes Wechtlin illustrierten „Passio Jesu Christi" übernommen, ohne auf Wechtlins Holzschnitte zurückzugreifen. In Dürers Buchausgabe stehen der Holzschnitt auf der prominenten rechten Seite und die entsprechende Textpassage auf der gegenüberliegenden linken Seite, wobei der Satzspiegel der 20 Verszeilen dem Bildformat folgt.

Die „Kleine Passion" ist mit 37 Holzschnitten Dürers umfangreichste druckgraphische Folge. Wegen der einheitlichen stilistischen Gestaltung der Blätter wird heute davon ausgegangen, dass sämtliche Holzschnitte innerhalb von zwei bis drei Jahren ab 1509 entstanden sind. In der Passion Christi sah Dürer eine seiner wichtigsten Gestaltungsaufgaben als Künstler und mit großer Erzählfreude widmete er sich diesem Thema in der „Kleinen Passion". Dabei spannt er den Bogen vom Sündenfall des ersten Menschenpaares bis zum Jüngsten Gericht und erweitert die Passionsgeschichte zu einem kompletten Zyklus der christlichen Heilslehre.

Dürer konzentriert die jeweilige Darstellung auf eine prägnante Kernaussage. Nur wenige Handelnde treten auf, wobei die Figuren in dem kleinen Format relativ groß dargestellt sind. Zudem nutzt Dürer eine differenzierte Lichtregie, um den Blick des Betrachters auf die wesentlichen Inhalte zu lenken: Über die Darstellung legt er aus Kreuz- und Parallelschraffuren einen grauen Mittelton, aus dem er die im Licht stehenden Figuren plastisch herausarbeitet. Die suggestiven Mittel von Dürers reifer druckgraphischer Meisterschaft verfehlten ihre Wirkung beim Publikum nicht. Die Holzschnitte der „Kleinen Passion" waren ungemein populär, weshalb sie sehr häufig kopiert wurden.

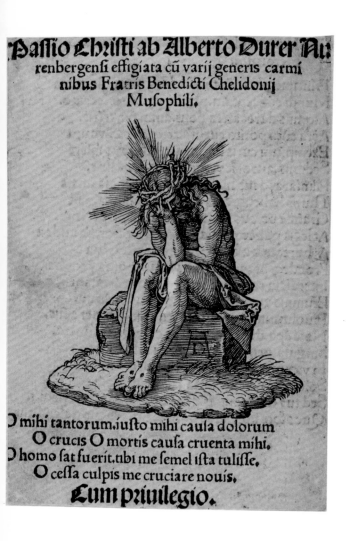

The Latin title of this sheet reads: "The Sufferings of Christ by Albrecht Dürer of Nuremberg, drawn with diverse lyrics by Brother Benedict Schwalbe, a friend of the Muses."

Christ, now removed from the Cross, sits on a small boulder, his feet displaying the wounds of the crucifixion, while his head, crowned with thorns, is surmounted by a cruciform nimbus. With an attitude of deep melancholy, the Man of Sorrows buries his face in his right hand, one elbow resting on a knee. In a way that is both simple and expressive, Dürer confronts us with the profound despair and loneliness of the Son of God. In the verses printed below, Christ refers to the Passion he has suffered, imploring the viewer not to torment him by continually committing new sins.

54

Übersetzung des lateinischen Titels: Das Leiden Christi von Albrecht Dürer aus Nürnberg gezeichnet mit verschiedenartigen Liedern des Bruders Benedict Schwalbe, des Freundes der Musen.

Der vom Kreuz abgenommene Christus kauert auf einem Stein, seine Füße zeigen die Wundmale, das dornenbekrönte Haupt wird von einem Kreuznimbus hinterfangen. In der Haltung der Melancholie hat der Schmerzensmann sein Gesicht tief in der Hand des rechten, aufgestützten Arms vergraben. Einfach und ausdrucksvoll führt Dürer dem Betrachter die tiefe Verzweiflung und Einsamkeit des Gottessohnes vor Augen, der sich im untenstehenden Vers unter Verweis auf seine erlittene Passion mit dem flehentlichen Appell an den Betrachter wendet, ihn nicht immer wieder neu mit Sünden zu quälen.

The Man of Sorrows
The Small Passion, title page
Ca 1511
Woodcut
128 : 98 mm
Monogrammed; typographic text: Passio Christi ab Alberto Durer Nu/renbergensi effigiata cu[m] varij generis carmi/nibus Fratris Benedicti Chelidonij / Musophili. (above)
O mihi tantorum. iusto mihi causa dolorum / O crucis O mortis causa cruenta mihi./ O homo sat fuerit. tibi me semel ista tulisse./ O cessa culpis me cruciare nouis./ Cum priuilegio. (below)
2nd state with the title text in printed letters; Latin book edition of 1511
Watermark 20 (high crown)

Provenance: acquired in 1802/1803 from Artaria by Ludwig X, Landgrave of Hesse.
Inv. no. GR 130

Literature: Bartsch 16; Meder 125; Hollstein 125; Schoch et al. 186.
Antwerp 1970, 76.

Der Schmerzensmann
Kleine Passion, Titelblatt
um 1511
Holzschnitt
128 : 98 mm
monogrammiert; typographischer Text: Passio Christi ab Alberto Durer Nu/renbergensi effigiata cu[m] varij generis carmi/nibus Fratris Benedicti Chelidonij / Musophili. (oben)
O mihi tantorum. iusto mihi causa dolorum / O crucis O mortis causa cruenta mihi./ O homo sat fuerit. tibi me semel ista tulisse./ O cessa culpis me cruciare nouis./ Cum priuilegio. (unten)
2. Zustand mit dem Titeltext in Letterndruck. Lateinische Buchausgabe von 1511
Wasserzeichen 20 (Hohe Krone)

Herkunft: 1802/1803 über Artaria an Ludwig X. Landgraf von Hessen.
Inv. Nr. GR 130

Literatur: Bartsch 16; Meder 125; Hollstein 125; Schoch u. a. 186. Antwerpen 1970, 76.

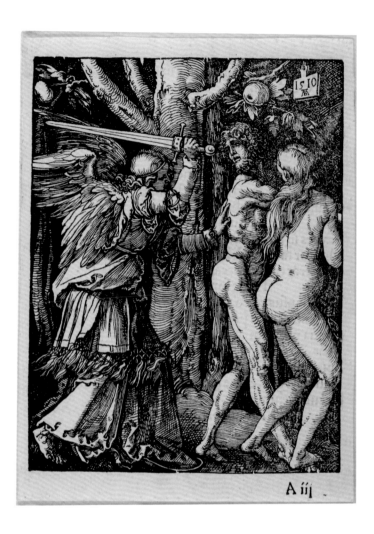

Dürer has invented a simple and powerfully expressive image for the expulsion: the angel drives Adam and Eve from Eden, pursuing them with a raised sword. In their hasty flight, the naked couple, shown in attitudes of fearful anxiety, gaze back regretfully.

55

Dürer findet ein einfaches und ausdruckstarkes Bild für die Vertreibung: Der Engel jagt mit erhobenem Schwert Adam und Eva aus dem Paradies. Bei seiner hastigen Flucht blickt das nackte Menschenpaar in angstvoller Haltung wehklagend zurück.

The Expulsion from Paradise
The Small Passion, 3
1510
Woodcut
126 : 98 mm
Monogrammed, dated
Latin book edition of 1511
No watermark

Provenance: acquired in 1802/1803 from Artaria by Ludwig X, Landgrave of Hesse. Inv. no. GR 133

Literature: Bartsch 18; Meder 127; Hollstein 127; Schoch et al. 188.
Antwerp 1970, 78.

Die Vertreibung aus dem Paradies
Kleine Passion, 3
1510
Holzschnitt
126 : 98 mm
monogrammiert, datiert
Lateinische Buchausgabe von 1511
ohne Wasserzeichen

Herkunft: 1802/1803 über Artaria an Ludwig X. Landgraf von Hessen.
Inv. Nr. GR 133

Literatur: Bartsch 18; Meder 127; Hollstein 127; Schoch u. a. 188.
Antwerpen 1970, 78.

In no other Passion cycle did Dürer depict the scene that constitutes the actual prelude to the Passion drama. A crowd surrounds Jesus, who passes through the city gates riding a donkey. A cruciform halo surrounds his head, and he blesses the believers with his right hand. His followers pray, welcoming him with palm branches and paying tribute to their Savior, who enters now as lord and sovereign.

56

In keinem seiner anderen Passionszyklen hat Dürer die Szene, die der Auftakt des eigentlichen Passionsdramas ist, bildlich gestaltet. Viel Volk umringt Jesus, der auf einer Eselin durch das Stadttor reitet. Ein Kreuznimbus umstrahlt sein Haupt, mit seiner Rechten segnet er die Gläubigen. Die Menschen beten, grüßen mit Palmzweigen und huldigen dem Heiland, der hier als Herr und König auftritt.

Christ's Entry into Jerusalem
The Small Passion, 6
Ca 1508/09
Woodcut
127 : 98 mm
Monogrammed, with laterally reversed "D"
Precedes the text
No watermark

Provenance: acquired in 1802/1803 from Artaria by Ludwig X, Landgrave of Hesse. Inv. no. GR 144

Literature: Bartsch 22; Meder 130; Hollstein 130; Schoch et al. 191.

Christi Einzug in Jerusalem
Kleine Passion, 6
um 1508/09
Holzschnitt
127 : 98 mm
monogrammiert, mit seitenverkehrtem „D"
Vor dem Text
ohne Wasserzeichen

Herkunft: 1802/1803 über Artaria an Ludwig X. Landgraf von Hessen.
Inv. Nr. GR 144

Literatur: Bartsch 22; Meder 130; Hollstein 130; Schoch u. a. 191.

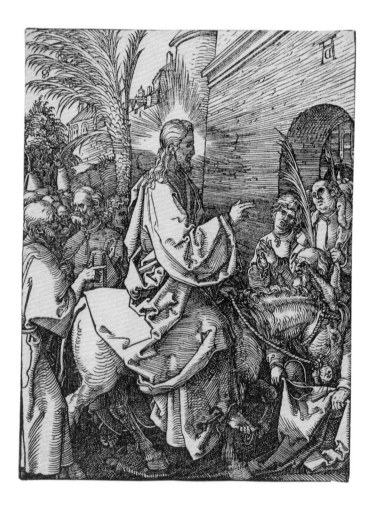

The 12 apostles are crowded together in a nearly symmetrical arrangement around a circular table that is laid with the traditional Jewish Passover meal, including lamb, bread, and wine. At the center sits Jesus, who announces his imminent betrayal with a dramatic gesture. While John sleeps peacefully on Christ's breast, the remaining apostles, visibly dismayed, engage in heated debate. One right foreground figure is isolated from the group; he stares at Jesus as though spellbound. Though still unsuspected by his companions, Judas holds a moneybag that signifies his treachery. Particularly when compared to the Last Supper from the Large Passion (cat. 40), it becomes evident that Dürer has simplified the compositional structures of the Small Passion, concentrating now on the essential.

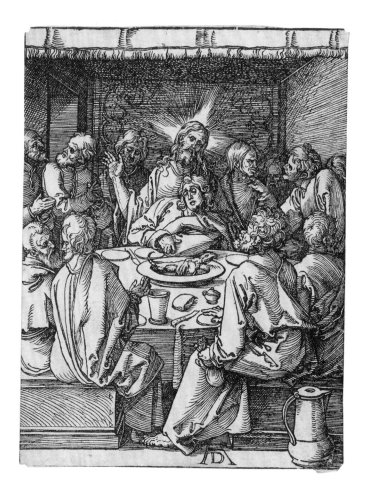

Nach dem traditionellen jüdischen Passahmahl, mit Lamm, Brot und Wein, sitzen die 12 Apostel dicht gedrängt in fast symmetrischer Anordnung um einen runden Esstisch. Im Zentrum steht Jesus, der mit ausholender Geste den Verrat bekannt gibt. Während Johannes friedlich an Christi Brust schläft, debattieren die Apostel bestürzt miteinander. Lediglich der Jünger vorne rechts ist aus der Gruppe isoliert und starrt gebannt auf Jesus. Der Geldbeutel in seiner Hand weist ihn als den – von den Aposteln noch nicht erkannten – Verräter Judas aus. Gerade im Vergleich mit der Abendmahl-Szene aus der „Großen Passion" (Kat. Nr. 40) wird deutlich, wie Dürer die Bildkomposition in der „Kleinen Passion" vereinfacht und auf das Wesentliche konzentriert.

The Last Supper	Das letzte Abendmahl
The Small Passion, 9	Kleine Passion, 9
Ca 1508/09	um 1508/09
Woodcut	Holzschnitt
126 : 98 mm	126 : 98 mm
Monogrammed	monogrammiert
Precedes the text	Vor dem Text
No watermark	ohne Wasserzeichen
Provenance: acquired in 1802/1803 from Artaria by Ludwig X, Landgrave of Hesse. Inv. no. GR 149	Herkunft: 1802/1803 über Artaria an Ludwig X. Landgraf von Hessen. Inv. Nr. GR 149
Literature: Bartsch 24; Meder 133; Hollstein 133; Schoch et al. 194.	Literatur: Bartsch 24; Meder 133; Hollstein 133; Schoch u. a. 194.

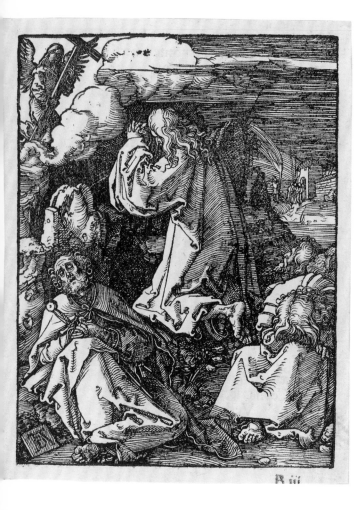

Although Dürer treated the theme of Christ on the Mount of Olives on many occasions, the Small Passion expresses an entirely new conception of Jesus in prayer. The clear sky, where an angel shows Christ on the Cross, illuminates the nocturnal scene, casting an intense light on Christ and the sleeping apostles Peter, John, and Jacob. Yet Christ seems unaware of the angel's presence. Absorbed in prayer, he strives to achieve clarity, to arrive at a decision. Through his use of lighting and composition, Dürer shifts the figure of Christ and his profound inner struggle to the center of interest.

Wenngleich Dürer das Thema von Christus am Ölberg häufig behandelte, so bringt er in der „Kleinen Passion" eine völlig neue Auffassung des betenden Christus zum Ausdruck. Der geöffnete Himmel, in dem eine Engelsgestalt Christus das Kreuz weist, erleuchtet die Nachtszene und wirft Schlaglichter auf Christus und die schlafenden Apostel Petrus, Johannes und Jakobus. Doch Christus scheint den Engel nicht wahrzunehmen. Im Gebet versunken ringt er mit sich um Entscheidung und Klarheit. Durch Lichtregie und Bildkomposition rückt Dürer die Christusfigur und die tiefe Empfindung des inneren Kampfes ins Zentrum.

58

(Agony in the Garden) Christ on the Mount of Olives The Small Passion, 11 Ca 1510 Woodcut 126 : 97 mm Monogrammed Latin text edition of 1511, a Watermark 20 (high crown)	Christus am Ölberg Kleine Passion, 11 um 1510 Holzschnitt 126 : 97 mm monogrammiert Lateinische Textausgabe von 1511, a Wasserzeichen 20 (Hohe Krone)
Provenance: acquired in 1802/1803 from Artaria by Ludwig X, Landgrave of Hesse. Inv. no. GR 153	Herkunft: 1802/1803 über Artaria an Ludwig X. Landgraf von Hessen. Inv. Nr. GR 153
Literature: Bartsch 26; Meder 135; Hollstein 135; Schoch et al. 196.	Literatur: Bartsch 26; Meder 135; Hollstein 135; Schoch u. a. 196.

Christ before Pilate
The Small Passion, 16
Ca 1508/09
Woodcut
126 : 97 mm
Monogrammed
Precedes the text
Watermark (star as with oxhead)

Provenance: acquired in
1802/1803 from Artaria by
Ludwig X, Landgrave of Hesse.
Inv. no. GR 184

Literature: Bartsch 31; Meder
140; Hollstein 140; Schoch et al.
201.

Christus vor Pilatus
Kleine Passion, 16
um 1508/09
Holzschnitt
126 : 97 mm
monogrammiert
Vor dem Text
Wasserzeichen (Stern wie bei
Ochsenkopf)

Herkunft: 1802/1803 über
Artaria an Ludwig X. Landgraf von
Hessen.
Inv. Nr. GR 184

Literatur: Bartsch 31; Meder 140;
Hollstein 140; Schoch u. a. 201.

Dürer constructs his scene as a highly–
charged triangular relationship. In the left-
hand foreground, surrounded by soldiers,
stands Jesus. Facing him from the right and
looming up is his Jewish accuser, while Pi-
late is shown as a small figure at the center,
turned toward the prisoner. These extreme
disparities in scale are highly significant: al-
though Pilate is responsible for the final
verdict, he fears the Jews, and plans
to deliver Jesus up to them.

59

Dürer konstruiert die Szene als
spannungsvolle Dreiecksbezie-
hung: Vorne links von Soldaten
umringt steht Jesus Christus, rechts ge-
genüber am Bildrand hoch aufragend sein
jüdischer Ankläger und klein in der Mitte Pi-
latus, der sich dem Gefangenen zuwendet.
Die extremen Größenverhältnisse gewinnen
inhaltliche Bedeutung: Wenngleich Pilatus
der Entscheidungsträger ist, so fürchtet er
doch die Juden und wird ihnen Jesus aus-
liefern.

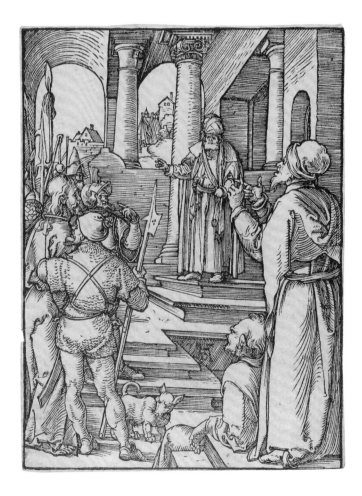

Dürer uses architecture to subdivide this scene. In the right foreground sits the lacerated Christ, surrounded by three myrmidons. They mock him, forcing the crown of thorns onto his head with brute force. In the left-hand background, Caiaphas negotiates with Pilate, who is indecisive about whether to impose a death sentence on the prisoner.

60

Dürer nutzt die Architektur, um die Szene zu gliedern. Vorne rechts im Profil sitzt der geschundene Christus umringt von drei Schergen, die ihn verspotten und ihm mit brachialer Gewalt die Dornenkrone aufs Haupt pressen. Links im Hintergrund verhandelt Kaiphas mit Pilatus, der unentschlossen ist, das Todesurteil über den Gefangenen zu verhängen.

The Crowning with Thorns
The Small Passion, 19
Ca 1509
Woodcut
127 : 97 mm
Monogrammed
Preceding the text
No watermark

Provenance: acquired in 1802/1803 from Artaria by Ludwig X, Landgrave of Hesse. Inv. no. GR 188

Literature: Bartsch 34; Meder 143; Hollstein 143; Schoch et al. 204.

Die Dornenkrönung
Kleine Passion, 19
um 1509
Holzschnitt
127 : 97 mm
monogrammiert
Vor dem Text
ohne Wasserzeichen

Herkunft: 1802/1803 über Artaria an Ludwig X. Landgraf von Hessen.
Inv. Nr. GR 188

Literatur: Bartsch 34; Meder 143; Hollstein 143; Schoch u. a. 204.

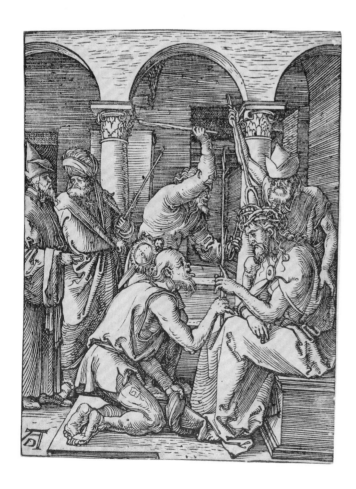

Against a darkened night sky, Dürer shows us Christ's lacerated body on the cross. Soldiers are grouped to the right, while Christ's followers stand on the left, near the cross. John raises his hands in a gesture of lamentation. A trio of women mourn in a more subdued fashion, while Mary Magdalene throws herself at her Savior's feet (see Large Passion cat. 43; Engraved Passion cat. 73).

61

Vor einem dunklen Nachthimmel zeigt Dürer den toten, geschundenen Christus am Kreuz. Rechts sind die Soldaten versammelt, links stehen die Anhänger Christi nahe am Kreuz: Johannes erhebt in klagender Geste seine Hände; eher verhalten trauern drei Frauen, während Maria Magdalena sich dem Heiland zu Füßen geworfen hat (vgl. „Große Passion" Kat. Nr. 43; „Kupferstich-Passion" Kat. Nr. 73).

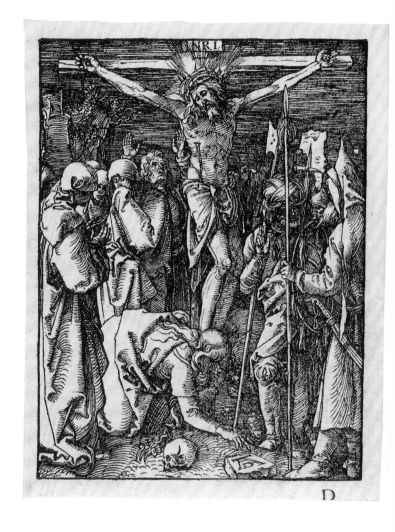

Christ on the Cross
The Small Passion, 25
Ca 1509
Woodcut
127 : 97 mm
Monogrammed
Latin text edition of 1511
No watermark

Provenance: acquired in 1802/1803 from Artaria by Ludwig X, Landgrave of Hesse.
Inv. no. GR 195

Literature: Bartsch 40; Meder 149; Hollstein 149; Schoch et al. 210.

Christus am Kreuz
Kleine Passion, 25
um 1509
Holzschnitt
127 : 97 mm
monogrammiert
Lateinische Textausgabe von 1511
ohne Wasserzeichen

Herkunft: 1802/1803 über Artaria an Ludwig X. Landgraf von Hessen.
Inv. Nr. GR 195

Literatur: Bartsch 40; Meder 149; Hollstein 149; Schoch u. a. 210.

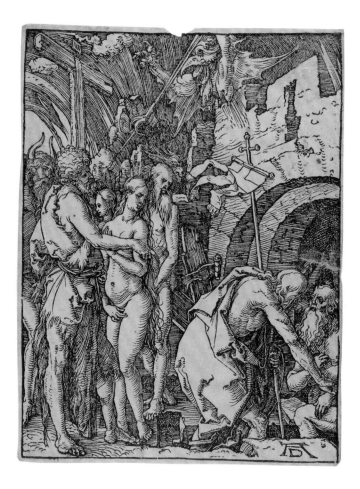

This apocryphal scene, also recounted in the Golden Legend, does not appear in the Bible. After his death on the cross, Christ descends into Limbo, where he rends the gates of hell and releases the souls of the patriarchs. A victory banner held in his left hand, Jesus bends down toward a patriarch, lifting him up out of the dark depths by one wrist. Visible among those already liberated are Moses (with horns), John the Baptist, and Adam and Eve. Dürer included this scene in all of his Passion cycles, but this small woodcut may well be the earliest version (see Engraved Passion cat. 75).

62

Nicht in der Bibel sondern apokryph und in der „Legenda aurea" wird die Szene geschildert: Nach seinem Kreuzestod steigt Christus hinab in die Hölle, wo er die Tore aufbricht und die Seelen der Altväter rettet. Die Siegesfahne in der Linken beugt sich Jesus einem Patriarchen entgegen, um ihm durch einen Griff ans Handgelenk aus der dunklen Tiefe empor zu helfen. Zu den bereits Befreiten zählen Moses (mit Hörnern), Johannes der Täufer, Adam und Eva. In all seinen Passionszyklen gestaltete Dürer die Szene, doch darf der kleine Holzschnitt als die früheste Bildfindung gelten (vgl. „Kupferstich-Passion", Kat. Nr. 75).

Christ in Limbo
The Small Passion, 26
Ca 1509
Woodcut
126 : 97 mm
Monogrammed
Without text, b
No watermark

Provenance: acquired in 1802/1803 from Artaria by Ludwig X, Landgrave of Hesse. Inv. no. GR 3150

Literature: Bartsch 41; Meder 150; Hollstein 150; Schoch et al. 211.
Antwerp 1970, 89.

Christus in der Vorhölle
Kleine Passion, 26
um 1509
Holzschnitt
126 : 97 mm
monogrammiert
Ohne Text, b
ohne Wasserzeichen

Herkunft: 1802/1803 über Artaria an Ludwig X. Landgraf von Hessen.
Inv. Nr. GR 3150

Literatur: Bartsch 41; Meder 150; Hollstein 150; Schoch u. a. 211.
Antwerpen 1970, 89.

Here, Dürer depicts the difficult lowering of Christ from the cross with a length of cloth. Head and arms hanging downward lifelessly, Christ's form falls heavily onto one of the men's shoulders. Another helper stands at the foot of the cross, using a pair of pliers to remove the last nail from the Savior's feet. In the foreground right, the scene is observed by a bearded elderly man, presumably Joseph of Arimathea. In the left-hand background, Mary and John mourn together with the other followers.

Dürer veranschaulicht die schwierige Prozedur der Kreuzabnahme. Mit Hilfe eines Tuches wird der Leichnam herabgelassen und fällt schwer auf die Schulter eines Mannes, leblos hängen Kopf und Arme herab. Am Kreuzesstamm ist ein Helfer dabei, mit einer Zange den letzten Nagel aus den beiden Füßen des Toten herauszuziehen. Vorne rechts beobachtet ein bärtiger Alter, vermutlich Joseph von Arimathia, die Szene. Links im Hintergrund trauern mit weiteren Gläubigen Maria und Johannes.

63

The Deposition
The Small Passion, 27
Ca 1509/10
Woodcut
127 : 98 mm
Monogrammed
Without text
No watermark

Provenance: acquired in 1802/1803 from Artaria by Ludwig X, Landgrave of Hesse.
Inv. no. GR 170

Literature: Bartsch 42; Meder 151 a; Hollstein 151; Schoch et al. 212.
Antwerp 1970, 90.

Die Kreuzabnahme
Kleine Passion, 27
um 1509/10
Holzschnitt
127 : 98 mm
monogrammiert
Ohne Text
ohne Wasserzeichen

Herkunft: 1802/1803 über Artaria an Ludwig X. Landgraf von Hessen.
Inv. Nr. GR 170

Literatur: Bartsch 42; Meder 151 a; Hollstein 151; Schoch u. a. 212.
Antwerpen 1970, 90.

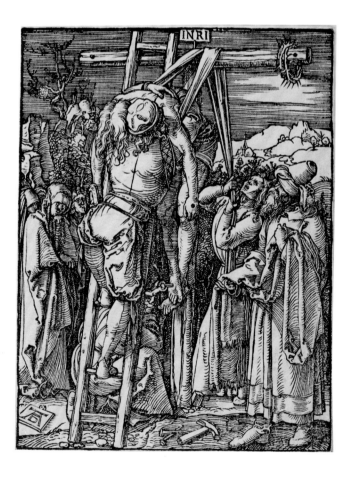

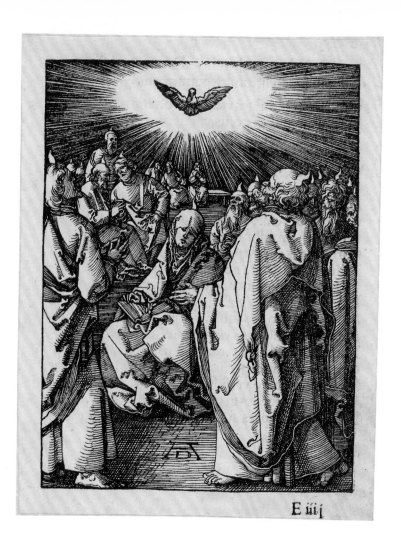

E üí·j

In this sheet, Dürer focuses entirely on the meditation of the believer and the visionary events of the Pentecost miracle, the authentic birthday celebration of the Church. Taking the form of a dove, the Holy Ghost is surrounded by glittering light. According to the Acts of the Apostles (2: 1-3), the Holy Spirit descended in the form of tongues of fire upon the original community of Christ's followers, at which point the apostles began speaking in tongues. Seated at their center is the Mother of God, who reads from the Holy Scripture, the ultimate source of faith, which she holds on her lap.

64

The Descent of the Holy Ghost
(Pentecost)
The Small Passion, 36
Ca 1510
Woodcut
127 : 96 mm
Monogrammed
Latin text edition of 1511
Watermark 20 (high crown)

Provenance: acquired in
1802/1803 from Artaria by
Ludwig X, Landgrave of Hesse.
Inv. no. GR 206

Literature: Bartsch 51; Meder
160; Hollstein 160; Schoch et al.
221.

Die Sendung des Heiligen Geistes
Kleine Passion, 36
um 1510
Holzschnitt
127 : 96 mm
monogrammiert
Lateinische Textausgabe 1511
Wasserzeichen 20 (Hohe Krone)

Herkunft: 1802/1803 über
Artaria an Ludwig X. Landgraf von
Hessen.
Inv. Nr. GR 206

Literatur: Bartsch 51; Meder 160;
Hollstein 160; Schoch u. a. 221.

In diesem Blatt konzentriert sich Dürer ganz auf die Andacht der Gläubigen und das visionäre Geschehen des Pfingstwunders, dem eigentlichen Geburtsfest der Kirche. In Gestalt einer Taube erscheint der Heilige Geist in gleißendem Licht. Nach der Apostelgeschichte (Apostelgeschichte 2, 1-3) senkt er sich in Form von Feuerzungen auf die Urgemeinde der Anhänger Christi herab, so dass die Jünger in fremden Sprachen sprechen können. In ihrer Mitte sitzt die Gottesmutter und liest in der Heiligen Schrift, der entscheidenden Glaubensquelle, die sie auf ihrem Schoß hält.

Among the burghers of late medieval European cities, where small families and kinship associations assumed increasing importance, the Holy Family was regarded as exemplary. Dürer relates his Christian theme closely to motifs from everyday life, allowing believers to experience divinity in an emotionally tinged, highly personal manner. At the same time, the scene reflects the popular piety of the time, with its emphasis on venerating the Virgin and the cult of St. Anne. Using clear lines and broad surfaces, Dürer balances the woodcut's interplay of light and dark. He arranges the members of the family around the tall tree which rises at the center of the composition, framing it with the figures of Joseph and Joachim. Their heartfelt gestures underline the loving relationship between Mary, her mother Anne, and the infant Jesus, who climbs into Anne's arms.

65

Für das Bürgertum spätmittelalterlicher Städte, wo Kleinfamilien und verwandtschaftliche Bande an Bedeutung gewannen, wurde die Heilige Familie vorbildhaft. Dürer zeigt das christliche Bildthema mit engen Bezügen zur Alltagswelt und bietet dem Gläubigen damit die Möglichkeit zu einer gefühlsbetonten, persönlichen Gotteserfahrung. Zugleich entspricht die Darstellung auch der volkstümlichen Frömmigkeit mit ihrer starken Marienverehrung, die auch den Annenkult mit einschloss. Mit klaren Linien und großen Flächen gestaltet Dürer das ausgewogene Hell-Dunkel-Spiel des Holzschnitts. Er hat die Familiengruppe um den im Bildzentrum aufragenden Baum plaziert, die Gestalten von Joseph und Joachim rahmen die Szene. Die innigen Gesten betonen die liebevolle Beziehung zwischen Maria, ihrer Mutter Anna und dem Jesuskind, das in Annas Arme strebt.

The Holy Family with Joachim and Anne Under a Tree
1511
Woodcut
235 : 158 mm
Monogrammed, dated
No watermark

Provenance: acquired in 1802/1803 from Artaria by Ludwig X, Landgrave of Hesse. Inv. no. GR 282

Literature: Bartsch 96; Meder 215 e; Hollstein 215; Schoch et al. 226.

Die Heilige Familie mit Joachim und Anna unter dem Baum
1511
Holzschnitt
235 : 158 mm
monogrammiert, datiert
ohne Wasserzeichen

Herkunft: 1802/1803 über Artaria an Ludwig X. Landgraf von Hessen. Inv. Nr. GR 282

Literatur: Bartsch 96; Meder 215 e; Hollstein 215; Schoch u. a. 226.

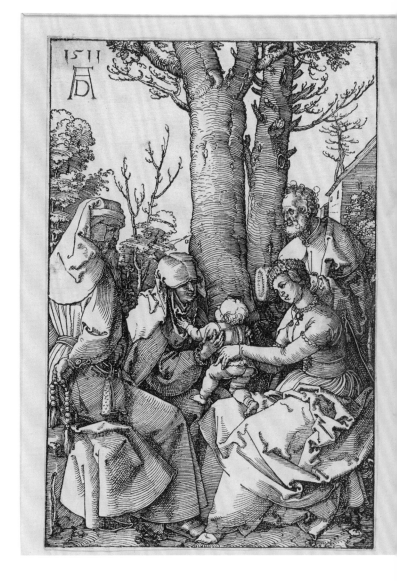

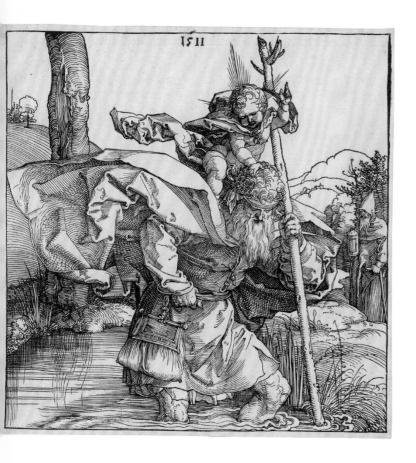

In discussions of the authorship of this woodcut, which does not bear Dürer's monogram, the version owned by the Hessisches Landesmuseum in Darmstadt is highly significant. Found on the reverse is a weak proof of a murder scene (The Death of Abel) from 1511 that is securely attributed to Dürer, which situates the production of the St. Christopher in his workshop (see Schulz 1971). The scene is bright and transparent, and the movement and three-dimensionality of the figures is emphasized by areas of light and shade. Leaning forward and bearing the Christ child—shown in the act of blessing—on his shoulders, Christopher wades knee-deep into the river, facing a wind that blows his mantle upward like a sail. Striking here is the spatial presence of the saint, who seems almost to stride beyond the edge of the image, generating an extraordinary sense of proximity between the pious viewer-believer, the saint, and the Christ Child. The result is a revival of the medieval worship of the 14 auxiliary saints, one characterized less by reverential fear on the part of believers than by the human dimension of their relationship to the saints (see cat. 30).

66

In der Diskussion um die Autorschaft des Holzschnitts, der nicht Dürers Monogramm trägt, kommt dem Blatt aus dem Hessischen Landesmuseum Darmstadt eine wichtige Rolle zu. Auf seiner Rückseite befindet sich ein schwacher Abklatsch der für Dürer gesicherten „Mordszene" (Abels Tod) aus dem Jahr 1511, was die Herstellung des „heiligen Christophorus" in Dürers Werkstatt bestätigt (vgl. Schulz 1971). Hell und transparent erscheint die Szene, einzelne Licht- und Schattenpartien unterstreichen die Bewegung und Plastizität der Figuren. Nach vorne gebeugt, das segnende Christuskind auf den Schultern tragend, watet Christophorus durch den knietiefen Fluss, wobei der Gegenwind die Umhänge wie Segel bläht. Auffallend ist die räumliche Präsenz des Heiligen, der geradewegs aus dem Bildrahmen zu steigen scheint, wodurch eine außergewöhnliche Nähe zwischen dem gläubigen Betrachter, dem Heiligen und dem Christuskind entsteht. Hier gelingt eine Neubelebung der mittelalterlichen Verehrung der 14 Nothelfer, die weniger die ehrfurchtsvolle Angst des Gläubigen als vielmehr seine menschliche Beziehung zu den Heiligen betont (vgl. Kat. Nr. 30).

St. Christopher 1511 Woodcut 213 : 214 mm dated Watermark 89 (bear) Reverse bears an impression of The Death of Abel	Der heilige Christophorus 1511 Holzschnitt 213 : 214 mm datiert Wasserzeichen 89 (Bär) Rückseite Gegendruck mit „Abels Tod"
Provenance: acquired in 1802/1803 from Artaria by Ludwig X, Landgrave of Hesse. Inv. no. GR 288	Herkunft: 1802/1803 über Artaria an Ludwig X. Landgraf von Hessen. Inv. Nr. GR 288
Literature: Bartsch 103; Meder 223 a; Hollstein 223; Schoch et al. 228. Barbara Schulz: "Bemerkungen zu dem Dürerholzschnitt des hl. Christopherus mit dem Gegendruck von Abels Tod," in: Kunst in Hessen und am Mittelrhein, 11, 1971, pp. 81-83.	Literatur: Bartsch 103; Meder 223 a; Hollstein 223; Schoch u. a. 228. Barbara Schulz: Bemerkungen zu dem Dürerholzschnitt des hl. Christopherus mit dem Gegendruck von Abels Tod, in: Kunst in Hessen und am Mittelrhein, 11, 1971, 81-83.

Depicted here is a vision of Pope Gregory the Great (540 - 604). While Gregory was saying mass, Christ as the Man of Sorrows appeared to him on the altar accompanied by the instruments of the Passion. This motif is based on a legend about the pope, according to which an oblate baker woman once laughed during the ceremony at the words: "This is the body of Christ." Having herself baked the consecrated wafer, she refused to believe in transubstantiation. Gregory took the wafer from her and prayed for her, requesting a sign from God, which soon appeared in the form of the Savior on the altar. The apparition of the Man of Sorrows is perceptible only to Gregory, while the deacons, altar boys, and dignitaries remain oblivious to the miracle. The intimate relationship between Gregory and Christ is underlined by the lighting scheme and the view axes, as well as by the identical pose of the two figures. Dürer heightens the drama by shifting the miracle from the church interior, setting it under the night sky.

Dargestellt wird die Vision von Papst Gregor dem Großen (540 - 604), dem während der Messe Christus als Schmerzensmann zwischen all seinen Leidenssymbolen auf dem Altar erscheint. Zurück geht das Thema auf die Papst-Legende, nach der bei der Messfeier eine Oblatenbäckerin bei den Worten „Dies ist der Leib Christi" lachte, da sie selbst das Brot gebacken hatte und nicht an die Transsubstantiation glauben wollte. Gregor entzog ihr die Hostie, betete für sie und erbat ein göttliches Zeichen, das mit der Erscheinung des Heilands auf dem Altar eintrat. Sichtbar ist der Schmerzensmann nur für Gregor, die ihn umgebenden Diakone, Messdiener und Würdenträger bemerken das Wunder nicht. Die enge Verbindung zwischen dem Papst und dem Heiland wird neben der Lichtführung und den Blickachsen auch durch die identische Körperhaltung der beiden betont. Zur Steigerung der Dramatik verlegt Dürer das Geschehen aus dem Kirchenraum unter den freien nächtlichen Himmel.

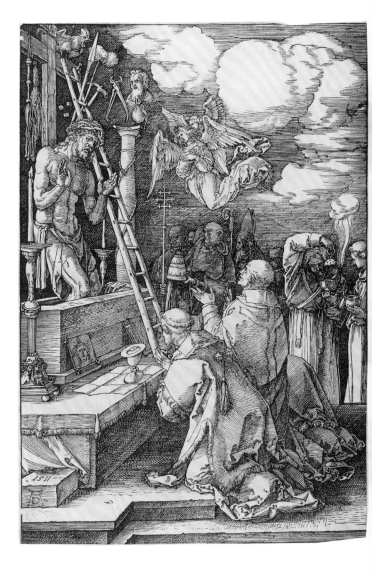

The Mass of St. Gregory	Die Messe des heiligen Gregor
1511	1511
Woodcut	Holzschnitt
298 : 207 mm	298 : 207 mm
Monogrammed, dated	monogrammiert, datiert
Watermark 62 (oxhead)	Wasserzeichen 62 (Ochsenkopf)
Provenance: acquired in 1802/1803 from Artaria by Ludwig X, Landgrave of Hesse. Inv. no. GR 3154	Herkunft: 1802/1803 über Artaria an Ludwig X. Landgraf von Hessen. Inv. Nr. GR 3154
Literature: Bartsch 123; Meder 226 b; Hollstein 226; Schoch et al. 230. Antwerp 1970, 97.	Literatur: Bartsch 123; Meder 226 b; Hollstein 226; Schoch u. a. 230. Antwerpen 1970, 97.

This finely executed woodcut, printed on an entire sheet of paper, represents a high point in Dürer's graphic production. He shows the Holy Trinity in the form of the Throne of Grace, with God the Father holding the dead Christ on his lap while the Holy Ghost hovers above them in the guise of a dove. The triadic group is surrounded by angels holding the instruments of the Passion. The bodily poses and gestures of the mourning figures are emphatically emotional, while the blowing heads of the four winds below express the tumult of the elements in response to the death of the Son of God. They also underscore the scene's supernatural character, endowing the Throne of Grace with a divine weightlessness. The intimate character of this devotional image, one meant to be seen close-up, is addressed to believers who engage in private meditation.

68

Ein Höhepunkt in Dürers druckgraphischem Werk ist dieser auf einem ganzen Bogen gedruckte, sehr fein ausgeführte Holzschnitt. Er zeigt die Dreifaltigkeit im Typus des Gnadenstuhls, wobei Gottvater den toten Christus vor sich in seinem Schoß hält, während über ihnen der Heilige Geist in Form einer Taube schwebt. Die Dreiergruppe wird von den Engeln mit den Passionswerkzeugen umgeben. Körperhaltung und Gesten der Trauernden sind gefühlsbetont, die blasenden Köpfe der vier Winde unter der Szene bringen den Aufruhr der Elemente über den Tod des Gottessohnes zum Ausdruck. Außerdem unterstreichen sie das Überirdische der Szene und verleihen dem Gnadenstuhl etwas himmlisch Schwereloses. Der intime Charakter des Andachtsbildes, das auf Nahsicht angelegt ist, richtet sich an den Gläubigen, der im privaten Raum betet.

The Holy Trinity (The Throne of Grace)
1511
Woodcut
389 : 282 mm
Monogrammed, dated
No watermark

Provenance: acquired in 1802/1803 from Artaria by Ludwig X, Landgrave of Hesse. Inv. no. GR 3153

Literature: Bartsch 122; Meder 187 c; Hollstein 187; Schoch et al. 231.

Die Heilige Dreifaltigkeit (Der Gnadenstuhl)
1511
Holzschnitt
389 : 282 mm
monogrammiert, datiert
ohne Wasserzeichen

Herkunft: 1802/1803 über Artaria an Ludwig X. Landgraf von Hessen. Inv. Nr. GR 3153

Literatur: Bartsch 122; Meder 187 c; Hollstein 187; Schoch u. a. 231.

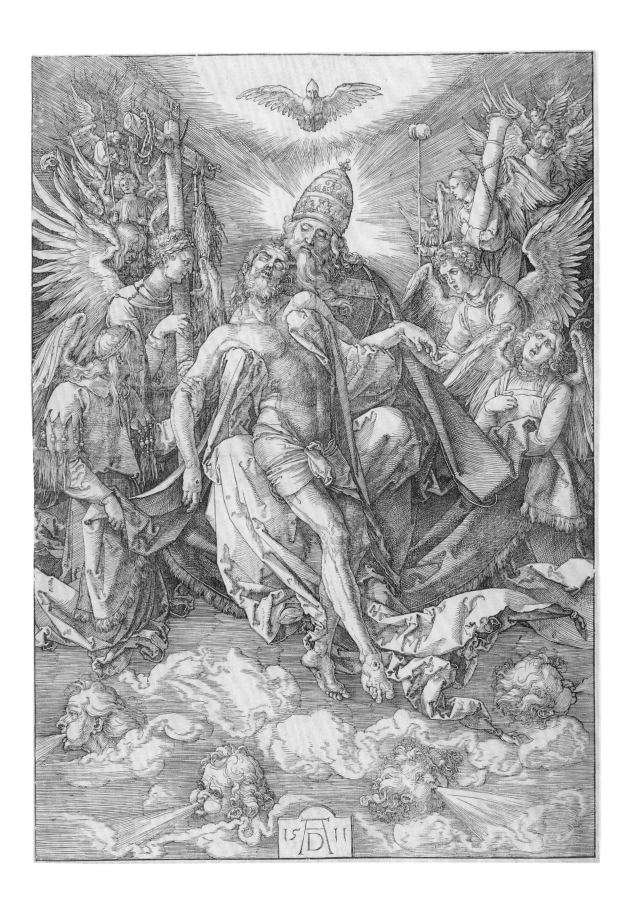

epictions of Christ's Passion occupy an exceptionally important position within Dürer's artistic oeuvre; he completed three Passion cycles in all. In addition to the woodcuts of the Large Passion (cat. 40-44) and the Small Passion, (cat. 54-64), he executed the individual compositions of the so-called Engraved Passion between 1507 and 1512/13. The series consists of 16 individual sheets in a small format which Dürer executed in a loose sequence during a six year period. An important model was Martin Schongauer's Engraved Passion, dating from the 1470s. Characteristic of Dürer's compositional strategy are strong light–dark contrasts, with individual figures and entire scenes brightly lit and set dramatically against dark backgrounds. This allowed him to heighten the narrative intensity, staging the familiar Passion story as a highly–charged drama. Without overloading his reduced pictorial space, Dürer uses a nuanced cutting technique to vividly describe architectural detail, costumes, and physiognomy. His strokes painstakingly modulate the illumination, while the properties of diverse materials are rendered with precision. The omission of any containing or framing element shifts the sufferings of Christ still closer to the viewer, who witnesses the drama's 16 scenes from slightly below. Differently than in the other Passion cycles, Dürer renounces the use of explanatory textual commentary. In assembling his Engraved Passion, which he offered at a relatively high price, Dürer was presumably appealing to educated art connoisseurs who would acquire the collection not solely for purposes of private devotion, but also for their exceptional artistic quality. Among collectors and in particular among artists, the Engraved Passion was held in high esteem, as suggested by numerous early copies and imitations.

THE ENGRAVED PASSION / DIE KUPFERSTICH-PASSION

er Darstellung der Leiden Christi kommt in Dürers künstlerischem Schaffen eine herausragende Bedeutung zu. Dürer fertigte insgesamt drei Passionszyklen: neben den Holzschnitten der „Großen Passion" (Kat. Nrn. 40-44) und „Kleinen Passion" (Kat. Nrn. 54-64) zwischen 1507 und 1512/13 die sogenannte „Kupferstich-Passion". Sie besteht aus 16 Einzelblättern in kleinem Format, die Dürer innerhalb von sechs Jahren in loser Abfolge erarbeitete. Die „Kupferstich-Passion" von Martin Schongauer aus den 1470er Jahren war wichtiges Vorbild. Charakteristisch für Dürers Gestaltung sind starke Hell-Dunkel-Kontraste, durch die er Einzelfiguren und Szenen vor dunklem Hintergrund schlaglichtartig beleuchtet. Damit gelingt es, die Erzähldramaturgie bühnenmäßig zu steigern und die vertraute Passionsgeschichte lebendig und spannend in Szene zu setzen. Ohne den kleinen Bildraum zu überfrachten, beschreibt Dürer mit differenzierter Stichtechnik architektonische Details, Kostüme und Physiognomien. Sorgfältig modulieren seine Stichlagen die Lichtführung, präzise sind die unterschiedlichen Materialeigenschaften erfasst. Durch Weglassen einer rahmenden Einfassungslinie rückt das Leiden Christi noch näher an den Betrachter, der aus leichter Untersicht in den 16 Szenenbildern dem Geschehen beiwohnt. Anders als bei seinen anderen Zyklen verzichtet Dürer auf einen erklärenden Textkommentar. Vermutlich hatte Dürer bei der Herausgabe seiner „Kupferstich-Passion", die er zu einem relativ hohen Preis feil bot, den gebildeten Kunstliebhaber im Sinn, der die 16 Blätter nicht allein zur frommen Andacht erwarb, sondern auch aus Bewunderung für die künstlerische Meisterleistung. Unter Sammlern und insbesondere auch unter Künstlern erfreute sich die „Kupferstich-Passion" größter Wertschätzung, was bereits früh zu Kopien und Nachahmungen führte.

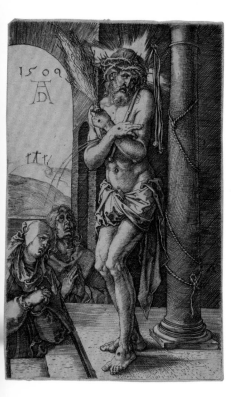

While the scene does not actually belong to the Passion story, it condenses the fundamental message of the narrative as a whole; hence its choice as the title page of the series. Christ bears the stigmata. All of his attributes – the crown of thorns, and the martyr's column with rope, scourge, and birch – refer to the Passion he has suffered, indicated sketchily by the three crosses set on Mount Golgotha near the horizon line. Just as Mary and John stand below the steps, praying to the Redeemer, viewers of The Engraved Passion were expected to gaze upward in humility at Christ the Savior. Having accepted suffering and dying on the cross as a mortal man, he was resurrected as the Son of God.

Zwar gehört die Darstellung nicht zur eigentlichen Passionsgeschichte, doch konzentriert sich in ihr ihre Grundaussage, was das Blatt zum Titelblatt der Folge macht. Christus trägt die Wundmale. All seine Attribute, Dornenkrone, Martersäule mit

69

The Man of Sorrows at the
Column
1509
The Engraved Passion, 1
Engraving
118 : 74 mm
Monogrammed, dated
Watermark 20 (high crown, lower
part)

Provenance: acquired in
1802/1803 from Artaria by
Ludwig X, Landgrave of Hesse.
Inv. no. GR 3

Literature: Bartsch 3; Meder 3 a;
Hollstein 3; Schoch et al. 45.

Der Schmerzensmann an der
Säule
1509
Kupferstich-Passion, 1
Kupferstich
118 : 74 mm
monogrammiert, datiert
Wasserzeichen 20 (Hohe Krone,
unterer Teil)

Herkunft: 1802/1803 über
Artaria an Ludwig X. Landgraf von
Hessen.
Inv. Nr. GR 3

Literatur: Bartsch 3; Meder 3 a;
Hollstein 3; Schoch u. a. 45.

Strick, Geißel und Rute, verweisen auf die erlittene Passion und seinen Tod am Kreuz, der am Horizont durch drei Kreuze auf dem Golgatha-Hügel skizziert ist. Wie Maria und Johannes unterhalb der Stufen stehen und in Andacht zu dem Heiland beten, so soll der Betrachter der „Kupferstich-Passion" in Demut zu dem Erlöser Christus emporblicken. Als Mensch nahm er das Leid auf sich und starb am Kreuz, als Gottessohn ist er auferstanden.

70

Dürer sets this rarely depicted interrogation scene in a dimly lit room. In the custody of two myrmidons and harried by an agitated crowd, Christ stands before the high priest, upon whom the light falls. We witness the decisive highpoint of the exchange, as reported in Mark 14: 61-65, Luke 22: 63-65, and in Matthew: "And the high priest answered and said unto him, I adjure thee by the living God, that you tell us whether you be Christ, the Son of God. Jesus saith unto him, Thou hast said... Then the high priest rent his clothes, and saith, What need we any further witnesses? Ye have heard the blasphemy: what think ye? And they all condemned him to be guilty of death...." (Matthew 26: 63-67).

Dürer verlegt die selten dargestellte Dialogszene in einen niedrigen düsteren Raum. Im Griff zweier Schergen und gefolgt von der aufgebrachten Menge steht Christus vor dem Hohepriester. Auf diesen richtet sich das Licht. Wir sehen den entscheidenden Höhepunkt des Verhörs, wie er bei Markus (Markus 14, 61-65), Lukas (Lukas 22, 63-65) oder Matthäus geschildert wird. „Der Hohepriester sprach zu Jesus: Ich beschwöre dich bei dem lebendigen Gott, dass du uns sagest, ob Du seist Christus, der Sohn Gottes. Jesus sprach zu ihm: Du sagst es ... Da zerriss der Hohepriester seine Kleider und sprach: Er hat Gott gelästert! Was bedürfen wir weiteres Zeugnis? Siehe, jetzt habt ihr seine Gotteslästerung gehöret. Was dünkt euch? Sie antworteten und sprachen: Er ist des Todes schuldig..." (Matthäus 26, 63-67).

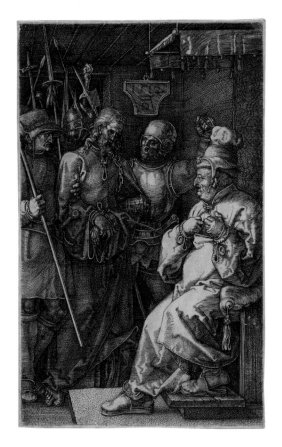

Christ Before Caiaphas
1512
The Engraved Passion, 4
Engraving
116 : 73 mm
Monogrammed, dated
No watermark

Provenance: acquired in
1802/1803 from Artaria by
Ludwig X, Landgrave of Hesse.
Inv. No. GR 6

Literature: Bartsch 6; Meder 6 a;
Hollstein 6; Schoch et al. 48.

Christus vor Kaiphas
1512
Kupferstich-Passion, 4
Kupferstich
116 : 73 mm
monogrammiert, datiert
ohne Wasserzeichen

Herkunft: 1802/1803 über
Artaria an Ludwig X. Landgraf von
Hessen.
Inv. Nr. GR 6

Literatur: Bartsch 6; Meder 6 a;
Hollstein 6; Schoch u. a. 48.

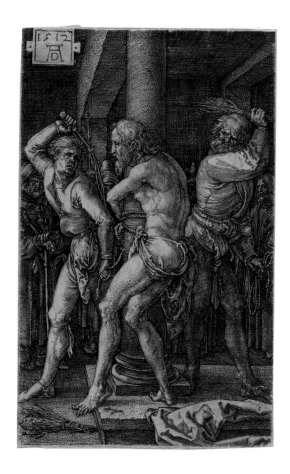

A comparison with the Flagellation from the Large Passion (cat. 41) highlights Dürer's use of the dissimilar technical resources of the woodcut and engraving media respectively for contrasting expressive contents. In the more economical woodcut medium, Dürer makes his argument through bold figural contours and eloquent gestures. Here, the engraved medium allows a subtler approach. A gloomy vault is illuminated by flickering light; the physiognomies of the protagonists are finely modeled and well–characterized psychologically. Two myrmidons use scourge and birch on the figure seen bound to the column. His back is convulsed with pain from the blows, yet his body remains uninjured. The figure of Christ, shown in a three–quarter profile view, makes an almost athletic impression. The immobile facial expression of the strict profile view testifies to the Son of God's exalted forbearance and readiness to endure suffering.

71

Der Vergleich mit der „Geißelung" aus der „Großen Passion" (Kat. Nr. 41) zeigt, wie Dürer die technischen Möglichkeiten des Holzschnitts und Kupferstichs für unterschiedliche inhaltliche Aussagen nutzt. Beim sparsamen Holzschnitt argumentiert Dürer mit treffenden Figurenumrissen und sprechenden Bewegungen. Der Stich erlaubt ihm subtilere Gestaltungen. Hier erhellen flackernde Lichtflecken ein düsteres Gewölbe, fein sind die Physiognomien der Akteure modelliert und psychologisch charakterisiert. Mit Geißel und Rute schlagen zwei Schergen den an die Säule Gebundenen. Sein Rücken krümmt sich unter den Schlägen, doch ist der Körper unversehrt. Die ins Dreiviertelprofil gewendete Christusfigur wirkt fast athletisch. Aus dem regungslosen Gesichtsausdruck des strengen Profils spricht die Leidensfähigkeit des in Duldsamkeit erhabenen Gottessohns.

The Flagellation	Die Geißelung
1512	1512
The Engraved Passion, 6	Kupferstich-Passion, 6
Engraving	Kupferstich
116 : 73 mm	116 : 73 mm
Monogrammed, dated	monogrammiert, datiert
No watermark	ohne Wasserzeichen
Provenance: acquired in 1802/1803 from Artaria by Ludwig X, Landgrave of Hesse. Inv. no. GR 8	Herkunft: 1802/1803 über Artaria an Ludwig X. Landgraf von Hessen. Inv. Nr. GR 8
Literature: Bartsch 8; Meder 8 c; Hollstein 8; Schoch et al. 50.	Literatur: Bartsch 8; Meder 8 c; Hollstein 8; Schoch u. a. 50.

Ecce Homo
1512
The Engraved Passion, 8
Engraving
115 : 73 mm
Monogrammed, dated
No watermark

Provenance: acquired in
1802/1803 from Artaria by
Ludwig X, Landgrave of Hesse.
Inv. no. GR 10

Literature: Bartsch 10; Meder 10
a; Hollstein 10; Schoch et al. 52.

Ecce Homo
1512
Kupferstich-Passion, 8
Kupferstich
115 : 73 mm
monogrammiert, datiert
ohne Wasserzeichen

Herkunft: 1802/1803 über
Artaria an Ludwig X. Landgraf von
Hessen.
Inv. Nr. GR 10

Literatur: Bartsch 10; Meder 10 a;
Hollstein 10; Schoch u. a. 52.

John (John 19: 5-15) recounts that after the flagellation, the crowning with thorns and the mocking, Pilate displayed Jesus before the people in front of the courthouse. The mob howls its demand: "Crucify him!" This early, black version from Darmstadt, with its rich burring, offers a particularly richly contrasted impression of Dürer's lighting. The scene has been reduced to essentials: the courthouse is indicated only by a darkened portal above some stone steps. Standing on them in the background to the right is Pilate, who leads the bound figure of Christ. The mob has fused into a single mass, represented by a single figure that is positioned in the light. Standing motionless before the Son of God, its attitude expresses less aggression than unyielding hardness. As so often in the sheets of the Engraved Passion (see cat. 70, 71, 73), Dürer gives more priority to the meditative and the contemplative than to richly detailed narrative elements.

72

Johannes (Johannes 19, 5-15) berichtet wie Jesus nach der Geißelung, Dornenkrönung und Verspottung vor dem Gerichtsgebäude durch Pilatus dem Volk zur Schau gestellt wird. Die Menge fordert „Kreuzige ihn!". Das frühe schwarze Darmstädter Exemplar mit reichlich stehendem Grat bringt Dürers Lichtregie besonders kontrastreich zur Geltung. Die Darstellung ist auf Wesentliches reduziert: Ein dunkles Portal mit Stufen markiert das Gerichtsgebäude. Darauf steht rechts im Hintergrund Pilatus, der den gefesselten Christus vorführt. Die Menge verschmilzt zu einem Pulk. Nur ein Mensch steht stellvertretend für alle im Licht, dem Gottessohn regungslos gegenüber. Weniger Aggressivität als unbarmherzige Härte spricht aus seiner Haltung. Wie häufig in den Blättern der „Kupferstich-Passion" (vgl. Kat. Nrn. 70, 71, 73) betont Dürer auch in dieser Szene das Nachdenklich-Kontemplative vor dem Detailreich-Erzählenden.

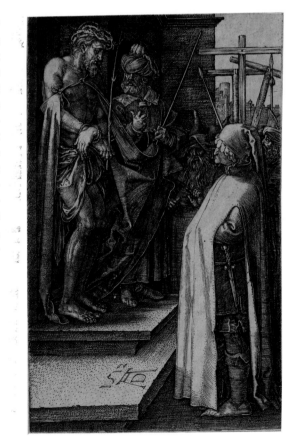

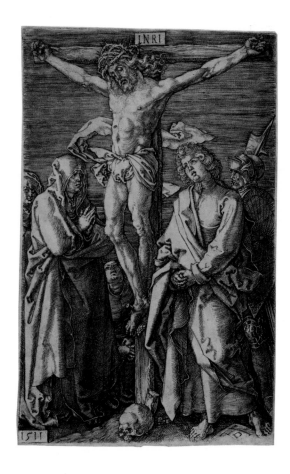

Dürer concentrates this depiction on the crucified figure of Christ and on the large figures of Mary and John. All others occupy the background, where they sink into the darkness of night. Against the already twilit sky, Christ's athletic body radiates light, heralding his triumph over death (see Large Passion **cat. 43**; Small Passion **cat. 61**).

Dürer konzentriert seine Darstellung auf den Gekreuzigten und die großen Figuren der Maria und des Johannes. Sämtliche anderen Anwesenden im Hintergrund versinken im Dunkel der Nacht. Hell erstrahlt Christi athletischer Körper vor dem bereits verdüsterten Himmel und verkündet seinen Triumph über den Tod (vgl. „Große Passion" Kat. Nr. 43; „Kleine Passion" Kat. Nr. 61).

73

Christ on the Cross
1511
The Engraved Passion, **11**
Engraving
117 : 75 mm
Monogrammed, dated
No watermark

Provenance: acquired in 1802/1803 from Artaria by Ludwig X, Landgrave of Hesse.
Inv. no. GR 13

Literature: Bartsch 13; Meder 13 b; Hollstein 13; Schoch et al. 55.

Christus am Kreuz
1511
Kupferstich-Passion, **11**
Kupferstich
117 : 75 mm
monogrammiert, datiert
ohne Wasserzeichen

Herkunft: 1802/1803 über Artaria an Ludwig X. Landgraf von Hessen.
Inv. Nr. GR 13

Literatur: Bartsch 13; Meder 13 b; Hollstein 13; Schoch u. a. 55.

74

While the Lamentation of Christ is not drawn from the gospels of the Bible, it has numbered among the standard scenes of the Passion narrative since the mid–10th century. The earliest of the 16 individual scenes, this engraving dates from immediately after the second Italian journey. Differing from the later compositions, this scene has been set against a pale background. The lighting scheme of the Lamentation is less polished, and its tonal values are shaped with less subtlety than the subsequent members of the series. Later, Dürer would also reduce the level of pathos expressed by the figures.

Die Beweinung Christi entstammt zwar nicht den Evangelien der Bibel, doch gehörte sie seit der zweiten Hälfte des 10. Jahrhunderts zu den üblichen Szenen der Passionsgeschichte. Der Kupferstich ist als der früheste der 16 Einzelszenen direkt nach der zweiten Italienreise entstanden. Anders als in den späteren Blättern stellt Dürer die Szene vor einen hellen Hintergrund. Die Lichtregie der Beweinung ist weniger ausgefeilt und die Tonwerte sind weniger subtil eingesetzt als in den späteren Blättern der Folge. Auch nimmt Dürer in den späteren Stichen das Pathos der Figuren zurück.

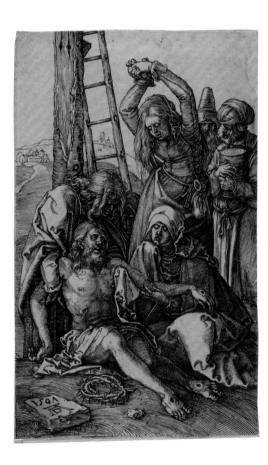

The Lamentation
1507
The Engraved Passion, 12
Engraving
116 : 71 mm
Monogrammed, dated
Watermark 62 (oxhead)

Provenance: acquired in
1802/1803 from Artaria by
Ludwig X, Landgrave of Hesse.
Inv. no. GR 14

Literature: Bartsch 14; Meder 14
a; Hollstein 14; Schoch et al. 56.

Die Beweinung
1507
Kupferstich-Passion, 12
Kupferstich
116 : 71 mm
monogrammiert, datiert
Wasserzeichen 62 (Ochsenkopf)

Herkunft: 1802/1803 über
Artaria an Ludwig X. Landgraf
von Hessen.
Inv. Nr. GR 14

Literatur: Bartsch 14; Meder 14
a; Hollstein 14; Schoch u. a. 56.

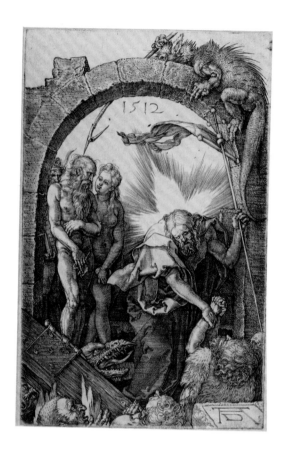

The descent of Christ into Limbo is not mentioned in the gospels of the Bible; it appears only in the Apocrypha. It is absent from the authoritative canon of the late medieval Passion cycle. Nonetheless, there exist earlier depictions, for instance by Martin Schongauer. In a novel and fantastical way, Dürer shows Christ's descent into Hell from the perspective of the damned. Christ, surrounded by light and bearing a victory banner, pulls John the Baptist up toward him by one wrist. Beyond the portal of Hell, which is guarded by dragons, stand the rescued progenitors of humankind, Adam and Eve, along with Moses, who carries the Tablets of the Law. This engraving was produced shortly after the woodcuts on the same theme from the Large and Small Passions. Dürer adopts individual elements such as the depictions of Moses and of Adam and Eve (see cat. 62).

75

Die Höllenfahrt Christi bleibt in den Evangelien der Bibel unerwähnt und taucht nur in den Apokryphen auf. Die Szene gehört nicht zum verbindlichen Kanon der spätmittelalterlichen Passionszyklen. Gleichwohl gibt es Darstellungen, etwa von Martin Schongauer, als Vorläufer. Neu und phantasiereich zeigt Dürer hier erstmals Christi Höllenfahrt gesehen aus der Perspektive der Verdammten. Der lichtumstrahlte Christus mit der Siegesfahne zieht Johannes den Täufer am Handgelenk zu sich empor. Jenseits des von Drachen bewachten Höllenportals stehen die bereits geretteten Ureltern, Adam und Eva, sowie Moses mit den Gesetzestafeln. Der Kupferstich entstand kurz nach den Holzschnitten zum selben Thema aus der „Großen" und „Kleinen Passion". Dürer übernimmt einzelne Elemente, etwa die Darstellung von Moses und Adam und Eva (vgl. Kat. Nr. 62).

Christ in Limbo
1512
The Engraved Passion, 14
Engraving
116 : 74 mm
Monogrammed, dated
No watermark

Provenance: acquired in 1802/1803 from Artaria by Ludwig X, Landgrave of Hesse. Inv. no. GR 16

Literature: Bartsch 16; Meder 16 a; Hollstein 16; Schoch et al. 58.

Christus in der Vorhölle
1512
Kupferstich-Passion, 14
Kupferstich
116 : 74 mm
monogrammiert, datiert
ohne Wasserzeichen

Herkunft: 1802/1803 über Artaria an Ludwig X. Landgraf von Hessen. Inv. Nr. GR 16

Literatur: Bartsch 16; Meder 16 a; Hollstein 16; Schoch u. a. 58.

Ecce Homo (The Man of Sorrows with Bound Hands)
1512
Drypoint
117 : 75 mm
Monogrammed, dated
Watermark 62 (oxhead)

Provenance: acquired in 1802/1803 from Artaria by Ludwig X, Landgrave of Hesse. Inv. no. GR 21

Literature: Bartsch 21; Meder 21 a; Hollstein 21; Schoch et al. 64.

Ecce Homo (Schmerzensmann mit gebundenen Händen)
1512
Kaltnadel
117 : 75 mm
monogrammiert, datiert
Wasserzeichen 62 (Ochsenkopf)

Herkunft: 1802/1803 über Artaria an Ludwig X. Landgraf von Hessen. Inv. Nr. GR 21

Literatur: Bartsch 21; Meder 21 a; Hollstein 21; Schoch u. a. 64.

This drypoint was produced along with the last 10 scenes of the Engraved Passion, and shares their small format. The pair of intertwined trees set on the horizon reiterates the stooped pose of the suffering figure of Christ. The classical contrapposto of the elongated figure is enveloped in a billowing mantle which hangs heavily from the right shoulder. The figure is depicted with bound hands and crowned with thorns, but without the stigmata, identifying it as the Christ of the Ecce Homo scene (see cat. 72).

76

With the words: "Behold! A man!" (John 19: 4–5), Pilate presents the tormented figure to the people, whereupon the crowd demands his crucifixion. This rare, early impression, with its distinct, black horizon line still visible above the left upper thigh, documents Dürer's experiments with the drypoint medium. Particularly in the rendering of the grasses and branches, he exploits the sketchy charm of this technique, while the drapery of the garments is formed from the disciplined, parallel and intersecting hatching lines so typical of the engraved medium. In a thoroughly painterly manner, Dürer sets the blurring of the fine drypoint lines against the deep, velvety black of the raised burr, which captures the black ink.

Das Kaltnadelblatt entstand zeitgleich mit den letzten zehn Blättern der „Kupferstich-Passion" und in demselben kleinen Format wie diese. Zwei am Landschaftshorizont aufragende ineinander gewundene Baumstämme wiederholen die gebeugte Haltung des leidenden Christus. Den klassischen Kontrapost der überlangen Gestalt verhüllt ein schwer von der rechten Schulter fallender, gebauschter Mantel. Der Gefesselte mit Dornenkrone wird ohne Wundmale gezeigt, was ihn zum Christus der „Ecce Homo"-Szene macht (vgl. Kat. Nr. 72). Mit den Worten „Sehet, welch ein Mensch!" (Johannes 19, 4-5) stellte Pilatus den Gepeinigten dem Volk zur Schau, worauf die Menge seine Kreuzigung forderte. Gerade der vorliegende seltene, frühe Abzug mit der deutlich über dem linken Oberschenkel sichtbaren schwarzen Horizontlinie zeigt, dass Dürer mit der kalten Nadel experimentiert. Insbesondere bei der Wiedergabe der Gräser und Äste nutzt er die skizzenhafte Anmutung dieser Technik, während er die Draperie des Gewandes mit den eher für den Kupferstich typischen, disziplinierten Parallel- und Kreuzschraffuren bildet. Durchaus malerisch setzt Dürer das Verschwimmen der feinen Kaltnadellinien gegen das tiefe samtige Schwarz der am aufgeworfenen Grat haftenden schwarzen Druckfarbe.

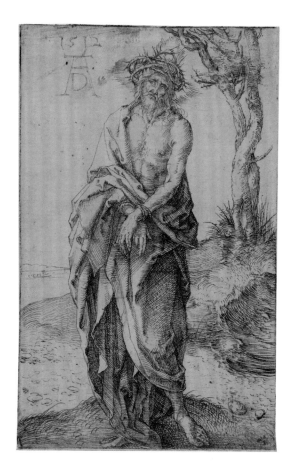

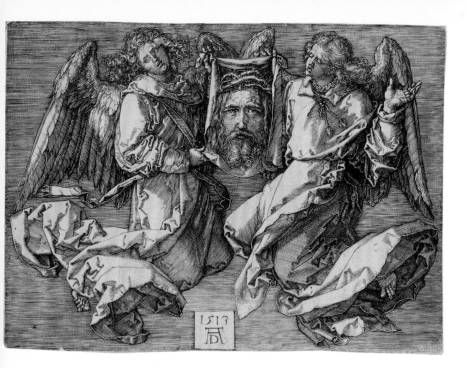

Around 1400, the legend of Veronica was integrated into the narrative of Christ's ordeal. Along the road to Golgotha, Veronica offers Jesus a cloth in order to wipe the blood and sweat from his face. When returned, it bears the likeness of Christ's face with the crown of thorns. Until the Sack of Rome in 1527, the presumed original Sudarium was displayed in St. Peter's, where it attracted many pilgrims. In this engraved sheet, intended for private devotion, Dürer sets a pair of angels, dressed in white robes and illuminated by strong light, against a nocturnal background. In mute lamentation, they present Veronica's veil to the eyes of the believer (see cat. 88). On the basis of comparisons with Dürer's Christomorphic painted self–portrait of 1500, there have been many references to certain features of Christ's likeness that are reminiscent of a self–portrait.

77

The Sudarium Held by Two Angels 1513 Engraving 100 : 139 mm Monogrammed, dated No watermark	Das Schweißtuch, von zwei Engeln gehalten 1513 Kupferstich 100 : 139 mm monogrammiert, datiert ohne Wasserzeichen
Provenance: acquired in 1802/1803 from Artaria by Ludwig X, Landgrave of Hesse. Inv. no. GR 25	Herkunft: 1802/1803 über Artaria an Ludwig X. Landgraf von Hessen. Inv. Nr. GR 25
Literature: Bartsch 25; Meder 26 b; Hollstein 26; Schoch et al. 68. Antwerp 1970, 103.	Literatur: Bartsch 25; Meder 26 b; Hollstein 26; Schoch et al. 68. Antwerpen 1970, 103.

Um 1400 wurde die Legende von Veronika in den Leidensweg Christi integriert: Auf dem Weg nach Golgatha reicht Veronika Jesus ein Tuch, um sein Gesicht von Blut und Schweiß zu säubern. Als sie das Tuch zurückerhält, hat sich darauf der Abdruck von Christi Haupt mit der Dornenkrone verewigt. Bis zum Sacco di Roma (1522) wurde das vermeintliche Original des Sudariums in St. Peter in Rom ausgestellt und zog zahlreiche Pilger an. Mit seinem für die private Andacht gedachten Kupferstichblatt zeigt Dürer vor nächtlichem Hintergrund zwei von grellem Licht beschienene Engel in langen weißen Gewändern. In stummer Klage halten sie dem Betrachter das Schweißtuch der Veronika vor Augen (vgl. Kat. Nr. 88). Mehrfach wurde durch Vergleich mit dem gemalten christomorphen Selbstbildnis Dürers von 1500 auf selbstbildnishafte Züge im Antlitz Christi verwiesen.

78

For centuries, this sheet – entitled simply The Knight– has posed riddles. Like no other work by the artist, this engraving has been exploited by various political movements and used for purposes of agitation, for example by the National Socialists. All of this has made an unprejudiced viewpoint difficult.

The knight fills the foreground of the pictorial surface. His armor is sumptuous, if old-fashioned. A lance resting on his shoulder, the man – who is no longer young – sits upright on his horse, the reins held firmly in his left hand. Accompanied by his faithful hound, he emerges from the darkness, approaching the weak light that falls from the left-hand side. The stony path leads into a narrow gorge where exposed roots cling to walls of living rock. Seen on the ground are a skull and a lizard. A distant sign of human civilization is a castle set atop a mountainous ridge. His gaze directed forward in tense concentration, the knight passes a pair of eerie companions: emerging from the darkness on the right-hand side is a bizarre devil, the tip of its spear–like weapon buried in the ground. On the left, on the same level as the knight and displaying a half–filled hourglass is Death, who is seated on a nag. His face is reminiscent of the attacker in Dürer's first engraving (cat. 1). It remains unclear whether these terrifying apparitions are actually present, or whether they appear only in the knight's mind's eye. Two distinct and divergent tendencies are distinguishable among the manifold interpretations of this print. On the basis of a fantastic, 16th-century tale about the Nuremberg mounted escort Philipp Rink, the knight has been seen as a ghost rider or robber knight, an identification given iconographic support by the foxtail seen fastened

onto his lance. In the "Physiologus," the foxtail is an emblem of the devil. By the same token, this symbol could stand for the defeat of satanic forces. The opposing camp regards the mounted figure as a Christian knight (miles christianus), who follows his path to salvation, fearless and resolute. Clearly, the composition is related to Dürer's proportional studies of horses (see cat. 35, 36, 37). Not unlike the equestrian monuments of antiquity and the Renaissance, and oriented by Donatello's Gattamelata (1447) in Padua and by Verrocchio's Colleoni in Venice (1492), which Dürer had actually seen, this mounted figure was constructed according to ideal measurements. In a way comparable to the engraving Adam and Eve (cat. 32), The Knight can also be regarded as an artistic master model, one characterized by graphic precision and formal confidence. In the 17th century, this superb early exemplar, now in Darmstadt, belonged to the Parisian art dealer and collector Pierre Mariette.

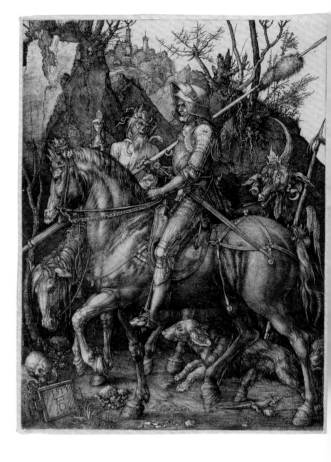

Seit Jahrhunderten wirft das Blatt, das Dürer selbst schlicht als „Reiter" bezeichnete, Rätsel auf. Wie kein anderes Werk Dürers wurde der Stich von verschiedenen politischen Lagern ideologisch benutzt und für agitatorische Zwecke missbraucht, beispielsweise auch durch die Nationalsozialisten. Dadurch scheint eine unvoreingenommene Sichtweise erschwert.

Der Reiter füllt die Bildfläche des Vordergrunds, seine Rüstung ist kostbar, wenn auch altmodisch. In aufrechter Haltung, mit geschulterter Lanze, sitzt der nicht mehr junge Mann auf seinem Pferd, die Zügel fest im Griff. Aus dem Dunkel kommend zieht er mit dem Hund als treues Begleittier dem von links einfallenden fahlen Licht entgegen. Der steinige Weg führt in eine enge Schlucht mit kahlen Felswänden, durchzogen von freiliegenden Wurzeln. Am Boden sind ein Totenschädel und eine Eidechse zu erkennen. Als fernes Zeichen menschlicher Zivilisation ist auf dem Bergrücken eine Burg zu sehen. Den Blick mit gespannter Aufmerksamkeit vorwärts gerichtet zieht der Reiter vorbei an zwei unheimlichen Gesellen: Rechts taucht aus dem Dunkel ein bizarrer Teufel mit aufgepflanzter Stangenwaffe auf. Links auf Höhe des Reiters präsentiert der Tod, der auf einer Schindmähre sitzt, ein noch halb gefülltes Stundenglas. Sein Gesicht erinnert an den Gewalttätigen in Dürers erstem Stich (Kat. Nr. 1). Fraglich ist, ob die Schreckensgestalten anwesend sind, oder ob sie der Reiter im Geiste schaut. In der Fülle der Interpretationen lassen sich zwei gegensätzliche Stränge herausschälen. Aufgrund einer fabelhaften Erzählung um den Nürnberger Geleitreiter Philipp Rink aus dem 16. Jahrhundert deutet man den Reiter als Geisterreiter oder Raubritter, ikonographisch erklärt durch den auf die Lanze gespießten Fuchsschwanz. Im „Physiologus" steht der Fuchsschwanz als Sinnbild des Teufels. Gleichwohl könnte diese Trophäe auch das Gegenteil, nämlich die Überwindung des Teuflischen, bedeuten. Die andere Seite sieht in dem Reiter den christlichen Ritter (Miles Christianus), der ohne Furcht und Tadel seinem Weg zum Seelenheil folgt. Zweifellos muss der Reiter auch im Zusammenhang mit Dürers Proportionsstudien zum Pferd gesehen werden (vgl. Kat. Nrn. 35, 36, 37). Ähnlich den Reiterdenkmälern der Antike oder Renaissance, orientiert an Donatellos Gattamelata von 1447 in Padua oder dem Colleoni von Verrocchio aus dem Jahr 1492 in Venedig, die Dürer aus eigener Anschauung kannte, ist die ritterliche Gestalt auf dem Pferd nach idealen Maßverhältnissen konstruiert. Vergleichbar dem Stich „Adam und Eva" (Kat. Nr. 32) erhält „Der Reiter" auch die Bedeutung eines mit graphischer Präzision und Formsicherheit gearbeiteten kunsttheoretischen Musterblatts. Das vorzügliche, frühe Darmstädter Exemplar gehörte im 17. Jahrhundert dem Pariser Kunsthändler und Sammler Pierre Mariette.

The Knight, Death, and the Devil
1513
Engraving
244 : 188 mm
On the signature tablet: S · 1513 · / [Dürer's monogram]
No watermark
Reverse bears an old inscription in brown ink: P. Mariette 1662

Provenance: Pierre Mariette Collection, Paris; acquired in 1802/1803 from Artaria by Ludwig X, Landgrave of Hesse. Inv. no. GR 93

Literature: Bartsch 98; Meder 74 a; Hollstein 74; Schoch et al. 69.

Der Reiter (Ritter, Tod und Teufel)
1513
Kupferstich
244 : 188 mm
Auf dem Signaturtäfelchen: S·1513·/ [Dürermonogramm]
ohne Wasserzeichen
Rückseite alt bezeichnet mit Tinte in Braun: P. Mariette 1662

Herkunft: Sammlung Pierre Mariette, Paris; 1802/1803 über Artaria an Ludwig X. Landgraf von Hessen.
Inv. Nr. GR 93

Literatur: Bartsch 98; Meder 74 a; Hollstein 74; Schoch u. a. 69.

In the literature on Dürer, the engravings The Knight (cat. 78), St. Jerome in his Study, and Melancholia (cat. 80) are referred to as the "three master engravings." This designation suggests that Dürer conceived them as a triptych, but there is no evidence for this. Probably because the daytime piece complements the nocturnal scene, Dürer often marketed St. Jerome in his Study together with Melancholia. Altogether, Dürer produced six prints on the theme of St. Jerome (see cat. 3). To distinguish this one clearly from the others, he named it "Hieronymus im Gehäus" meaning that the saint is seen indoors here rather than in a wild or natural setting.

Occupying the vanishing point of a central perspective view, the church father is shown seated at his writing desk at the rear of his study, presumably engaged in translating the Bible from the Greek original into the Latin Vulgate. The chamber is generously proportioned. Light falls through the tall windows, with their medieval bull's-eye glass panes. Ceiling, floor, and walls are made of wood. Not unlike a tomb, a step opens up in the flooring. Lying on the floor in the foreground is a sleeping dog, which is accompanied by a half–dozing lion – the same one that, according to legend, became the saint's faithful companion after Jerome removed a thorn from its throbbing paw. In 1514, Dürer had not yet seen a lion with his own eyes, which may account for the rather droll appearance of this catlike predator. Vanitas symbols are scattered around the room: on the wall above the radiant head of the aged church father and next to his cardinal's hat is an hourglass. A crucifix stands on the table, a dried bottle gourd hangs from the ceiling, and a skull sits on the windowsill. In the left foreground, the plaster is crumbling. Oddly, certain objects seem to have taken on lives of their own: the pillows – often regarded in the Middle Ages as emblems of indolence (see cat. 20)– adopt intriguingly sentient attitudes. Anthropomorphic faces can be detected in the wood grain. Disorder prevails: slippers are misaligned, heavy books have been set down with their spines upward, and even the artist's signature tablet lies flat on the floor.

In comparison to The Knight and Melancholia, St. Jerome in his Study has been subjected to art historical interpretation and research with far less frequency. As Matthias Mende (Schoch et al. 70) has pointed out, the composition may be interpreted as an allusion to Erasmus of Rotterdam, upon whom contemporaries projected Jerome's role as editor, translator, and interpreter of the Holy Scripture. For its technical brilliance, this engraving has enjoyed unqualified esteem since the 16th century. As shown by this excellent early impression from Darmstadt, Dürer produces a range of gray tones from the finest lines and dots, shaping the scene in a quasi–painterly fashion based on a gray mid–tone.

79

In der Dürer-Literatur werden die Stiche „Reiter" (Kat. Nr. 78), „Hieronymus im Gehäus" und „Melancholie" (Kat. Nr. 80) als „Die drei Meisterstiche" betitelt. Das legt nahe, Dürer habe die drei Blätter als Tripthychon konzipiert, was sich jedoch nicht belegen lässt. Wohl weil sich das Tag- mit dem Nachtstück ergänzte, hat Dürer den „Hieronymus im Gehäus" häufiger zusammen mit der „Melancholie" abgegeben. Insgesamt schuf Dürer sechs druckgraphische Blätter zum heiligen Hieronymus (vgl. Kat. Nr. 3). Zur klaren Unterscheidung nannte Dürer das vorliegende Blatt „Hieronymus im Gehäus" und meinte damit das Haus im Gegensatz zur Wildnis oder freien Natur.

Im Fluchtpunkt der Zentralperspektive sitzt hinten im Raum der Kirchenvater in konzentrierter Arbeit am Schreibpult, vermutlich überträgt er die Bibel aus dem griechischen Urtext in die lateinische Vulgata. Sein Studierkabinett ist großzügig dimensioniert: Durch hohe, mit mittelalterlichen Butzenscheiben gefüllte, Fenster fällt Licht; Decke, Boden und Wände sind mit Holz ausgekleidet. Doch der Zutritt zu dem Zimmer wird mehrfach behindert. Gleich einem Graben tut sich im Boden eine Stufe auf. Außerdem lagern im vorderen Bereich ein schlafender Hund und ein halbwacher Löwe, dem Hieronymus der Legende nach einmal einen Dorn aus der Pranke zog und der seitdem zu seinem Begleiter wurde. 1514 kannte Dürer noch keinen Löwen aus eigener Anschauung, was der Grund für die possierliche, eher katzenähnliche Darstellung des Raubtieres sein dürfte. Vanitassymbole sind im Raum verteilt: Über dem erleuchteten Haupt des alten Kirchenvaters befindet sich an der Wand neben seinem Kardinalshut eine Sanduhr; ein Kruzifix steht auf dem Tisch; an der Decke hängt ein getrockneter Flaschenkürbis; ein Totenschädel liegt auf der Fensterbank; hinten links bröckelt der Verputz der Mauer. Einzelne Dinge im Zimmer scheinen ein seltsames Eigenleben zu führen. Irritierend aktiv wirken die Kissen, die im Mittelalter häufig als Sinnbild der Faulheit verstanden wurden (vgl. Kat. Nr. 20). Auch in der Holzmaserung sind anthropomorphe Gesichter zu entdecken. Unordnung macht sich breit, die Pantoffel sind verrückt, schwere Bücher sind mit dem Rücken nach oben aufgestellt, das Signaturtäfelchen liegt am Boden. Anders als der „Reiter" oder die „Melancholie" wurde der „Hieronymus im Gehäus" weit seltener Gegenstand kunstgeschichtlicher Interpretation und Forschung. Wie Matthias Mende (Schoch u. a. 70) ausführt, kann in Hieronymus eine Anspielung auf Erasmus von Rotterdam gesehen werden. Die Zeitgenossen projizierten Hieronymus' Rolle als Herausgeber, Übersetzer und Ausleger der Heiligen Schrift auf Erasmus. Uneingeschränkte Hochachtung erfuhr der Stich seit dem 16. Jahrhundert aufgrund der technischen Meisterleistung. Der sehr gute, frühe Darmstädter Abdruck lässt deutlich erkennen, dass Dürer aus feinsten Stich- und Punktierlagen differenzierteste Grauabstufungen bildet, um aus diesem grauen Mittelton die Szene malerisch zu entwickeln.

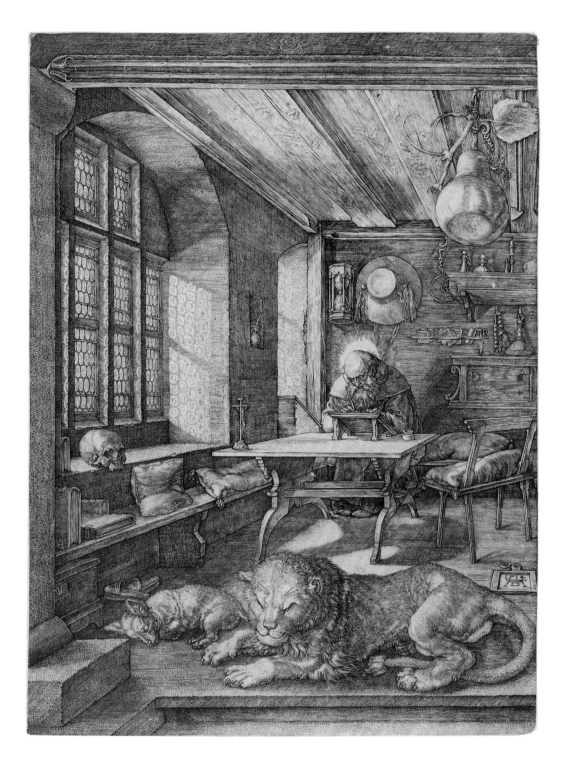

St. Jerome in his Study
1514
Engraving
249 : 189 mm
Monogrammed, dated
No watermark

Provenance: acquired in
1802/1803 from Artaria by
Ludwig X, Landgrave of Hesse.
Inv. no. GR 59

Literature: Bartsch 60; Meder 59
a; Hollstein 59; Schoch et al. 70.

Hieronymus im Gehäus
1514
Kupferstich
249 : 189 mm
monogrammiert, datiert
ohne Wasserzeichen

Herkunft: 1802/1803 über
Artaria an Ludwig X. Landgraf von
Hessen.
Inv. Nr. GR 59

Literatur: Bartsch 60; Meder 59 a;
Hollstein 59; Schoch u. a. 70.

In the upper left third of the sheet, Dürer opens a view onto a broad surface of water, with houses and mountains set along the shore. The sky is illuminated by a comet or star and a rainbow, which arches above the horizon. In flight below the rainbow is a fantastic bat–like creature, its mouth open in a cry. Set in capital letters on the inside of this creature's outspread wings – as though tattooed into the skin by the artist – is the engraving's title. The central element of this complex pictorial structure is the female figure with massive wings who is shown seated on a stone bench. She wears a long dress, the contemporary costume of a Nuremberg housewife. Dangling from her belt are a bunch of keys and a money pouch. The woman, shown with her head resting in her left hand, is "Melancholia," since antiquity a familiar emblem of dejection and sadness. She holds a closed book in her lap, above which a compass is shown held in her right hand. Decorating her head is a wreath woven from plants. Seated alongside her on a large millstone that is covered by a shawl and which leans against a wall is a winged child. Wearing a serious expression, the child draws on a slate tablet, complete with stylus, which is held on its knees. To the left, a ladder leads upward out of the picture space. Access to its rungs is blocked by an enormous polyhedron. A sleeping hound lies curled up at the winged figure's feet.
Scattered around on the ground in apparent disorder are all sorts of devices, including tools such as a hammer, pincers, level, plane, saw, nails, and ruler. Apparently related to alchemical practices are the crucible set on a coal brazier, the sphere, the inkwell, and the enema syringe. Hanging on the wall of a tower–like building is a pair of balanced scales, a half–filled hourglass, and an hour bell, its clapper immobile. Set into the side of this structure is a magic square, the so–called "Jupiter Tablet"; the sums of the rows of numbers found in the horizontal, vertical, and diagonal columns are all 34.

No other work in the history of art has generated such an immense secondary literature. Nonetheless, a number of questions remain unresolved to this day. It is impossible to say with any certainty whether the time of day depicted is dawn or dusk. Nor are the individual objects, animals, and figures unambiguously decipherable in terms of an integrated conception. Also uncertain is the significance of the "I" of the title. Should it be read as a "1," or is "i" intended, and hence the imperative of the Latin verbs "ire," that is, "go," "set course," whereby the time of day would not be the dusk of nightfall, but instead the glow of the rising day. In 2007, Erlfriede Scheil read the "§"as a paragraph header, reinterpreting the engraving as a representation of justice. Unquestionably, Dürer refers through his allegorical figure to the Humanism of his own times. He alludes to the ancient teaching of the Four Temperaments, comprised of the Melancholic, the Sanguine, the Choleric, and the Phlegmatic types, as well as to the Seven Liberal Arts. Italian Neoplatonism regarded melancholia and genius as interdependent traits. This retains an idea of Aristotle's, who in his Problema Physica poses the question of why outstanding philosophers, poets, visual artists, and politicians are consistently melancholic personalities. Against this background, Dürer's Melancholia is interpretable as an artistic self–portrait.

In the medium of the copperplate engraving, Dürer succeeds in adequately visualizing the intellectual complexity of "Melancholia," for the graphic medium transposes the pictorial idea onto the abstract plane of black-and-white. In this print, Dürer's virtuosic technique allows him to attain such a painterly effect that he has little need of color. Where the surface remains blank, the white of paper is metamorphosed into light. With an uncommon sensuality, the elaborate play of light and shadow, composed of strokes and dots, evokes a variety of materials, allowing viewers to experience them on a haptic level. One can almost touch the cool, rustling taffeta of the dress, stroke the dog's short hair, or run one's fingers over the smooth surface of the polyhedron, with its sharp edges.

Im linken oberen Drittel öffnet Dürer den Ausblick auf eine in der Dämmerung liegende Wasserfläche mit Häusern und Bergen am rechten Ufer. Den Himmel erleuchten ein Komet oder Stern und ein Regenbogen, der sich über den Horizont spannt. Darunter fliegt ein fledermausähnliches Fantasiewesen mit schreiend geöffnetem Mund. Auf der Innenseite seiner Schwingen steht in großen Lettern der gestochene Titel des Kupferstichs. Dürer hat ihn gleichsam in die aufgespannte Flughaut des Tieres tätowiert. Zentrale Gestalt des komplexen Bildgefüges ist ein auf einer Steinbank sitzendes weibliches Wesen mit gewaltigen Flügeln. Es trägt das Kleid der zeitgenössischen Nürnberger Hausfrauentracht, am Gürtel baumeln Schlüsselbund und Geldbeutel. Die Frau, die ihren Kopf in die linke Hand stützt, ist die „Melancholie", ein seit dem Altertum bekanntes Sinnbild für Schwermut und Trauer. Auf dem Schoß hält sie ein verschlossenes Buch, darüber mit der Rechten einen Stechzirkel. Ihren Kopf ziert ein aus Pflanzen gewundener Kranz. Links neben der Figur sitzt ein geflügeltes Kind auf einem großen, an die Wand gelehnten Mühlstein unter sich eine Decke. Mit ernster Mine hält es ein Schiefertäfelchen samt Griffel auf seinen Knien. Links daneben führt eine Leiter nach oben aus dem Bild. Den Zutritt zu ihren Sprossen verstellt ein riesiger Polyeder. Zu Füßen der Sitzenden liegt zusammengerollt ein Jagdhund. In scheinbarer Unordnung sind am Boden allerlei Gerätschaften verstreut. Handwerksutensilien wie Hammer, Kneifzange, Richtscheit, Hobel, Säge, Nägel und Lineal. Wissenschaftlich-alchimistisch wirken der Schmelztiegel über dem Kohlefass, die Kugel, das Tintenfass, eine Klistierspritze. An der Wand des turmartigen Baus hängt eine austarierte Waage; eine Sanduhr, die noch halb gefüllt ist; eine Stundenglocke, deren Schlegel still steht; sowie ein Magisches Quadrat, die sogenannte Jupiter-Tafel: Die Addition seiner Zahlen in der Längs-, Quer- und Diagonalreihe ergibt jeweils die Zahl 34.

Kein anderes Werk der Kunstgeschichte hat eine solche Fülle an Sekundärliteratur nach sich gezogen wie Dür-

80

ers „Melancholie", gleichwohl bleiben bis heute viele Fragen offen. Weder lässt sich eindeutig entscheiden, ob eine Morgen- oder Abenddämmerung gemeint ist, noch sind die einzelnen Gegenstände, die Tiere und Personen als Gesamtkonzeption zu entschlüsseln. Unklar bleibt auch das „I" im Titel. Ist es als „1" zu lesen, oder ist es als ein „i" gemeint und damit der Imperativ des lateinischen Verbs „ire", also „gehe", „weiche", womit die Tageszeit nicht die Abenddämmerung der einbrechenden Nacht, sondern die Morgendämmerung des anbrechenden Tages wäre. 2007 deutete Erlfriede Scheil das Zierzeichen „§" im Titel als Paragraphen und interpretierte den Kupferstich neu als eine Darstellung der Gerechtigkeit. Unbestritten aktiviert Dürer mit seiner allegorischen Figur das humanistische Gedankengut seiner Zeit. Er bezieht sich auf das antike Schema der Lehre der vier Temperamente, zu denen der Melancholiker, Sanguiniker, Choleriker und Phlegmatiker gehören, genauso wie auf die Sieben freien Künste. Der italienische Neuplatonismus sah Melancholie und Genialität in wechselseitiger Abhängigkeit von einander. Damit führte er einen Gedanken des Aristoteles fort, der in seiner „Problema physica" die Frage stellte, warum hervorragende Philosophen, Dichter, bildende Künstler oder Politiker immer Melancholiker gewesen sind. Vor diesem Hintergrund wird das Blatt auch als künstlerisches Selbstbildnis interpretierbar.

Im Medium des Kupferstichs gelingt es Dürer die intellektuelle Komplexität der „Melancholie" adäquat zu verbildlichen, denn das graphische Medium transponiert die Bildidee auf das Abstraktionsniveau des Schwarz-Weiß. Dabei erzielt Dürer mit seiner virtuosen Stichtechnik im graphischen Medium eine malerische Gestaltung, die Farbigkeit keineswegs vermissen lässt. Dort wo die Fläche unbearbeitet ist, verwandelt sich das weiße Papier in Licht. Ungemein sinnlich evoziert das komplexe Hell-Dunkel-Spiel aus Strichen und Punkten die unterschiedlichen Materialien des Bildes. Die Betrachtung vermag ein haptisches Erleben zu vermitteln. Der Betrachter fühlt den kühlen, raschelnden Taft des Kleides, er streicht mit den Augen über das Kurzhaar des Hundes, oder spürt die kalte glatte Oberfläche des Polyeders mit seinen scharfen Kanten.

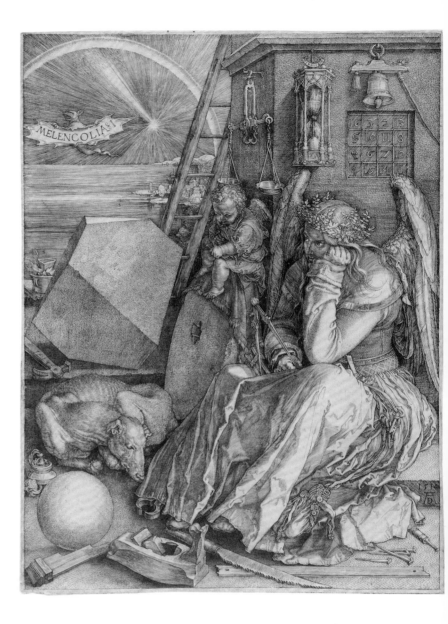

Melencolia I (Melancholia)
1514
Engraving
237 : 187 mm
Monogrammed, dated. On the bat's wings: MELENCOLIA § I
No watermark

Provenance: acquired in 1802/1803 from Artaria by Ludwig X, Landgrave of Hesse. Inv. no. GR 70

Literature: Bartsch 74; Meder 75, 2 a; Hollstein 75; Schoch et. al. 71. Elfriede Scheil: "Albrecht Dürers 'Melencholia § I' und die Gerechtigkeit," in: Zeitschrift für Kunstgeschichte, vol. 70, no 2, Deutscher Kunstverlag, Munich and Berlin 2007, pp. 201-214.

Melencolia I (Die Melancholie)
1514
Kupferstich
237 : 187 mm
monogrammiert, datiert. Auf den Flügeln der Fledermaus: MELENCOLIA § I
ohne Wasserzeichen

Herkunft: 1802/1803 über Artaria an Ludwig X. Landgraf von Hessen. Inv. Nr. GR 70

Literatur:
Bartsch 74; Meder 75, 2 a; Hollstein 75; Schoch u. a. 71. Elfriede Scheil: Albrecht Dürers „Melencholia § I" und die Gerechtigkeit, in: Zeitschrift für Kunstgeschichte, Jg. 70, Heft 2, Deutscher Kunstverlag, München und Berlin 2007, S. 201-214.

Virgin and Child in Front of a Wall
1514
Engraving
147 : 101 mm
Monogrammed, dated
No watermark

Provenance: acquired in
1802/1803 from Artaria by
Ludwig X, Landgrave of Hesse.
Inv. no. GR 39

Literature: Bartsch 40; Meder 36,
1 b; Hollstein 36; Schoch et al. 73.

Maria mit dem Kind an der Mauer
1514
Kupferstich
147 : 101 mm
monogrammiert, datiert
ohne Wasserzeichen

Herkunft: 1802/1803 über
Artaria an Ludwig X. Landgraf von
Hessen.
Inv. Nr. GR 39

Literatur: Bartsch 40; Meder 36, 1
b; Hollstein 36; Schoch u. a. 73.

A leaden heaviness lies across this group of mother and child, which dates from around the same period as Melancholia. Besides their common atmosphere of sadness, this small engraving shares with the larger masterwork its skillful execution of the finest detail, as seen in particular through a comparison of the garments. The pictorial type of Mary as the Mother of God was so familiar to the contemporary public that Dürer could dispense with the use of a halo or corona; his Virgin Mary is entirely worldly in character. The architectural detail in the left upper corner resembles the southern front of Nuremberg's Kaiserburg. Reversed left–to–right, the topography precisely recapitulates the view of the castle Dürer enjoyed from his own residence on Tiergärtnertor. The artist's mother had lived with him beginning in 1509, and this engraving may be connected to her death in May of 1514.

81

Bleierne Schwere liegt über der Mutter-Kind-Gruppe, die zeitgleich mit der „Melancholie" entstanden ist. Neben der traurigen Stimmung hat der kleine Kupferstich mit dem großen Meisterstich auch die stecherische Ausführung feinster Details gemeinsam, wie insbesondere beim Vergleich der Gewänder augenfällig wird. Der Bildtypus der Gottesmutter Maria ist beim damaligen Publikum so präsent, dass Dürer auf einen Heiligenschein oder Strahlenkranz verzichten kann, seine Maria ist ganz diesseitig. Die Architektur, die die linke obere Ecke füllt, zeigt die Südfront der Nürnberger Kaiserburg. Seitenverkehrt ist es die topographisch genaue Wiedergabe der Ansicht, die man von Dürers Wohnhaus am Tiergärtnertor aus auf die Burg hat. Eventuell steht der Kupferstich in Zusammenhang mit dem Tod der Mutter Dürers im Mai 1514, die seit 1509 in seinem Haus wohnte.

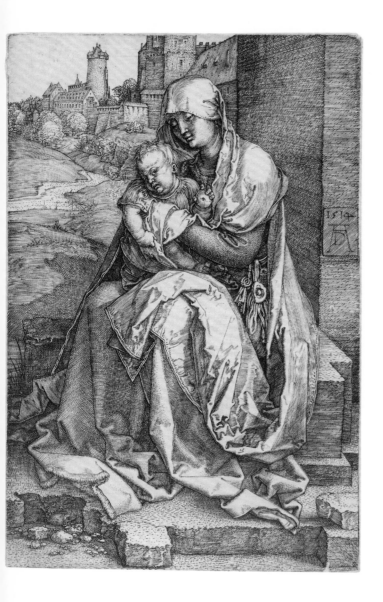

Dating from approximately 20 years after his first images of peasants, this small sheet suggests that Dürer continued to cultivate an interest in depicting the lower classes and their customs. By renouncing the use of a background, Dürer emphasizes the exemplary character of his figure study. This black, warm early impression from Darmstadt features the most delicate contours and dotting, which render with great precision the musician's shabby clothing, his instrument, and his yearning, melancholic expression. The loud, shrill tone of the bagpipes was well-suited to the uncouth dance festivities of the peasantry. This old man, shown out of doors blowing into his instrument while leaning against a tree, may be regarded as a counterpart to the Dancing Peasant Couple (cat. 83).

82

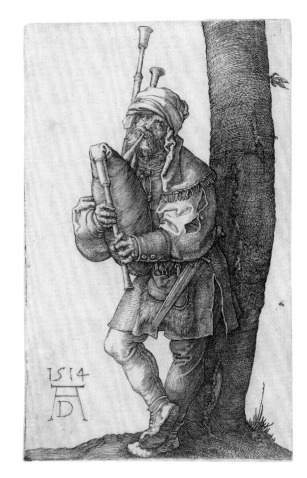

Rund 20 Jahre nach den ersten Bauerndarstellungen offenbart das kleine Blatt des Dudelsackpfeifers, dass Dürer nach wie vor an der Beschreibung niederer Kreise und ihrer Gebräuche interessiert ist. Durch den Verzicht auf eine Hintergrundgestaltung betont Dürer den exemplarischen Charakter seiner Figurstudie. Der schwarze, warme frühe Abdruck aus Darmstadt zeigt feinste Stichlagen und Punktierungen, mit denen die ärmlichen Kleider des Musikanten, sein sehnsüchtig-melancholischer Gesichtsausdruck und das Instrument exakt erfasst werden. Die lauten und schrillen Töne der Sackpfeife passen zu den derben Tanzfesten der Hirten und Bauern, weshalb der Alte, der an einen Baum angelehnt im Freien sein Instrument bläst, als Pendant zu dem „tanzenden Bauernpaar" (Kat. Nr. 83) betrachtet werden kann.

The Bagpiper	Der Dudelsackpfeifer
1514	1514
Engraving	Kupferstich
117 : 76 mm	117 : 76 mm
Monogrammed, dated	monogrammiert, datiert
No watermark	ohne Wasserzeichen
Provenance: acquired in 1802/1803 from Artaria by Ludwig X, Landgrave of Hesse. Inv. no. GR 86	Herkunft: 1802/1803 über Artaria an Ludwig X. Landgraf von Hessen. Inv. Nr. GR 86
Literature: Bartsch 91; Meder 90 a; Hollstein 90; Schoch et al. 76.	Literatur: Bartsch 91; Meder 90 a; Hollstein 90; Schoch u. a. 76.

Rollicking joyfully, an earthy peasant and his corpulent counterpart join hands. Their wild dance sends garments and limbs flying in all directions, their vigorous movements seeming to suspend the laws of gravity. Dürer confidently masters the complicated overlapping of the figures, which whirl around a central axis. The small composition – of which the early Darmstadt version offers a richly contrasting version – is permeated by dynamism. At the same time, Dürer's rendering of the various materials and his illumination of their surfaces shows a high degree of virtuosity, bringing the small genre scene into close proximity with the large-format masterworks. For the first time, Dürer depicts a peasant couple while omitting a larger scenic frame along the lines of a peasant comedy or dance festivity. He also renounces the moralizing perspective of his earlier depictions of peasants. Favored for this reason by Marxist-oriented art historians, this engraving has been interpreted as a monument to the peasantry. The small sheet is one of Dürer's most popular engravings, and was copied and imitated in numerous peasant scenes during the 16th and 17th centuries.

83

Dancing Peasant Couple
1514
Engraving
118 : 76 mm
Monogrammed, dated
No watermark

Provenance: acquired in
1802/1803 from Artaria by
Ludwig X, Landgrave of Hesse.
Inv. no. GR 85

Literature: Bartsch 90; Meder 88
a; Hollstein 88; Schoch et al. 77.

Das tanzende Bauernpaar
1514
Kupferstich
118 : 76 mm
monogrammiert, datiert
ohne Wasserzeichen

Herkunft: 1802/1803 über
Artaria an Ludwig X. Landgraf von
Hessen.
Inv. Nr. GR 85

Literatur: Bartsch 90; Meder 88 a;
Hollstein 88; Schoch u. a. 77.

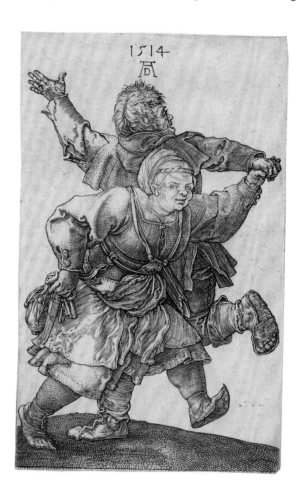

Ausgelassen packen sich der derbe Bauer und die füllige Bäuerin bei der Hand. Ihr wildes Tanzen lässt Röcke und Glieder in alle Richtungen fliegen. Im Tanzrausch scheint die Schwerkraft aufgehoben zu sein. Souverän meistert Dürer die komplizierten Überschneidungen der um ihre Achse wirbelnden Figuren. Das kleine Format, dessen Darmstädter Exemplar früh und kontrastreich ist, wird von Dynamik durchdrungen. Gleichzeitig führt Dürer bei der Materialgestaltung und der Oberflächenbeleuchtung ein Höchstmaß an stecherischer Virtuosität vor, was das kleine Genreblatt durchaus in Nähe der großformatigen Meisterstiche rückt. Dürer macht hier erstmals ein Bauernpaar ohne einen szenischen Rahmen in der Art der Bauernschwänke oder Tanzfeste zum Gegenstand. Zudem verzichtet er auf die moralisierende Betrachtungsweise früherer Bauerndarstellungen. Aus diesem Grund wurde der Kupferstich gerne von der marxistisch orientierten Kunstgeschichte als Dürers Denkmal für den Bauernstand gelesen. Das kleine Blatt ist einer der populärsten Kupferstiche Dürers und fand zahlreiche Kopien und Zitate in nachfolgenden Bauerntanzdarstellungen des 16. und 17. Jahrhunderts.

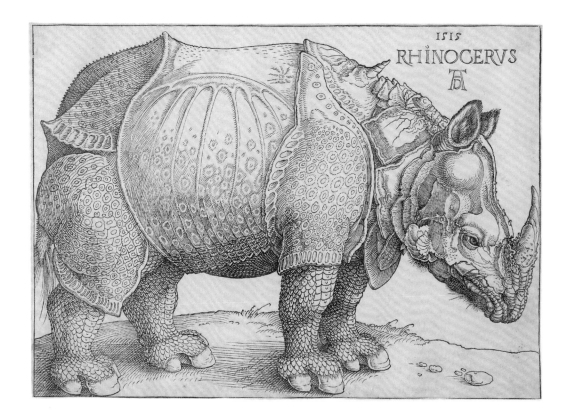

On 20 May 1515, a rhinoceros from India arrived at Lisbon Harbor, a gift to the king of Portugal. To commemorate the event, Dürer produced a broadsheet depicting the rhinoceros accompanied by five lines of text describing the creature's ferocity. As in the present example, the text portion was often subsequently removed. The basis for Dürer's composition was not a firsthand inspection of this creature, but instead written descriptions of the event received by Nuremberg merchants. Dürer's woodcut emphasizes the menacing character of the rhinoceros, whose massive bulk threatens to burst the image's boundaries. The rhinoceros's powerful frame is enveloped by a chased shell that resembles armor, and its fantastic head is surmounted by an imposing horn. Dürer has added a smaller horn to its withers. Grotesque details underline the creature's exotic qualities. With this large broadsheet edition, Dürer was able to satisfy the contemporary craving for exotic natural phenomena while providing information about distant lands lying far beyond Europe.

84

Am 20. Mai 1515 traf aus Indien ein Rhinozeros als Geschenk für den portugiesischen König im Hafen von Lissabon ein. Anlässlich dieses Ereignisses schuf Dürer ein Flugblatt mit dem Bild des Rhinozeros und fünf Textzeilen, die auf die Bösartigkeit des Tieres hinweisen. Wie bei dem vorliegenden Exemplar wurde dieser Text später häufig abgeschnitten. Grundlage für Dürers Gestaltung war nicht die eigene Anschauung des Tieres, sondern der schriftliche Bericht des Geschehens, der an die Nürnberger Kaufmannschaft gesandt wurde. Dürers Holzschnitt inszeniert die Gefährlichkeit des Rhinozeros, dessen massige Gestalt den Bildrahmen zu sprengen scheint. Groteske Details unterstreichen die Absonderlichkeit des Tieres. Gleich einer Rüstung umschließen ziselierte Schalen seinen wuchtigen Leib, ein Schuppenpanzer überzieht die Beine, auf dem phantastischen Kopf sitzt das imposante Horn, ein kleineres von Dürer hinzu gedichtetes Horn befindet sich auf dem Widerrist. Mit dem auflagenstarken Flugblatt des bizarren Rhinozeros konnte Dürer die Sensationsgier seiner Zeitgenossen nach exotischen Naturerscheinungen sowie nach Informationen aus außereuropäischen Ländern befriedigen.

The Rhinoceros
1515
Woodcut
212 : 300 mm
Monogrammed, dated and labeled: "RHINOCERUS"
Watermark 171 (anchor in a circle)
1st edition with text removed

Provenance: acquired in 1802/1803 from Artaria by Ludwig X, Landgrave of Hesse. Inv. no. GR 317

Literature: Bartsch 136; Meder 273; Hollstein 273; Schoch et al. 241.

Rhinocerus (Das Rhinozeros)
1515
Holzschnitt
212 : 300 mm
monogrammiert, datiert und bezeichnet: "RHINOCERUS"
Wasserzeichen 171 (Anker im Kreis)
1. Ausgabe mit abgeschnittenem Text

Herkunft: 1802/1803 über Artaria an Ludwig X. Landgraf von Hessen. Inv. Nr. GR 317

Literatur: Bartsch 136; Meder 273; Hollstein 273; Schoch u. a. 241.

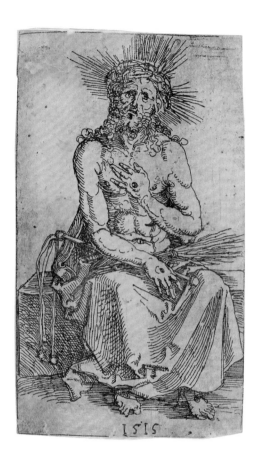

The Seated Man of Sorrows
1515
Etching on iron
111 : 65 mm
dated
No watermark

Provenance: acquired in
1802/1803 from Artaria by
Ludwig X, Landgrave of Hesse.
Inv. no.: GR 22

Literature: Bartsch 22; Meder 22,
1 b; Hollstein 22; Schoch et al. 78.

Der Schmerzensmann, sitzend
1515
Eisenradierung
111 : 65 mm
datiert
ohne Wasserzeichen

Herkunft: 1802/1803 über
Artaria an Ludwig X. Landgraf von
Hessen.
Inv. Nr.: GR 22

Literatur: Bartsch 22; Meder 22, 1
b; Hollstein 22; Schoch u. a. 78.

Dürer's six iron engravings, executed between 1515 and 1518 (see cat. 86-90), are among the earliest independent metal etchings executed anywhere. Dürer acquired the new technique through his knowledge of armor making. Because it allowed a stylus to be scratched into the soft plate without pressure, the technique encourages a free drawing style not unlike pen-and-ink. This sheet was Dürer's first attempt at etching on iron. His contours are still applied in a halting, tentative manner, and etching defects are noticeable. Only a few prints were executed during Dürer's own lifetime, for as with all iron etchings, the plate quickly became stained with rust.

85

Die sechs Eisenradierungen Dürers, die er zwischen 1515 und 1518 gearbeitet hat (vgl. Kat. Nrn. 86-90), gehören zu den frühesten eigenständigen Metallradierungen überhaupt. Durch seine Kenntnis der Kunst der Waffenschmiede kam Dürer zu der neuen Technik. Da bei der Radierung ohne Druck mit einer Nadel in einen weichen Ätzgrund geritzt wird, erlaubt die Technik einen freien Duktus, vergleichbar der Federzeichnung. Das Blatt gilt als Dürers erster Versuch mit der Eisenradierung. Seine Linien sind noch stockend und zaghaft gesetzt, Ätzfehler sind zu erkennen. Zu Dürers Lebzeiten entstanden nur wenige Drucke, denn schon bald zeigten sich, wie bei allen Eisenradierungen, Rostflecken auf der Platte.

86

At the center of this composition, an athletic male nude half-kneels on the ground, tearing his hair with both hands. This figure's dramatic gestures are the source of the print's title, The Desperate Man. The male figure seen in a profile view on the left-hand side is identifiable as Dürer's brother Endres. Nearby is the head of an old man, and behind it, half-concealed, a goat-legged satyr holding a tankard. Shown sleeping directly behind the half-kneeling figure is a nude woman, resting on a pillow. She has been regarded as a water nymph. These figures occupy no unified space, dimensions are inconsistent, and the fall of the light is contradictory. Apparently, Dürer used this sheet as a kind of practice piece on which to experiment with the new technique, producing studies of heads, garments, and nudes. Nonetheless, the enigmatic constellation of figures and gestures has given rise to speculation concerning its deeper significance.

Im Zentrum kauert in halb aufrechter Haltung ein athletischer männlicher Akt am Boden und rauft sich mit beiden Händen die Haare. Aufgrund dieser dramatischen Gebärde erhielt das Blatt auch den Titel „Der Verzweifelnde". In der am linken Rand dargestellten Halbfigur eines Mannes im Profil erkannte man Dürers Bruder Endres. Daneben steht ein Greisenkopf, dahinter halbverdeckt ein bocksbeiniger Sartyr mit einer Kanne. Direkt hinter dem Knienden schläft eine nackte weibliche Figur auf einem Kissen. In ihr sah man die Darstellung einer Quellnymphe. In der Figurenszene existiert kein verbindender Bildraum, die Größenverhältnisse wechseln, die Lichtführung ist uneinheitlich. Offensichtlich nutzte Dürer die Eisenradierung als eine Art Studienblatt, auf dem er in der neuen Technik mit Kopf-, Gewand-, und Aktstudien experimentierte. Gleichwohl gab die rätselhafte Konstellation und Gebärdensprache der Figuren vielfach Anlass zu Spekulationen über einen tieferen Sinnzusammenhang.

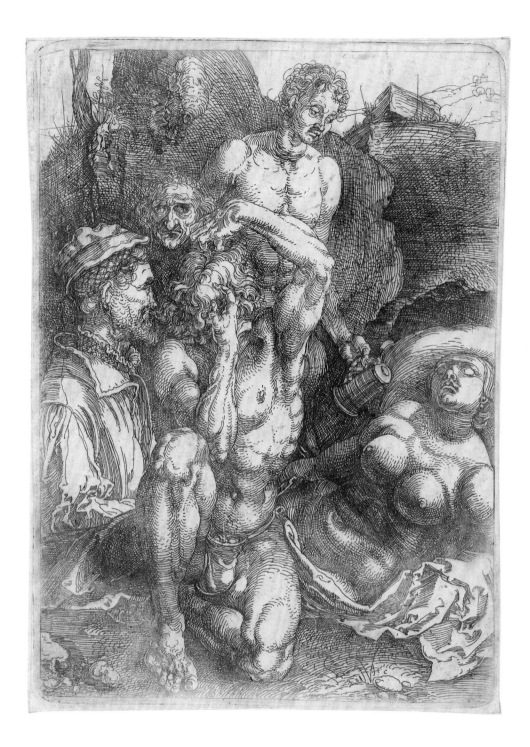

Study Sheet with Five Figures
(The Desperate Man)
Ca 1515
Etching on iron
184 : 135 mm
No watermark

Provenance: acquired in
1802/1803 from Artaria by
Ludwig X, Landgrave of Hesse.
Inv. no.: GR 66

Literature: Bartsch 70; Meder 95,
1 a; Hollstein 95; Schoch et al. 79.

Studienblatt mit fünf Figuren (Der
Verzweifelnde)
um 1515
Eisenradierung
184 : 135 mm
ohne Wasserzeichen

Herkunft: 1802/1803 über
Artaria an Ludwig X. Landgraf
von Hessen.
Inv. Nr.: GR 66

Literatur: Bartsch 70; Meder 95, 1
a; Hollstein 95; Schoch u. a. 79.

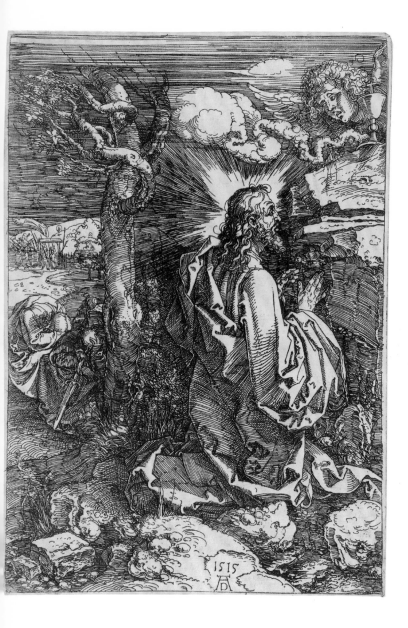

Dürer depicts Christ's meditations in the Garden of Gethsemane in highly dramatic and intensely psychological terms. The sleeping apostles and approaching henchmen are ancillary figures, while the center of the nocturnal scene is occupied by the isolated Son of God. Independent of his Passion series, Dürer returned repeatedly to the theme of Christ on the Mount of Olives, regarded by believers in the late Middle Ages as a model for correct prayer. Dürer has attained a virtuosic mastery of etching technique. His broad, uniform lines are juxtaposed with pristine white areas, which seem to be illuminated by a blazing light. The composition is pervaded by a flickering play of light and dark whose expressiveness and structure are closer to a woodcut than to an engraving.

87

Hoch dramatisch und psychologisierend gestaltet Dürer Christi Gebet im Garten Gethsemane. Die schlafenden Jünger und nahenden Häscher sind Nebensache, im Zentrum der Nachtszene steht der einsame Gottessohn. Auch außerhalb seiner Passionsfolgen widmete sich Dürer mehrfach dem Thema „Christus am Ölberg", das insbesondere im Spätmittelalter den Gläubigen als Vorbild für das richtige Beten galt. Dürer beherrscht nun virtuos die Radiertechnik. Seine breiten, gleichförmigen Ätzlinien setzt er gegen unbearbeitete weiße Stellen, die wie vom aufblitzenden Licht erhellt sind. Ein flackerndes Hell-Dunkel überzieht das Blatt, dessen Expressivität und Struktur mehr dem Holzschnitt als dem Kupferstich vergleichbar sind.

The Agony in the Garden (Christ on the Mount of Olives)
1515
Etching on iron
222 : 156 mm
Monogrammed, dated
No watermark

Provenance: acquired in 1802/1803 from Artaria by Ludwig X, Landgrave of Hesse.
Inv. no. GR 19

Literature: Bartsch 19; Meder 19 c; Hollstein 19; Schoch et al. 80.

Christus am Ölberg
1515
Eisenradierung
222 : 156 mm
monogrammiert, datiert
ohne Wasserzeichen

Herkunft: 1802/1803 über Artaria an Ludwig X. Landgraf von Hessen.
Inv. Nr. GR 19

Literatur: Bartsch 19; Meder 19 c; Hollstein 19; Schoch u. a. 80.

Sudarium Held by an Angel
1516
Etching on iron
186 : 136 mm
Monogrammed, dated
No watermark

Provenance: acquired in
1802/1803 from Artaria by
Ludwig X, Landgrave of Hesse.
Inv. no. GR 26

Literature: Bartsch 26; Meder 27,
1 c; Hollstein 27; Schoch et al. 82.

Das Schweißtuch, von einem
Engel gehalten
1516
Eisenradierung
186 : 136 mm
monogrammiert, datiert
ohne Wasserzeichen

Herkunft: 1802/1803 über
Artaria an Ludwig X. Landgraf
von Hessen.
Inv. Nr. GR 26

Literatur: Bartsch 26; Meder 27, 1
c; Hollstein 27; Schoch u. a. 82.

Particularly in comparison with the engraving The Sudarium Held by Two Angels (cat. 77), Dürer has clearly shaped this scene based on his knowledge of the specific technical potential of the medium of iron etching. While the engraving of the "vera ikon" is traditionally frontal and symmetrical, he uses the spontaneous and sketch–like character of the etched line to generate a new pictorial idea, one permeated by shimmering light and immaterial light-ness. Held by a hovering angel, the sacred cloth relic billows out like a sail. The point of rest in this theatrically animated scene is provided by the four angels, rendered in smaller dimensions, seen bearing the instruments of the Passion in the lower zone. Technical innovation enabled Dürer to arrive at an artistic reformulation of his theme, but the result hardly fulfills the function of a traditional devotional image.

Gerade im Vergleich mit dem Kupferstich „Das Schweißtuch, von zwei Engeln gehalten" (Kat. Nr. 77) wird deutlich, dass Dürer seine Darstellung aus der Kenntnis der spezifischen technischen Möglichkeiten des Mediums der Eisenradierung entwickelt hat. Zeigte Dürers Kupferstich die „Vera icon" auf traditionelle Weise frontal-symmetrisch, so nutzt er nunmehr die spontanen und skizzenhaften Möglichkeiten der radierten Linie für eine neue, von zuckendem Licht und immaterieller Leichtigkeit durchdrungene Bildidee. Von einem schwebenden Engel gehalten bläht sich die heilige Tuchreliquie gleich einem Segel. Den Ruhepol in dieser theatralisch-bewegten Szene bilden die vier in kleinerem Maßstab wiedergegebenen Engel mit den Leidenswerkzeugen im unteren Bereich. Die technische Innovation brachte Dürer zu einer künstlerischen Formulierung des Themas, die kaum mehr die Funktion eines traditionellen Andachtsbildes erfüllt.

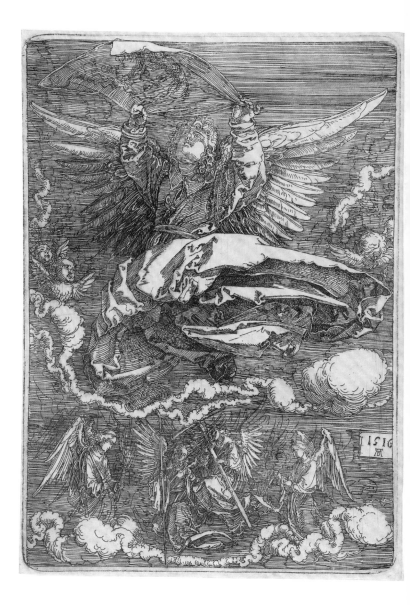

88

The Abduction on the Unicorn
(The Rape of Proserpine)
1516
Etching on iron
307 : 215 mm
Monogrammed, dated
Watermark 171 (anchor in a
circle)

Provenance: acquired in
1802/1803 from Artaria by
Ludwig X, Landgrave of Hesse.
Inv. no. GR 68

Literature: Bartsch 72; Meder 67
(before rust staining); Hollstein
67; Schoch et al. 83.

Die Entführung auf dem Einhorn
(Der Raub der Proserpina)
1516
Eisenradierung
307 : 215 mm
monogrammiert, datiert
Wasserzeichen 171 (Anker im
Kreis)

Herkunft: 1802/1803 über
Artaria an Ludwig X. Landgraf von
Hessen.
Inv. Nr. GR 68

Literatur: Bartsch 72; Meder 67
(Vor den Rostflecken); Hollstein
67; Schoch u. a. 83.

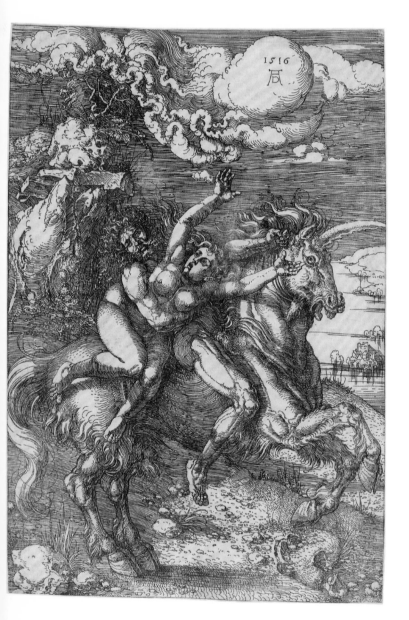

It remains uncertain whether Dürer intended to depict the Rape of Proserpine or some other mythic tale of abduction, for the turbulent scene can be securely identified neither with classical mythology nor with the medieval sagas. Apparently, Dürer plays here with mythological sources, mixing elements drawn from various contexts to form a new and independent pictorial conception. Mounted on a shaggy unicorn with goat's hooves, a rider with wild, curly hair carries off a nude woman. He holds his victim, who gestures despairingly, in one muscular arm. Through the juxtaposition of the boisterous unicorn and the struggling male and female figures, so difficult to disentangle from one another, eroticism and violence are fused into a single act of unrestrained passion.

89

Unklar ist, ob Dürer hier den Raub der Proserpina oder eine andere mythische Entführungsgeschichte darstellt, denn die stürmische Szene lässt sich weder einem Mythos der Antike noch einer Erzählung aus der mittelalterlichen Sagenwelt eindeutig zuordnen. Offensichtlich spielt Dürer mit den tradierten mythologischen Bildmustern und mischt Elemente unterschiedlicher Kontexte zu einer neuen eigenständigen Bildidee. Auf einem zottigen Einhorn mit Bockshufen hat ein wild gelockter Reiter eine nackte Frau gepackt. Gleich einer Zange umgreift sein muskulöser Arm seine in verzweifelter Not gestikulierende Beute. In der Kombination aus dem ungestümen Einhorn und den zwei kämpfenden Leibern des Mannes und der Frau, die kaum mehr zu unterscheiden sind, verschmilzt Dürer Erotik und Gewalt zu einem Akt ungezügelter Leidenschaft.

Dürer uses an atypical horizontal format for a panoramic landscape which contains a reversed topographical view of the Franconian village of Kirchehrenbach. Set up on a ridge in the foreground is the cannon used to guard Nuremberg's fortifications, here watched over by a lansquenet. Present as well are a number of apparently foreign figures, accompanied by another lansquenet. The main figure of the bearded Oriental male figure wearing a turban goes back to costume studies executed by Dürer and based on a painting by Giovanni Bellini he saw in Venice. The composition has been interpreted as an allusion to the Turkish threat which compelled emperor and pope to join forces in a crusade against the Turks in 1518. This would make Dürer's etching a patri-

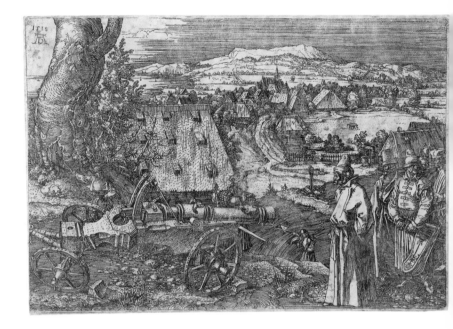

90

otic propaganda sheet in the spirit of the military policies of Maximilian I. It has been shown, however, that the cannon had been mustered already in 1518, while the foreign figures are by no means unambiguously identifiable as Turks. These inconsistencies undermine the interpretation mentioned above. Instead, Dürer seems to be alluding in general terms to the contrast between tranquil village idyll and martial posturing. It is worth noting that while Dürer executed a number of pure landscape drawings, he produced none in a print medium. To his tranquil panorama, he appends a significant foreground group as a contrasting element. Yet the transition between the two pictorial zones is marked by contradictions, including disproportionate relations of scale. Regardless, Dürer's Landscape with Cannon broke new ground for autonomous landscape etching in the 16th century.

Das ungewöhnliche Querformat nutzt Dürer für ein Landschaftspanorama, das die seitenverkehrte topographische Ansicht des fränkischen Dorfes Kirchehrenbach bei Forchheim wiedergibt. Auf der Anhöhe im Vordergrund ist eine Kanone, ein Nürnberger Festungsgeschütz, postiert, bewacht von einem Landsknecht. Hinzugetreten sind einige fremdländische Gestalten, begleitet von einem weiteren Landsknecht. Die Hauptfigur des bärtigen Orientalen mit Turban geht auf eine Kostümstudie Dürers nach einem Gemälde von Bellini in Venedig zurück. Man wollte in der Szene eine Anspielung auf die Türkengefahr sehen, denn im Jahr 1518 forcierten Kaiser und Papst einen Kreuzzug gegen die Türken. Damit wäre Dürers Radierung eine Art patriotisches „Propagandablatt" im Sinne der Rüstungspolitik Maximilian I. Jedoch wurde nachgewiesen, dass das Geschütz 1518 bereits ausgemustert war, und auch sind die Fremden keineswegs eindeutig als Türken zu identifizieren. Diese Ungereimtheiten widersprechen der oben genannten Sichtweise. Eher scheint Dürer in allgemeinem Sinn auf den Gegensatz zwischen friedlicher Dorfidylle und kriegerischem Gebaren anzuspielen. Bemerkenswert bleibt, dass Dürer, der im Medium der Zeichnung durchaus reine Landschaften ausführt, das in der Druckgraphik nicht tut. Zum beschaulichen Panorama kombiniert er als Kontrastelement eine bedeutsame Vordergrundstaffage. Dabei ergeben sich an den Übergängen der zwei Bildebenen Widersprüche, etwa durch disproportionale Größenverhältnisse. Unabhängig davon wurde Dürers „Landschaft mit Kanone" wegweisend für die autonome Landschaftsradierung im 16. Jahrhundert.

Landscape with Cannon
1518
Etching on iron
222 : 318 mm
Monogrammed, dated
Watermark 232 (small double eagle)

Provenance: acquired in 1802/1803 from Artaria by Ludwig X, Landgrave of Hesse. Inv. no. GR 2413

Literature: Bartsch 99; Meder 96 d; Hollstein 96; Schoch et al. 85.

Die Landschaft mit Kanone (Die große Kanone; Die Kanone)
1518
Eisenradierung
222 : 318 mm
monogrammiert, datiert
Wasserzeichen 232 (Kleiner Doppeladler)

Herkunft: 1802/1803 über Artaria an Ludwig X. Landgraf von Hessen. Inv. Nr. GR 2413

Literatur: Bartsch 99; Meder 96 d; Hollstein 96; Schoch u. a. 85.

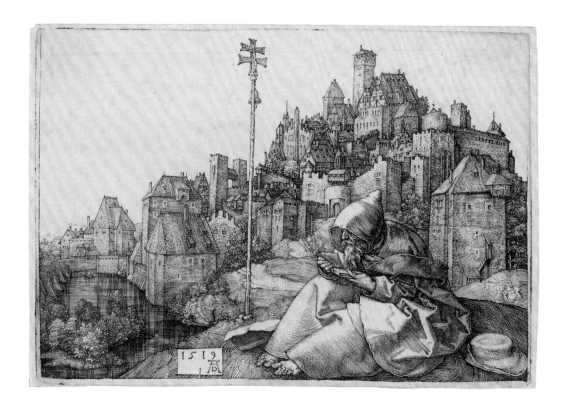

Depicted here is not the typical theme of the Temptation of St. Anthony by fiendish demons. Instead, this engraving shows the holy hermit reading with intense concentration before the gates of a city. Dürer has assembled the town's physiognomy from architectural elements observed in Nuremberg, Innsbruck, and Trento. These reminiscences, gathered to some extent during his first Italian journey, are also found in the background of the drawing Pupila Augusta (Winkler 153), which is datable to circa 1500. The tranquil and self-contained figure of the seated saint, concealed by his monk's cowl, echoes the silhouette of the town, set on the hilltop. Rising high into the heavens is a double cross with a bell, an emblem of Anthony's good works for the poor and afflicted. This silvery–black Darmstadt version, found in the 17th century in the collection of Pierre Mariette, gives an excellent impression of the tonal gradations achieved by Dürer by means of strokes and dotting. These nuances reinforce the composition's harmonious atmosphere.

91

St. Anthony Seated Before a
Townscape
1519
Engraving
100 : 141 mm
Monogrammed, dated
No watermark
Reverse bears an old inscription
in brown ink: P. Mariette 1674

Provenance: Pierre Mariette
Collection, Paris; acquired in
1802/1803 from Artaria by
Ludwig X, Landgrave of Hesse.
Inv. no. GR 57

Literature: Bartsch 58; Meder 51
a-b; Hollstein 51; Schoch et al. 87.

Der heilige Antonius vor der
Stadt
1519
Kupferstich
100 : 141 mm
monogrammiert, datiert
ohne Wasserzeichen
Rückseite alt bezeichnet mit Tinte
in Braun: P. Mariette 1674

Herkunft: Sammlung Pierre
Mariette, Paris; 1802/1803 über
Artaria an Ludwig X. Landgraf von
Hessen.
Inv. Nr. GR 57

Literatur: Bartsch 58; Meder 51
a-b; Hollstein 51; Schoch u. a. 87.

Dargestellt ist nicht das gängige Thema der Versuchung des Antonius durch teuflische Dämonen, sondern der Kupferstich zeigt den heiligen Eremiten konzentriert lesend vor den Toren einer Stadt. Deren Details hat Dürer aus architektonischen Elementen Nürnbergs, Innsbrucks und Trients zusammengefügt. Diese zum Teil auf seiner ersten Italienreise gesammelten Erinnerungen finden sich auch im Hintergrund der um 1500 entstandenen Zeichnung „Pupila Augusta" (Winkler 153). Mit der kauernden Gestalt des unter seiner Mönchskutte geborgenen Heiligen wiederholt Dürer in ruhiger Geschlossenheit die Stadtsilhouette auf dem Hügel. Als Zeichen für Antonius' Wohltaten an Armen und Kranken ragt das Doppelkreuz mit Glöckchen weit in den Himmel empor. Der schwarz-silbrige Darmstädter Abdruck, der sich im 17. Jahrhundert in der Sammlung Pierre Mariettes befand, zeigt die feinen Graubstufungen, die Dürer durch Stichlagen und Punktierungen erzielt. Sie unterstützen die ausgeglichene Grundstimmung des Blattes.

The Peasant and his Wife at
Market
1519
Engraving
114 : 72 mm
Monogrammed, dated
No watermark

Provenance: acquired in
1802/1803 from Artaria by
Ludwig X, Landgrave of Hesse.
Inv. no. GR 84

Literature: Bartsch 89; Meder 89
b; Hollstein 89; Schoch et al. 88.

Der Marktbauer und sein Weib
1519
Kupferstich
114 : 72 mm
monogrammiert, datiert
ohne Wasserzeichen

Herkunft: 1802/1803 über
Artaria an Ludwig X. Landgraf von
Hessen.
Inv. Nr. GR 84

Literatur: Bartsch 89; Meder 89 b;
Hollstein 89; Schoch u. a. 88.

This sheet, the last of Dürer's prints featuring peasants, was produced shortly before his trip to the Netherlands. Once again, mockery is perceptible in his depiction of these coarse-grained country people. The old woman with a chicken, a bag slung across her shoulder, seems better dressed than the younger man, who hawks his wares with outstretched arm. As in the Bagpiper (cat. 82), and the Dancing Peasant Couple (cat. 83), Dürer's principal interest here is in figures and types, which aligns this sheet with his proportional studies of diverse characters.

92

Dieses letzte Blatt von Dürers Bauerngraphik entstand kurz vor seiner niederländischen Reise. Wieder kann aus Dürers Darstellung der beiden grobschlächtigen Bauersleute ein gewisser Spott gelesen werden. Die Alte mit Hühnern und geschulterten Taschen scheint besser gekleidet als der jüngere Mann, der mit ausgestrecktem Arm zum Kauf der feilgebotenen Ware auffordert. Wie beim „Dudelsackpfeifer" (Kat. Nr. 82) oder dem „tanzenden Bauernpaar" (Kat. Nr. 83) liegt Dürers Hauptinteresse auf dem Studium der Typen und Figuren, weshalb man die Blätter auch in Zusammenhang mit Dürers Proportionsstudien zu unterschiedlichen Charakteren brachte.

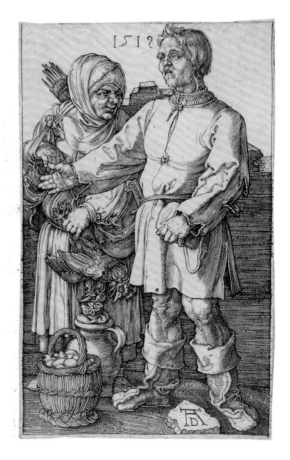

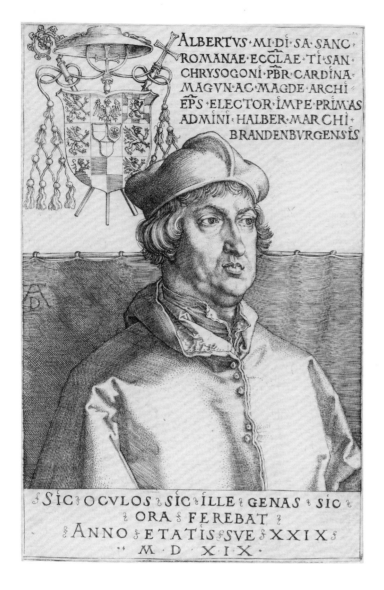

Dürer's engraved portrait was intended to serve as the title page for an inventory of Albrecht's Halle Reliquaries. The splendid coat of arms and the inscription were predetermined by the image's function as a donor portrait and book embellishment. The likeness itself, set against a dark textile background, was based on a portrait of Albrecht executed by Dürer during the Augsburg Diet of 1518 (Winkler 568). Dürer received a princely reward for his efforts. Alongside 20 ells of damask, his fee for 200 impressions together with the printing plate was 200 golden guilders, equal to two years of the income received by the artist from the Emperor Maximilian.

This engraving was commissioned by Albrecht (1490-1545), son of the Elector of Brandenburg, who was appointed cardinal during the 1518 Diet of Augsburg, and became one of the most influential representatives of the Holy Roman Empire. In 1508, Albrecht became Canon of Mainz, Archbishop of Magdeburg and Administrator of the Diocese of Halberstadt in 1513, and Archbishop and Prince Elector of Mainz in 1514. Albrecht was compelled to purchase the confirmation and permission for the anti-canonical unification of the three dioceses into one unit from the pope for an immense sum, and went into enormous debt to the Fugger banking house in Augsburg. Albrecht paid off this credit through commerce and through a trade in letters of indulgence in his ecclesiastical provinces and in the lands of Brandenburg, for which he received a commission from the pope in April of 1515. In exchange for money, believers received church certificates promising them either a shortening of their time in purgatory or the full remission of their sins. According to the official terms, receipts were to subsidize the new building of St. Peter's in Rome. A previous secret agreement, however, stipulated that one half of the funds would go to Albrecht. In the end, the issuing of such letters of indulgence triggered the proclamation of Martin Luther's 95 Theses, the Reformation, and finally a split in the Catholic church.

93

Der Kupferstich war ein Auftragswerk für Albrecht (1490-1545), den Sohn des brandenburgischen Kurfürsten, der während des Reichstags zu Augsburg 1518 zum Kardinal erhoben worden war und zu den einflussreichsten Repräsentanten des Reiches zählte. Albrecht wurde 1508 Domherr in Mainz, 1513 Erzbischof von Magdeburg und Administrator des Bistums Halberstadt und 1514 Erzbischof und Kurfürst von Mainz. Die Bestätigung und Erlaubnis zur widerkanonischen Vereinigung der drei Bistümer in einer Hand musste Albrecht dem Papst gegen eine immense Summe abkaufen und sich darum bei dem Bankhaus Fugger in Augsburg in große Schulden stürzen. Diesen Kredit tilgte Albrecht durch den Handel mit Ablassbriefen in seinen Kirchenprovinzen und in den brandenburgischen Ländern, womit ihn der Papst im April 1515 beauftragte. Gegen Geld erhielten die Gläubigen kirchliche Bescheinigungen, die ihnen die Verkürzung des Fegefeuers oder die Vergebung von Sünden versprachen. Die Einnahmen sollten nach der offiziellen Angabe für

den Neubau der Peterskirche in Rom verwendet werden, fielen aber nach vorheriger geheimer Abmachung halb an Albrecht. Die Ausschreibung jenes Ablasses zog schließlich den Thesenanschlag Martin Luthers, die Reformation und die konfessionelle Spaltung nach sich. Dürers Kupferstichporträt sollte als Titelblatt für das Verzeichnis von Albrechts Hallenser Reliquien dienen. Aus der Funktion als Buchschmuck und Stifterbild waren Dürer die Beischriften und das Prunkwappen vorgegeben; das Bildnis, das von einer dunklen Spannwand hinterfangen wird, entwickelte er aus einer Porträtzeichnung, die er während des Reichstags in Augsburg 1518 von Albrecht angefertigt hatte (Winkler 568). Dürer wurde für seine Arbeit fürstlich entlohnt. Für 200 Abzüge samt Platte betrug sein Honorar neben 20 Ellen Damast die Summe von 200 Goldgulden, was dem zweifachen Jahresgehalt entsprach, das der Künstler von Kaiser Maximilian erhalten hatte.

Cardinal Albrecht of Brandenburg (The Small Cardinal)
1519
Engraving
146 : 97 mm
Monogrammed, dated
No watermark
Printed before the text inscription found on the reverse.
Above are seven Latin verses: ALBERTVS · MI[SERICORDIA] · D[E]I· SA[CRO] · SANC[TAE] · / ROMANAE · ECCL[ESI]AE · TI[TVLI] · SAN[CTI] · / CHRYSOGONI · P[RES]B[ITE]R · CARDINA[LIS] · / MAGVN[TINENSIS] · AC · MAGDE[BVRGENSIS] · ARCHI=/ EP[ISCOPU]S · ELECTOR · IMPE[RII] · PRIMAS · / ADMINI[STRATORI · HALBER[STADENSIS] · MARCHI[O] · / BRANDENBVRGENSIS (Albrecht, Cardinal Priest through God's mercy of the Holy Roman Church with the Titulus Ecclesiae St. Chrysogonus, Archbishop of Mainz and Magdeburg, Prince–Elector of the Holy Roman Empire, Administrator of the Diocese of Halberstadt, Margrave of Brandenburg).
Below, the four–line Latin Hexameter: SIC OCVLOS SIC ILLE GENAS SIC / ORA FEREBAT / ANNO ETATIS SVE. XXIX/M. D · X · I · X. (So did his eyes, cheeks, and mouth appear in 1519 in the 29th year of his life).

Provenance: acquired in 1802/1803 from Artaria by Ludwig X, Landgrave of Hesse.
Inv. no. GR 96

Literature: Bartsch 102; Meder 100, 1 a; Hollstein 100; Schoch et al. 89.

Kardinal Albrecht von Brandenburg (Der kleine Kardinal)
1519
Kupferstich
146 : 97 mm
monogrammiert, datiert
ohne Wasserzeichen
Ausgabe vor dem Text auf der Rückseite. Oben sieben lateinische Textzeilen: ALBERTVS · MI[SERICORDIA] · D[E]I· SA[CRO] · SANC[TAE] · / ROMANAE · ECCL[ESI]AE · TI[TVLI] · SAN[CTI] · / CHRYSOGONI · P[RES]B[ITE]R · CARDINA[LIS] · / MAGVN[TINENSIS] · AC · MAGDE[BVRGENSIS] · ARCHI=/ EP[ISCOPU]S · ELECTOR · IMPE[RII] · PRIMAS · / ADMINI[STRATORI · HALBER[STADENSIS] · MARCHI[O] · / BRANDENBVRGENSIS (Albrecht, durch Gottes Barmherzigkeit Kardinal-Priester der Heiligen Römischen Kirche mit der Titelkirche des heiligen Chrysogonus, Erzbischof von Mainz und Magdeburg, Kurfürst, Primas des Reiches, Administrator des Bistums Halberstadt, Markgraf von Brandenburg). – Unten vierzeiliger lateinischer Hexameter: SIC OCVLOS SIC ILLE GENAS SIC / ORA FEREBAT / ANNO ETATIS SVE. XXIX/M. D · X · I · X. (So trug jener Augen, Wangen und Mund im 29. Jahr seines Lebensalters 1519).

Herkunft: 1802/1803 über Artaria an Ludwig X. Landgraf von Hessen.
Inv. Nr. GR 96

Literatur: Bartsch 102; Meder 100, 1 a; Hollstein 100; Schoch u. a. 89.

With this extremely rare sheet in very small dimensions, Dürer certifies his technical virtuosity as an engraver. Despite its miniature scale, the nocturnal crucifixion scene is richly detailed and displays great precision and brilliance. John stands to the left under the cross near a soldier. On the right-hand side, we see Mary and two sorrowing women, while a kneeling Mary Magdalene embraces the trunk of the cross. The sketchy individual contour lines – for instance the flat beams of the cross, the legs of the crucified figure, and John's chest – were deepened only later, suggesting that Dürer engraved this composition in a very soft metal, probably gold. It is believed that the tiny gold plate may have served as a decorative embellishment, hence the engraving's popular name, the "Saber Pommel of Emperor Maximilian."

94

Mit dem sehr seltenen Blatt stellt Dürer im kleinsten Format seine stecherische Virtuosität unter Beweis. Trotz der miniaturhaften Darstellung ist die nächtliche Kreuzigungsszene detailreich mit Schärfe und Brillanz erfasst. Unter dem Kreuz Christi stehen links Johannes und ein Kriegsknecht, rechts Maria und zwei trauernde Frauen, den Kreuzesstamm umschlingt die kauernde Maria Magdalena. Die skizzenhafte Andeutung einzelner Konturlinien, etwa am waagrechten Kreuzbalken, an den Beinen des Gekreuzigten oder auf der Brust des Johannes, die erst nachträglich vertieft wurden, legt nahe, dass Dürer die Kreuzigung in sehr weiches Metall, vermutlich Gold gestochen hat. Man vermutet, dass das kleine Goldplättchen als Schmuckstück gedient haben könnte, daher rührt auch der populäre Name des Stichs „Degenknopf Kaiser Maximilians".

The Small Crucifixion (The so-called "Saber Pommel of Emperor Maximilian")
Ca 1519
Impression of an engraved gold plate
Diameter 39 mm
No watermark

Provenance: acquired in 1802/1803 from Artaria by Ludwig X, Landgrave of Hesse.
Inv. no.: GR 23

Literature: Bartsch 23; Meder 24, 1; Hollstein 24; Schoch et al. 90.

Die kleine Kreuzigung (sog. „Degenknopf Kaiser Maximilians")
um 1519
Abdruck einer gravierten Goldplatte
Durchmesser 39 mm
ohne Wasserzeichen

Herkunft: 1802/1803 über Artaria an Ludwig X. Landgraf von Hessen.
Inv. Nr.: GR 23

Literatur: Bartsch 23; Meder 24, 1; Hollstein 24; Schoch u. a. 90.

95

Landscape and sky combine here to form the flattened backdrop of this nocturnal scene, illuminated only by the rays of the two haloes. On her lap, and resting in the fine folds of her ample white sleeves, Mary holds the sleeping child, swaddled tightly in linen. Despite the bright radiance of his cruciform nimbus, a dark shadow falls across his face. The heavy cloak lying across the Virgin's knees underscores the cubic, blocky shape and self-enclosed quality of the figural group, which might almost been hewn from stone. Through this sculptural character, so reminiscent of a pietà, Dürer alludes to Christ's Passion. Even Mary's lowered gaze seems to express less maternal solicitude than an awareness of the sufferings to come.

Landschaft und Himmel bilden die flache Hintergrundfolie der nächtlichen Szene, die nur von den Strahlen der Nimben erhellt wird. Auf dem Schoß, gebettet in das feine Gefältel ihrer weiten Ärmel, hält Maria das eng in Leinen gewickelte,

schlafende Kind, auf dessen Gesicht trotz des hell strahlenden Kreuznimbus dunkle Schatten liegen. Der schwere, über die Knie gelegte Mantel unterstreicht die kubische, blockhafte Geschlossenheit der Figurengruppe, die wie aus Stein gehauen wirkt. Mit der skulpturalen Gestaltung, die an eine Pietà erinnert, verweist Dürer auf die Passion Christi. Auch aus Marias gesenktem Blick scheint weniger mütterliche Fürsorge zu sprechen, als vielmehr das Wissen um den zukünftigen Schmerz.

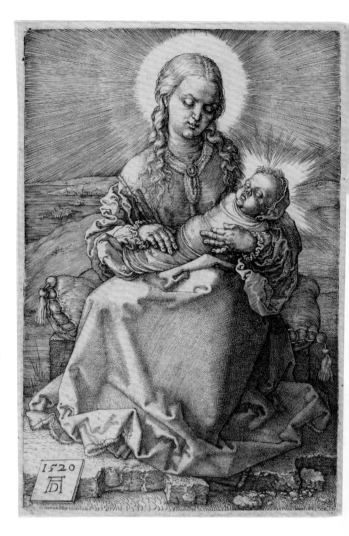

The Virgin with the Swaddled
Child
1520
Engraving
143 : 97 mm
Monogrammed, dated
No watermark

Provenance: acquired in
1802/1803 from Artaria by
Ludwig X, Landgrave of Hesse.
Inv. no. GR 37

Literature: Bartsch 38; Meder 40
a; Hollstein 40; Schoch et al. 91.

Die Jungfrau mit dem Wickelkind
1520
Kupferstich
143 : 97 mm
monogrammiert, datiert
ohne Wasserzeichen

Herkunft: 1802/1803 über
Artaria an Ludwig X. Landgraf von
Hessen.
Inv. Nr. GR 37

Literatur: Bartsch 38; Meder 40 a;
Hollstein 40; Schoch u. a. 91.

96 Dürer's eight–part triumphal chariot of the Emperor Maximilian was originally conceived as the main section of an enormous triumphal procession planned for execution in the medium of woodcut. The project was commissioned in 1512 from Dürer and other artists by Maximilian I himself, with the intention of proclaiming his own glory. Upon the ruler's death in 1519, the triumphal procession remained unfinished. In 1522, Dürer published his contribution as an independent work at his own expense. Altogether six pairs of horses draw the carriage, elaborately decorated in symbolic motifs and accompanied by numerous figures of the Virtues, on which the emperor is shown enthroned. As an artist, Dürer pays homage with the Triumphal Chariot to Maximilian, his most generous patron. At the same time, by timing the edition of the commemorative print to coincide with the emperor's death, he also exploited the demand for memorial panegyrics.

Dürers achteiliger Triumphwagen Kaiser Maximilians war ursprünglich als Hauptteil eines riesigen in Holz geschnittenen Triumphzuges gedacht, den der deutsche Kaiser Maximilian I. zu seinem Ruhme bei Dürer und anderen Künstlern 1512 in Auftrag gab. Beim Tod des Herrschers im Jahre 1519 war der Triumphzug noch unvollendet. 1522 gab Dürer seinen Anteil an diesem Unternehmen auf eigene Kosten als eigenständiges Werk heraus. Insgesamt sechs Pferdepaare ziehen den symbolreich geschmückten und von zahlreichen Tugenden begleiteten Wagen, auf dem der Kaiser thront. Als Künstler huldigt Dürer mit dem Triumphwagen seinem großmütigen Förderer Maximilian und gleichzeitig nutzt er mit der Auflage des Gedenkblatts geschickt die mit dem Tod des Kaisers gestiegene Nachfrage nach Erinnerungspanegyrik.

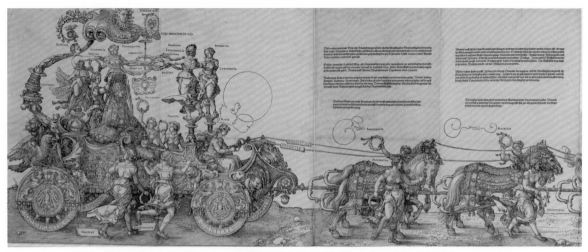

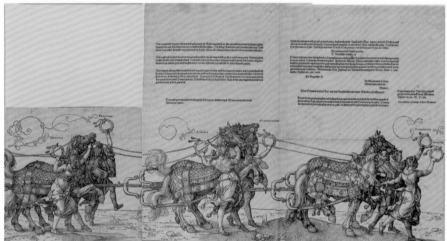

The Great Triumphal Chariot
1522 (1518)
Woodcut with 8 blocks,
Signed and dated 1522 on the 8th block

1st block: left half of the chariot with the enthroned emperor. 453 : 301 mm
2nd block: right half of the chariot. 413 : 305 mm
3rd block: first pair of horses with Providentia and Moderatio. 366 : 247 mm
4th block: second pair of horses with Alacritas and Oportunitas. 390 : 275 mm
7th block: fifth pair of horses with Audatia and Magnanimitas. 390 : 275 mm
8th block: sixth and front most pair of horses with Experientia and Solertia. Address and privilege in four verses: "This chariot was invented in Nuremberg / and cut and printed by Albrecht / Dürer in the year M. D. XXJJ." / Cum Gratia et Privilegio Cesaree Maiestatis." 397 : 323 mm

1st edition of 1522 with German text.
The Darmstadt exemplar lacks the 5th and 6th blocks
Provenance: acquired in 1802/1803 from Artaria by Ludwig X, Landgrave of Hesse.
Inv. no. GR 320 - 323

Literature: Bartsch 139; Meder 252; Hollstein 252; Schoch et al. 257.

Der große Triumphwagen
1522 (1518)
Holzschnitt von 8 Stöcken,
Signiert und 1522 datiert auf dem 8. Stock

1. Stock: Linke Hälfte des Wagens, mit dem thronenden Kaiser. 453 : 301 mm
2. Stock: Rechte Hälfte des Wagens. 413 : 305 mm
3. Stock: Erstes Pferdepaar mit Providentia und Moderatio. 366 : 247 mm
4. Stock: Zweites Pferdepaar mit Alacritas und Oportunitas. 390 : 275 mm
7. Stock: Fünftes Pferdepaar mit Audatia und Magnanimitas. 390 : 275 mm
8. Stock: Sechstes, vorderstes Pferdepaar mit Experientia und Solertia. Adresse und Privileg in 4 Zeilen: „Diser wagen ist zu Nurmberg erfunde / gerissen unnd gedruckt durch Albrechten / Thurer, im jar. M. D. XXJJ." / Cum Gratia et Privilegio Cesaree Maiestatis". 397 : 323 mm

1. Ausgabe 1522 mit deutschem Text.
Beim Darmstädter Exemplar fehlen der 5. und 6. Stock
Herkunft: 1802/1803 über Artaria an Ludwig X. Landgraf von Hessen.
Inv. Nr. GR 320 - 323

Literatur: Bartsch 139; Meder 252; Hollstein 252; Schoch u. a. 257.

97 In 1523, Dürer sent the finished plate of this engraving along with 500 printed exemplars to Albrecht of Brandenburg. The print was based on a silverpoint portrait drawing executed by Dürer in Nuremberg in 1522 or early 1523 (Winkler 896). This profile view draws on traditional portraiture formulae found on antique reliefs and coins. By placing the inscription both above and below the pictorial field and supplying the lower one with a recessed frame seen in perspective, Dürer reinforces the impression of a relief hewn into a stone panel.

Der vollendete Stich wurde 1523 von Dürer mit 500 Exemplaren an Albrecht von Brandenburg geschickt. Die dem Bildnis zugrunde liegende Silberstiftzeichnung hatte Dürer in Nürnberg 1522 oder Anfang 1523 angefertigt (Winkler 896). Bei der Profildarstellung des Kardinals bediente sich Dürer einer von antiken Reliefs und Münzen her geläufigen Bildnisform. Indem er die Inschriften ober- und unterhalb des Bildfeldes plaziert und die untere mit einem perspektivischen Rahmenprofil umgibt, unterstützt Dürer den Eindruck eines Steinplattenreliefs.

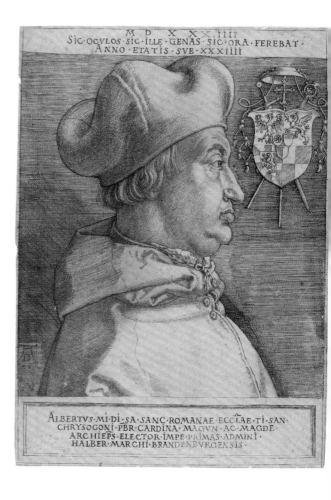

Cardinal Albrecht of Brandenburg (The Great Cardinal)
1523
Engraving
176 : 129 mm
Monogrammed, dated
No watermark

Above, the year 1523 and a two–line Latin hexameter: M D X X III / SIC · OCVLOS · SIC · ILLE · GENAS · SIC · ORA · FEREBAT · / ANNO · ETATIS · SVE · XXXIIII (So did his eyes, cheeks, and mouth appear in 1519 in the 43th year of his life). Appearing under the bust is a four–line Latin inscription: ALBERTVS · MI[SERICORDIA] · D[E]I · SA[CRO] · SANC[TAE] · ROMANAE · ECCL[ESI]AE · TI[TVLI] · SAN[CTI] · / CHRYSOGONI · P[RES]B[ITE]R · CARDINA[LIS] · MAGVN[TINENSIS] · AC · MAGDE[BVRGENSIS] · / ARCHIEP[ISCOPV]S · ELECTOR · IMPE[RII] · PRIMAS · ADMINI[STRATOR] · / HALBER[STADENSIS] · MARCHI[O] · BRANDENBVRGENSIS ·
(Albrecht, Cardinal Priest through God's mercy of the Holy Roman Church with the Titulus Ecclesiae St. Chrysogonus, Archbishop of Mainz and Magdeburg, Prince Elector of the Holy Roman Empire, Administrator [of the Diocese] of Halberstadt, Margrave of Brandenburg).

Provenance: acquired in 1802/1803 from Artaria by Ludwig X, Landgrave of Hesse.
Inv. no. GR 97

Literature: Bartsch 103; Meder 101, 1 a; Hollstein 101; Schoch et al. 97.

Kardinal Albrecht von Brandenburg (Der große Kardinal)
1523
Kupferstich
176 : 129 mm
monogrammiert, datiert
ohne Wasserzeichen

Oben Jahreszahl 1523 und zweizeiliger lateinischer Hexameter: M D X X III / SIC · OCVLOS · SIC · ILLE · GENAS · SIC · ORA · FEREBAT · / ANNO · ETATIS · SVE · XXXIIII (So trug jener Augen, Wangen und Mund im 34. Jahr seines Lebensalters). – Unter der Büste vierzeilige lateinische Inschrift: ALBERTVS · MI[SERICORDIA] · D[E]I · SA[CRO] · SANC[TAE] · ROMANAE · ECCL[ESI]AE · TI[TVLI] · SAN[CTI] · / CHRYSOGONI · P[RES]B[ITE]R · CARDINA[LIS] · MAGVN[TINENSIS] · AC · MAGDE[BVRGENSIS] · / ARCHIEP[ISCOPV]S · ELECTOR · IMPE[RII] · PRIMAS · ADMINI[STRATOR] · / HALBER[STADENSIS] · MARCHI[O] · BRANDENBVRGENSIS ·
(Albrecht, durch Gottes Barmherzigkeit Kardinal-Priester der Heiligen Römischen Kirche mit der Titelkirche des heiligen Chrysogonus, Erzbischof von Mainz und Magdeburg, Kurfürst, Primas des Reiches, Administrator [des Bistums] Halberstadt, Markgraf von Brandenburg).

Herkunft: 1802/1803 über Artaria an Ludwig X. Landgraf von Hessen.
Inv. Nr. GR 97

Literatur: Bartsch 103; Meder 101, 1 a; Hollstein 101; Schoch u. a. 97.

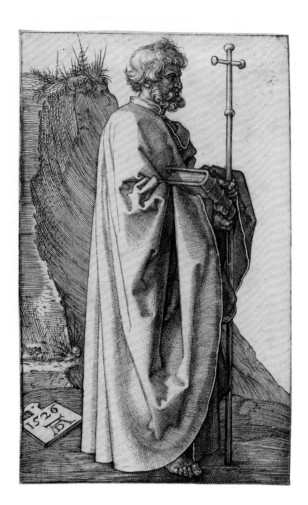

This sheet is the last in an unfinished series of apostles begun by Dürer in 1514 with Paul and Thomas, and continued in 1523 with three additional portraits. Of these, he published the one of Philip (seen here in an excellent early version) only in 1526. Three-dimensional in appearance, as though carved from a block of marble, the apostle stands in front of an embankment in a right profile view. The elaborate drapery of the saint's heavy cloak emphasizes his monumental and solemn pose. This lucid, serene composition is typical of Dürer's late style. The austerity of Philip figure's is also reflected in the character of Paul seen on the right–hand panel of the Four Apostles, dedicated by Dürer to his hometown of Nuremberg in 1526.

98

Das Blatt ist das letzte einer unvollendet gebliebenen Apostelfolge, die Dürer bereits 1514 mit den Aposteln Paulus und Thomas begonnen hatte, dann 1523 mit drei weiteren Apostel-Darstellungen fortführte, wovon er den Philippus – hier in einem frühen vorzüglichen Abdruck – erst 1526 veröffentlichte. Plastisch und wie in Marmor gehauen steht der Apostel im Profil nach rechts vor einer Böschung. Der Faltenwurf des schweren Mantels betont die monumentale, feierliche Haltung des Heiligen. Die klare und ruhige Gestaltung ist Ausdruck für Dürers Spätstil. Die Formstrenge des Philippus findet sich wieder in der machtvollen Charakterfigur des Paulus auf der rechten Tafel der „Vier Apostel", die Dürer 1526 seiner Heimatstadt Nürnberg widmete.

The Apostle Philip	Der Apostel Philippus
1523/26	1523/26
Engraving	Kupferstich
122 : 76 mm	122 : 76 mm
Monogrammed, dated: 1526	monogrammiert, datiert: 1526
(corrected from 1523)	(korrigiert aus: 1523)
No watermark	ohne Wasserzeichen
Provenance: acquired in	Herkunft: 1802/1803 über
1802/1803 from Artaria by	Artaria an Ludwig X. Landgraf von
Ludwig X, Landgrave of Hesse.	Hessen.
Inv. no. GR 45	Inv. Nr. GR 45
Literature: Bartsch 46; Meder 48	Literatur: Bartsch 46; Meder 48 a;
a; Hollstein 48; Schoch et al. 100.	Hollstein 48; Schoch u. a. 100.

Rarely has any artist so convincingly portrayed the spirit of an individual. As his sitter's principal expressive feature, Dürer has singled out the youthful thinker's high forehead, fringed with tousled hair and set against a pale background. Beginning at eye level, this half–length portrait is given a background of clouds. Melanchton's intellectual acuity is suggested by his large eye, which mirrors the crossbars of a window, and his alertness, suggested by his delicate temples with their protruding veins. The inscription, set by Dürer between the year and the artist's monogram as though on an engraved stone panel, refers to the thinker's exceptional mind. The basis for Dürer's engraving was probably a portrait drawing executed in November of 1525 during Melanchton's stay in Nuremberg (Winkler 901). The copperplate for the engraved portrait of Melanchton is the only one by Dürer that survives (it is found today at the Schlossmuseum in Gotha).

99

Philipp Melanchton
1526
Engraving
174 : 129 mm
Monogrammed, dated
No watermark

Inscription below in brown ink
Below, a five-line Latin inscription:
VIVENTIS · POTVIT · DVRERIVS · ORA · PHILIPPI / MENTEM · NON · POTVIT · PINGERE · DOCTA / MANVS / [Dürer's monogram]
(Philipp's appearance was captured by Dürer from life, but the hand of the artist was unable to comprehend his spirit).

Provenance: acquired in 1802/1803 from Artaria by Ludwig X, Landgrave of Hesse. Inv. no. GR 99

Literature: Bartsch 105; Meder 104 c; Hollstein 104; Schoch et al. 101.

Philipp Melanchton
1526
Kupferstich
174 : 129 mm
monogrammiert, datiert
ohne Wasserzeichen

Unten techts alt bezeichnet mit Tinte in Braun: P. Mariette 1663
Unten fünfzeilige lateinische Inschrift: VIVENTIS · POTVIT · DVRERIVS · ORA · PHILIPPI / MENTEM · NON · POTVIT · PINGERE · DOCTA / MANVS / [Dürermonogramm]
(Das Aussehen Philipps konnte Dürer nach dem Leben festhalten, nicht aber vermochte seine Künstlerhand dessen Geist zu erfassen).

Herkunft: 1802/1803 über Artaria an Ludwig X. Landgraf von Hessen.
Inv. Nr. GR 99

Literatur: Bartsch 105; Meder 104 c; Hollstein 104; Schoch u. a. 101.

Selten ist es so überzeugend gelungen, den Geist eines Menschen bildlich zu erfassen. Zum Hauptausdrucksträger macht Dürer die hohe Stirn des jugendlichen Denkers, die von zerzaustem Haar umspielt vor hellem Hintergrund steht, während ab Augenhöhe das Brustbild von Wolken hinterfangen wird. Die intellektuelle Scharfsicht des Humanisten verbildlicht sein großes Auge mit dem sich darin spiegelnden Fensterkreuz, seinen wachen Verstand die zarte Schläfe mit hervortretenden Adern. Schließlich verweist die Inschrift, die Dürer wie in eine Steintafel gehauen zwischen die Jahreszahl und sein Monogramm setzt, auf den überragenden Geist des abgebildeten Denkers. Grundlage für Dürers Kupferstich war vermutlich eine Porträtzeichnung, die er im November 1525 bei Melanchtons Aufenthalt in Nürnberg anfertigte (Winkler 901). Von allen gestochenen Platten Dürers hat sich die Kupferstichplatte des Melanchtons als einzige erhalten (heute im Schlossmuseum in Gotha).

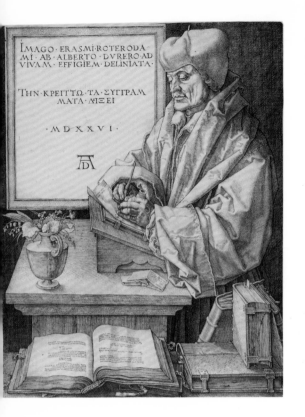

Unusual features for an engraved portrait by Dürer are both the large format and the placement of the texted panel. Dürer had executed a portrait drawing of Erasmus of Rotterdam in the Netherlands in 1521 (Winkler 805), but six additional years would pass before the artist would fulfill the scholar's desire for an engraved portrait. We see Erasmus in robes and doctor's cap, surrounded by books and writing at a lectern. Standing before him on the desk is a vase containing lilies of the valley and violets; lying next to him is a letter, its seal broken. The text found on the large, framed panel addresses the viewer in Greek, admonishing him to read Erasmus' books, said to contain his "true image." Herein lies the intellectual content of Dürer's likeness of the humanist Erasmus, also alluded to by the four books seen in the foreground.

100

That the humanist Erasmus adhered to Latin as a universal language while Dürer strove to establish German as a new scholarly language is indicative of the profound misunderstanding separating the two men. In the diary he kept during his trip through the low countries, Dürer expresses the futile hope that as a "knight of Christ," Erasmus would safeguard Luther's teachings, even at the cost of his own death as a martyr. Notwithstanding, Erasmus praises Dürer in his treatise "The Right Way of Speaking Latin and Greek" for the German artist's capacity for expressing various contents in the black-and-white print medium, an ability amply confirmed by Dürer's engraving of Erasmus.

Ungewöhnlich für die Bildnisstiche Dürers ist das größere Format wie die Plazierung der Schrifttafel. Bereits 1520 bzw. 1521 fertigte Dürer in den Niederlanden eine Porträtzeichnung von Erasmus von Rotterdam (Winkler 805), doch vergingen sechs Jahre, bis Dürer Erasmus' Wunsch nach einem gestochenen Porträt erfüllt hatte. Dürers Stich zeigt den Gelehrten im Talar und mit Doktorhut schreibend am Pult umgeben von Büchern. Vor ihm auf dem Tisch steht eine Blumenvase mit Maiglöckchen und Veilchen, neben ihm liegt ein aufgebrochener Brief. Die große gerahmte Schrifttafel fordert in Griechischer Sprache dazu auf, Erasmus' Schriften zu lesen, wenn man an seinem wahren Bild interessiert ist. Darin liegt der intellektuelle Gehalt von Dürers Bildnis, auf den auch das geschlossene und die vier geöffneten Bücher im Vordergrund verweisen.

Die Tatsache, dass der Humanist Erasmus an der Weltsprache Latein festhielt, während Dürer Deutsch als neue Wissenschaftssprache etablieren wollte, deutet auf die gravierenden Missverständnisse hin, die zwischen beiden bestanden. So erhoffte Dürer im Tagebuch der niederländischen Reise vergeblich, dass Erasmus als „Ritter Christi" die Lehre Luthers beschützen würde, selbst um den Preis des Märtyrertodes. Gleichwohl betonte Erasmus in seinem Traktat „Dialog über die richtige Aussprache des Lateinischen und Griechischen" Dürers Fähigkeit, sich im graphischen Medium des Schwarz-Weiß inhaltlich ausdrücken zu können, was Dürers Kupferstich von Erasmus hinlänglich unter Beweis stellt.

Erasmus of Rotterdam	Erasmus von Rotterdam
1526	1526
Engraving	Kupferstich
247 : 190 mm	247 : 190 mm
Monogrammed, dated	monogrammiert, datiert
No watermark	ohne Wasserzeichen
Found on the tablet is a seven–verse Latin and Greek inscription: IMAGO · ERASMI · ROTERODA= / MI · AB · ALBERTO · DVERERO · AD / VIVAM · EFFIGIEM · DELINIATA · / THN · ΚΡΕΙΤΤΩ · ΤΑ · ΣΥΓΓΡΑΜ / ΜΑΤΑ · ΔΕΙ Ξ ΕΙ / · MDXXVI · / [Dürer's monogram] (Portrait of Erasmus of Rotterdam, drawn according to life by Albrecht Dürer. His better image is to be found in his texts).	Auf der Tafel siebenzeilige lateinische und griechische Inschrift: IMAGO · ERASMI · ROTERODA= / MI · AB · ALBERTO · DVERERO · AD / VIVAM · EFFIGIEM · DELINIATA · / THN · ΚΡΕΙΤΤΩ · ΤΑ · ΣΥΓΓΡΑΜ / ΜΑΤΑ · ΛΕΙΞΕΙ · / · MDXXVI · / [Dürer-Monogramm] (Bildnis des Erasmus von Rotterdam, von Albrecht Dürer nach dem Leben gezeichnet. Das bessere Bild von ihm zeigen seine Schriften).
Provenance: acquired in 1802/1803 from Artaria by Ludwig X, Landgrave of Hesse. Inv. no. GR 101	Herkunft: 1802/1803 über Artaria an Ludwig X. Landgraf von Hessen. Inv. Nr. GR 101
Literature: Bartsch 107; Meder 105 d; Hollstein 105; Schoch et al. 102. Antwerp 1970, 130.	Literatur: Bartsch 107; Meder 105 d; Hollstein 105; Schoch u. a. 102. Antwerpen 1970, 130.

BIBLIOGRAPHY / LITERATUR

A complete bibliography regarding all works, including exhibition catalogues and more extensive literature, is listed in the critical catalogue raisonné on Albrecht Dürer's print works prepared by Rainer Schoch, Matthias Mende, and Anna Scherbaum (Schoch et al.).

. . .

Antwerp 1970
Albrecht Dürer. Druckgraphik / exhibition cat., Royal Palace, Antwerp; Palazzo Braschi Rome; National Library Madrid, Hans Mielke, Berlin 1970.
[Organized on the occasion of Dürer's 500th birthday. This selection of twenty prints owned by the Hessisches Landesmuseum Darmstadt, together with prints from the Kupferstichkabinett of the Berlin State Museums (SMPK), the Kupferstichkabinett of the Hamburger Kunsthalle, the Wallraf Richartz Museum in Cologne, and the Staatliche Graphische Sammlung in Munich were presented in a touring exhibition in Antwerp, Rome, and Madrid. In the present catalogue, the respective catalogue numbers are cited for each print from Darmstadt.]

Bartsch
Adam Bartsch: Le Peintre Graveur, vol. 7, Vienna 1808.

Darmstadt 1970
Albrecht Dürer. Holzschnitte. Kupferstiche. Radierungen aus dem Hessischen Landesmuseum in Darmstadt / exhibition cat., Hessisches Landesmuseum Darmstadt; Jahrhunderthalle Hoechst, Gisela Bergsträsser, Darmstadt 1970.

Hollstein
F. W. H. Hollstein: German Engravings, Etchings and Woodcuts, vol. VII, Albrecht and Hans Dürer, Amsterdam 1954.

Lehrs
Max Lehrs: Geschichte und kritischer Katalog des deutschen, niederländischen und französischen Kupferstichs im 15. Jahrhundert, 16 vols., Vienna 1908-1934.

Lugt
Frits Lugt: Les Marques de collections de dessins & d'estampes, Amsterdam 1921, Supplément, The Hague 1956.

Vollständige Literaturangaben zu allen Werken, Ausstellungskataloge sowie weiterführende Literatur, nennt das von Rainer Schoch, Matthias Mende und Anna Scherbaum bearbeitete kritische Werkverzeichnis der Druckgraphik Albrecht Dürers (Schoch u. a.).

. . .

Antwerpen 1970
Albrecht Dürer. Druckgraphik / Ausst. Kat. Königlicher Palast Antwerpen; Palazzo Braschi Rom; Nationalbibliothek Madrid. Hans Mielke. Berlin 1970.
[Anlässlich von Dürers 500sten Geburtstag wurde eine Auswahl von 20 Blättern aus den Beständen des Hessischen Landesmuseums Darmstadt zusammen mit Blättern des Kupferstichkabinetts der Staatlichen Museen Preußischer Kulturbesitz Berlin, des Kupferstichkabinetts der Hamburger Kunsthalle, des Wallraf-Richartz-Museums Köln und der Staatlichen Graphischen Sammlung München in einer Wanderausstellung in Antwerpen, Rom und Madrid vorgestellt. Im vorliegenden Katalog wird zu den Blättern aus Darmstadt die jeweilige Katalognummer genannt.]

Bartsch
Adam Bartsch: Le Peintre Graveur, Band 7. Wien 1808.

Darmstadt 1970
Albrecht Dürer. Holzschnitte. Kupferstiche. Radierungen aus dem Hessischen Landesmuseum in Darmstadt / Ausst. Kat. Hessisches Landesmuseum Darmstadt; Jahrhunderthalle Hoechst. Gisela Bergsträsser. Darmstadt 1970.

Hollstein
F. W. H. Hollstein: German Engravings, Etchings and Woodcuts, Band VII, Albrecht and Hans Dürer. Amsterdam 1954.

Lehrs
Max Lehrs: Geschichte und kritischer Katalog des deutschen, niederländischen und französischen Kupferstichs im 15. Jahrhundert, 16 Bde. Wien 1908-1934.

Lugt
Frits Lugt: Les Marques de collections de dessins & d'estampes. Amsterdam 1921, Supplément. Den Haag 1956.

Meder
Joseph Meder: Dürer-Katalog. Ein Handbuch über Albrecht Dürers Stiche, Radierungen, Holzschnitte, deren Zustände, Ausgaben und Wasserzeichen, Vienna 1932.

Panofsky 1955
Erwin Panofsky: The Life and Art of Albrecht Dürer, Princeton 1955.

Schoch et al.
Rainer Schoch, Matthias Mende, Anna Scherbaum: Albrecht Dürer. Das druckgraphische Werk: vol. I., Kupferstiche, Eisenradierungen und Kaltnadelblätter, Munich, London, New York 2001; vol. II, Holzschnitte und Holzschnittfolgen, Munich, London, New York 2002; vol. III, Buchillustrationen, Munich, London, New York 2004.

Winkler
Friedrich Winkler: Die Zeichnungen Albrecht Dürers, vols. I-IV, Berlin 1936-1939.

Exhibition catalogues on Dürer prints after 2004 (not listed in Schoch et al.):

Aachen 2004
Albrecht Dürer. Apelles des Schwarz-Weiss / exhibition cat. Suermondt-Ludwig-Museum Aachen. ed. by Dagmar Preising, Ulrike Villwock, and Christine Vogt, Aachen 2004.

Frankfurt 2007
Albrecht Dürer. Die Druckgraphiken im Städel Museum / exhibition cat. Guggenheim Museum Bilbao; Städel Museum Frankfurt am Main, ed. by Martin Sonnabend, [German edition] Cologne 2007.

Zurich 2006
Albrecht Dürer. Meisterstiche. Sammlung Landammann Dietrich Schindler / exhibition cat., Kunsthaus Zurich, Bernhard von Waldkirch, Magdalena Schindler, Zurich 2006.

Meder
Joseph Meder: Dürer-Katalog. Ein Handbuch über Albrecht Dürers Stiche, Radierungen, Holzschnitte, deren Zustände, Ausgaben und Wasserzeichen. Wien 1932.

Panofsky 1977
Erwin Panofsky: Das Leben und die Kunst Albrecht Dürers. München 1977 (Ins Deutsche übersetzt von Lise Lotte Möller).

Schoch u. a.
Rainer Schoch, Matthias Mende, Anna Scherbaum: Albrecht Dürer. Das druckgraphische Werk, Bd. I., Kupferstiche, Eisenradierungen und Kaltnadelblätter. München, London, New York 2001; Bd. II, Holzschnitte und Holzschnittfolgen. München, London, New York 2002; Bd. III, Buchillustrationen. München, London, New York 2004.

Winkler
Friedrich Winkler: Die Zeichnungen Albrecht Dürers, Bde. I-IV. Berlin 1936-1939.

Bei Schoch u.a. nicht mehr gelistete Ausstellungskataloge zu Dürer-Graphik nach 2004:

Aachen 2004
Albrecht Dürer. Apelles des Schwarz-Weiss / Ausst. Kat. Suermondt-Ludwig-Museum Aachen. Hrsg. von Dagmar Preising, Ulrike Villwock und Christine Vogt. Aachen 2004.

Frankfurt 2007
Albrecht Dürer. Die Druckgraphiken im Städel Museum / Ausst. Kat. Guggenheim-Museum Bilbao; Städel Museum Frankfurt am Main. Hrsg. von Martin Sonnabend. [Dt. Ausg.] Köln 2007.

Zürich 2006
Albrecht Dürer. Meisterstiche. Sammlung Landammann Dietrich Schindler / Ausst. Kat. Kunsthaus Zürich. Bernhard von Waldkirch, Magdalena Schindler. Zürich 2006.